MY TINY ATLAS

MY TINY ATLAS

OUR WORLD THROUGH YOUR EYES

EMILY NATHAN

TEN SPEED PRESS
California | New York

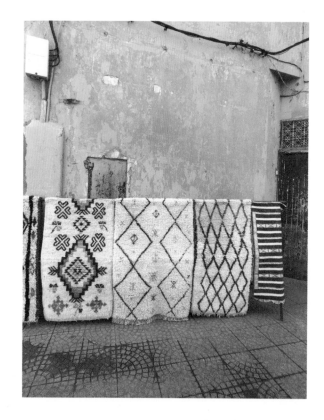

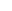 **Marrakech, Morocco**

Emily Nathan
@ernathan

→ **Madurai, Tamil Nadu, India**

Joe Greer
@ioegreer

When I started *Tiny Atlas* in 2012, I was a photographer with a notion to create an online lifestyle travel magazine filled with only the photography I loved: lots pictures of people (where people are rare in most travel publications), all color imagery (a perhaps arbitrary decision about consistency I held on to from my own professional photography), and images that showed what it felt like to be in a place, rather than what you might expect a place to look like based on previous images you had seen. And most importantly, as a photographer with my own opinions who knew the frustration of having my favorite shots tweaked or taken out, I wanted to show the photographer's edit.

In *Tiny Atlas*, I wanted to put in rather than cut out the moody shots of a beach during a storm. I wanted people in hotel rooms. I wanted rooms that were not hotels but locals' homes too. As a professional photographer, you have your work photographs and your personal images. A few of your work photographs might make the cut of images you still want to look at years after you shot them, but not many—at least for most of us. Today, I want pictures of people and places that mean something to me and to the photographers who come to *Tiny Atlas* for inspiration, for ideas, for images that change lives. And my hunch is that as I get older I will want to see pictures that meant something personal to me—not perfect moments, but moments of transformation. With *Tiny Atlas*, I wanted to create a magazine that aspired to that sentiment.

WHO AM I?

I have loved travel, and photography (don't they always go together?), ever since I was a kid—even though "travel" usually started with a nauseating ride to the Detroit airport in the backseat of my parents' car. It felt like an eternity from our suburban house. Apart from that car ride, I loved everything about traveling—the rush and excitement of airports, landing somewhere new and hauling our bags off the turnstile, racing through NYC in cabs to a soundtrack of endless cars honking, feeling warm humid air in the tropics, using a hotel telephone in a vacation condo, and swimming underwater laps pretending to be a mermaid while my parents slept in.

My dad was a typical gearhead doctor whose interest in photography was displayed on our kitchen walls in framed travel photos of foreign markets and landscapes and in our living room during family slideshows

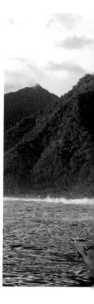

alongside popcorn from the air popper. After I developed my own interest in photography in middle school, my dad sent me off to summer camp with my first SLR camera. When the poorly exposed first few rolls returned from the lab, I set out to learn everything I could about the medium. I cobbled together a language of photography from a variety of sources, in the same way we learn language from all of the words flying toward our infant selves. I learned about exposure and aperture from art teachers and absorbed style and point of view from museums and print. Every weekend I would rush to grab both the travel section and the magazine from our weekly Sunday *New York Times*. But more than anything, I learned from shooting my own pictures and slowly finding my own unique take on the world, exposure by exposure.

Many years later, I had my first truly ecstatic experience with travel and photography. A few years after graduating from the University of Michigan, when I was still a photo assistant, I was hired to accompany Thayer Gowdy, a photographer I worked for in San Francisco, on a shoot on Symi, a tiny island in the Dodecanese chain in southern Greece (travel cements geography in your brain like nothing else). We had one afternoon off, so she and I decided to hike over the hill of the main town to a small fishing port on the other side. We were told it should take about an hour or two for the journey by foot.

The trip took us all day. And we did not get lost or hurt. Instead, we were two photographers with hearts and eyes wide open to experiencing a country and a place we had never been before, hiking with our cameras in hand. We stopped a million times. I stopped on a rocky hillside to record the sweet clanging music of bells on a passing herd of goats. We stopped to talk. We stopped to take pictures and connect with anyone we came across. I was taking pictures, but I was also taking in the world around me, unconsciously curating the experience. With *Tiny Atlas*, travel lifestyle is always mashed up with a photographer's lifestyle, as it was on that trip.

WHAT IS *TINY ATLAS*?

In *Tiny Atlas*, I wanted to create a project that communicated my values about travel: curiosity, openness, an environmental and social awareness, respect for locals, and an inquisitiveness about history, with a dash of the necessary traveler trio of faith, spontaneity, and luck. Most importantly, I wanted to communicate most of these ideas visually. Any writing tended to shy away from my life or the lives of the writers or shooters and focused more on the place. I wanted a publication with an outward gaze, just like a camera lens itself, that was curious about others. At the same time, I wanted a magazine that

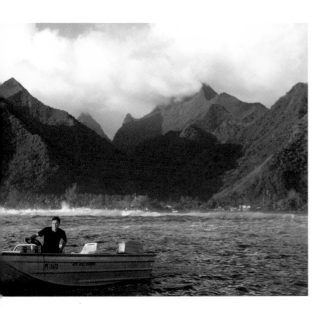

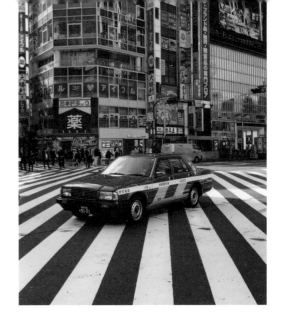

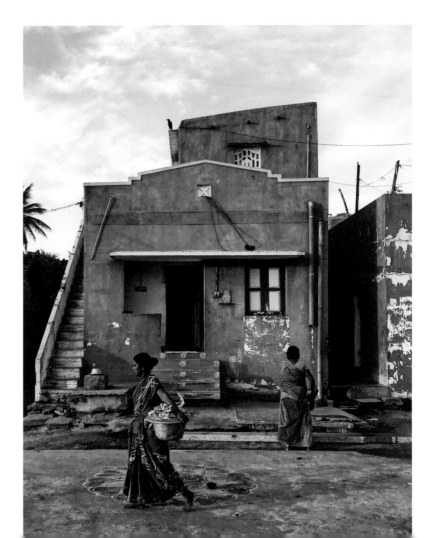

↑

Teahupo'o, Tahiti

Emily Nathan
@ernathan

↗

Tokyo, Japan

Sam Horine
@samhorine

→

**Thavalakuppam,
Tamil Nadu, India**

Elke Frotscher
@elice_f

was about places people would want to go on their leisure time. When evaluating contributions, we still use a metric coined by our magazine photo and partnerships director Deb Hearey: "Do I want to go there?" If the answer was yes, we would keep considering the image; if not, we decided it might be for another magazine.

While we had been very selective with the caliber of professional photographers in the digital magazine, once I initiated the *Tiny Atlas Quarterly* Instagram feed, suddenly anyone who understood our mission and could capture a gorgeous moment could contribute to the project. And there was an immediate joy in that openness. *Tiny Atlas* transformed from an editorial project connected to a few handfuls of photographers to a more global brand interacting with people all over of the world who were following our Instagram posts, and were passionate about becoming involved in our community. For the first few years I was able to look through every image tagged #mytinyatlas, searching for something new, something irresistible, something I had not seen before. So while #mytinyatlas is less and less about me, it has also always been a bit about my personal interests and relationships. And in a sea of corporate brand images and voices, starting something with a strong personal voice has resonated since day one.

THE COMMUNITY

One of the biggest surprises for me with *Tiny Atlas* has been how much my world has expanded through this home-brewed project. After years of curating content on our website and Instagram feed, my friend Laura Rubin suggested *Tiny Atlas* start taking our community along with us on trips, specifically to Tahiti and Tofino, British Columbia. So far, our trips have been one-off journeys to wildly gorgeous places. Using a couple of decades of editorial and commercial photography production as a base, we create experiences with partners that are focused on local immersion and on crafting days for people who like to take pictures (pro photographer or not). Sunsets are not for long dinners inside but for cooking outside and shooting; sunrises are for photo hikes; and bright midday sun and darkness— when the light isn't right—are the times for relaxing and sharing stories.

If you follow the *Tiny Atlas* Instagram feed, you will notice familiar names often pop up. Our "fam" is an ever-growing group connected to me and to the world through an always-expanding web of interlacing lives. I love when I can connect chef friends from San Francisco with olive farmers in Tuscany, or a model friend based in Los Angeles with

a lei maker in Honolulu. All of these people I met because I loved their work first. The personal relationships followed. Just as I met Elke and Ja Soon (who are featured artists in our Structured and Lush chapters, respectively) through their use of the #mytinyatlas tag, so too have I met everyone in this book. The tag has connected me to everyone who is featured here—it's the one degree of separation I have with millions.

WHAT IS THIS BOOK?

This book is about travel—but it's not the ultimate say on where to go this season or even this year. It will introduce you to some inspiring and beautiful locales, but it is less a guide than a record. It is a collection of images created by the *Tiny Atlas Quarterly* community of professional photographers and casual shooters alike—and me— that caught my eye and sparked the imagination of the *Tiny Atlas* community. They are pictures that made us stop and look.

Unlike a traditional atlas (or most travel media), the *Tiny Atlas* world is not organized by geography but by theme. So, too, for our book. It is organized by the themes that come up in our Instagram feed over and over. We honed in on ten themes for ten chapters that focused on the types of pictures we kept coming back to: all the water of our world in Afloat, the nature we experience in Wild, the food we find Delicious, the Lush plant life we seek out.

Whether you have known about our tag #mytinyatlas for years or are just discovering our homemade atlas today, I look forward to seeing your images and I hope you enjoy the ones we have selected to give you a beautiful overview of the world as we see it.

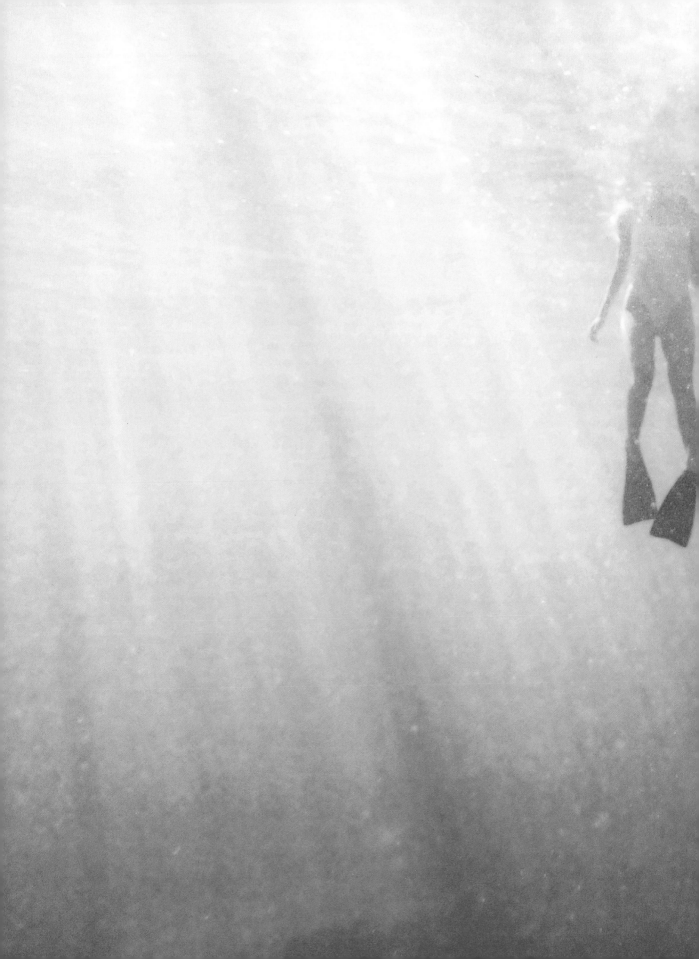

afloat

7

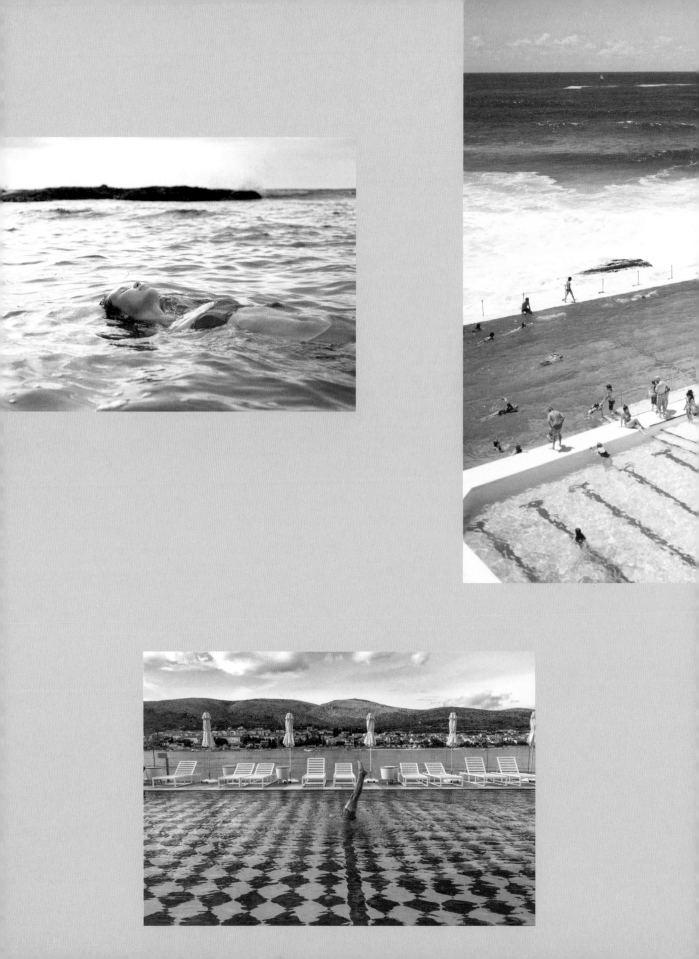

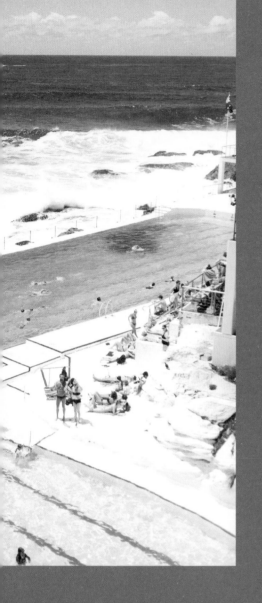

So much of travel is about getting to water. Travelers go out of their way to get to the ocean, a stream, a pool, or a lake. Going to the water is to take a reset. We arrive as standing, working people with the weight of the world on us and become floating, weightless beings with the weight of the world immediately lifted.

There are so many ways a photograph can capture the breadth of human experience with—and in—water. To address this multiplicity of feelings, photographers can start by shooting from a variety of perspectives. Take a picture from directly above and you'll get a bird's-eye view of the vastness of the open ocean; take a 50/50 shot (with your lens half above and half below the water's surface) and you'll get a sense of the immediacy of being in the water; take a picture underwater and you get a feeling of buoyancy. Using a shallow depth of field, as in the picture here from Paia, on Hawaii, focuses your eye on the swimmer and quickly draws you into her feeling of relaxation. To photograph an iceberg as it passes across a porthole in the Arctic, to observe a swimmer dunking underwater in Madagascar, or to sense the rush of surfing by shooting across the face of a wave while treading water requires an openness to perspective by the shooter.

←

Oahu, Hawaii, United States
Andrew Kearns
@andrewtkearns

↖

Paia, Maui, Hawaii, United States
Emily Nathan
@ernathan

↑

Bondi Icebergs Club, Sydney, New South Wales, Australia
Morgan Ashley Johnson
@morganashleyjo

←

Brown Beach House, Trogir, Croatia
Jeralyn Gerba
@jgerba

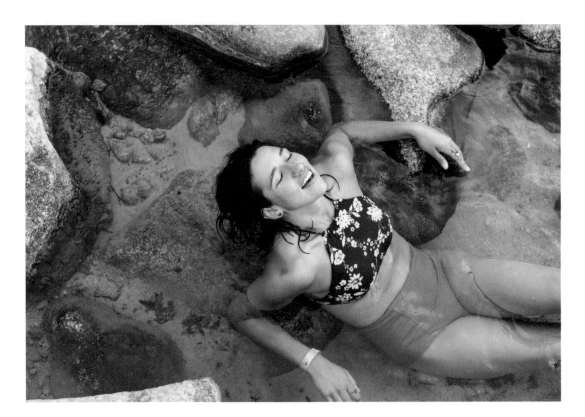

↑

**Mount Princeton Hot
Springs Resort, Nathrop,
Colorado, United States**

Jules Davies
@julesville_

→

Kapitan Khlebnikov,
Beechey Island, Canadian
Arctic Archipelago of
Nunavut, Canada

Simone Bramante
@brahmino

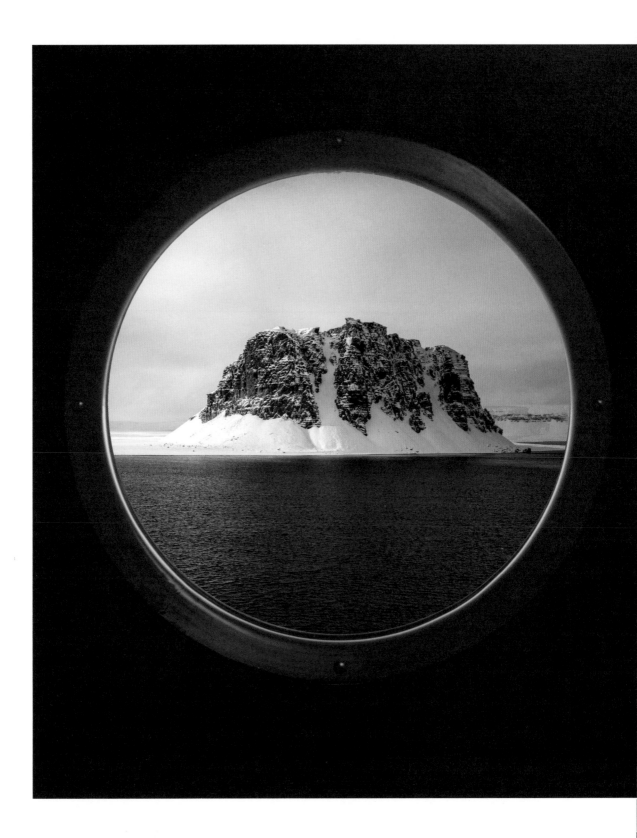

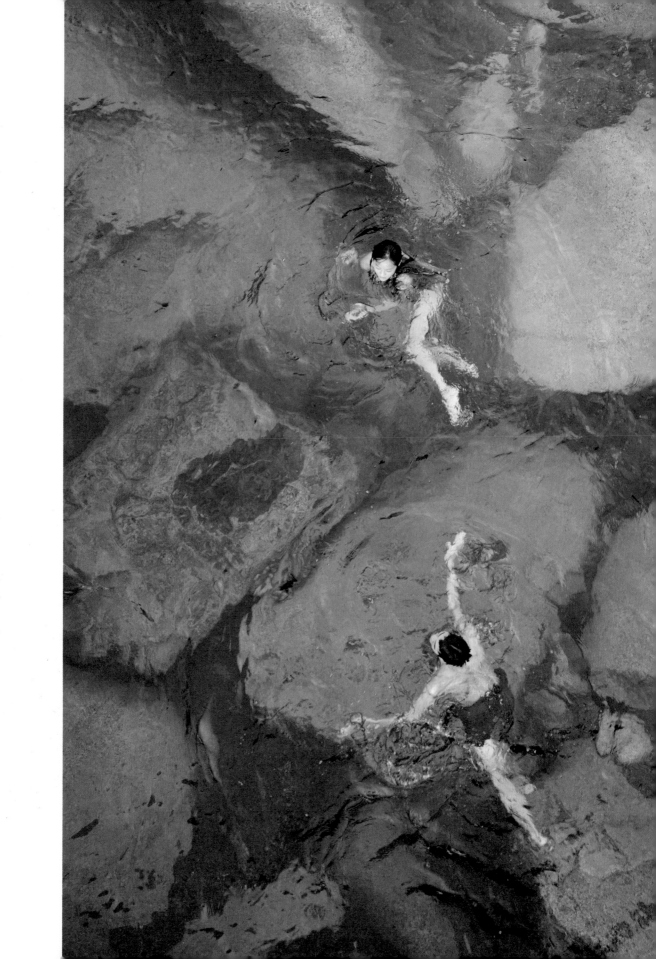

THE 40-MILE-LONG Yuba River runs along
the evergreen forests and oak woodlands of
California's Sierra Nevada mountain range. The
South Yuba River State Park spans half the
length of the river and is characterized by deep
emerald swimming holes surrounded by granite
rocks and miles of wilderness trails—including the
popular Pacific Crest Trail. In the spring you will
be greeted by rushing white water and wildflowers
throughout the rugged river canyon, but during the
summer these rapids turn into serene swimming
destinations and sunny beaches. Enjoy a picnic at
Bridgeport, or travel upriver to get away from the
bustling activity of the covered bridge, and capture
the contrast of the turquoise waters with the rocks
from above.

South Fork of Yuba River,
South Yuba River State Park,
California, United States

Emily Dulla
@emilydulla

Keyhole Falls hot springs,
Pemberton, British
Columbia, Canada

Sammie Chan
@sammiechn

Lummi Island,
Washington,
United States

Emily Nathan
@ernathan

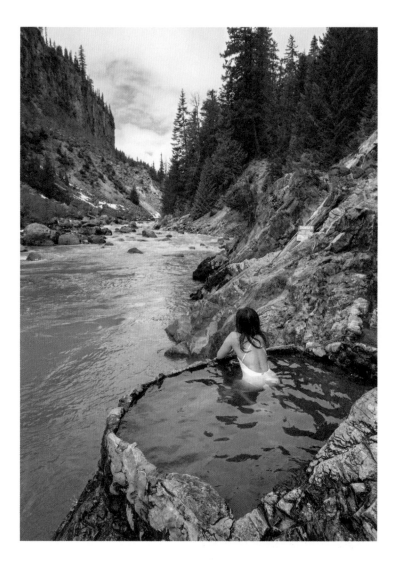

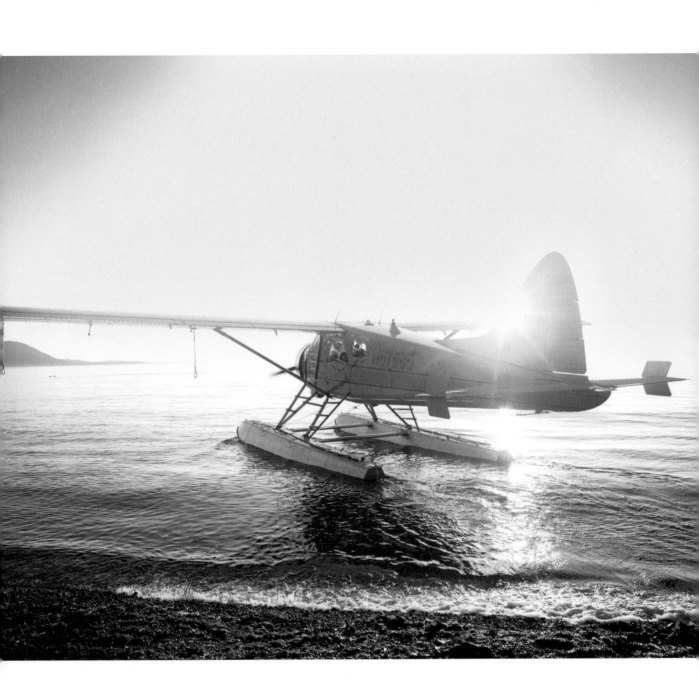

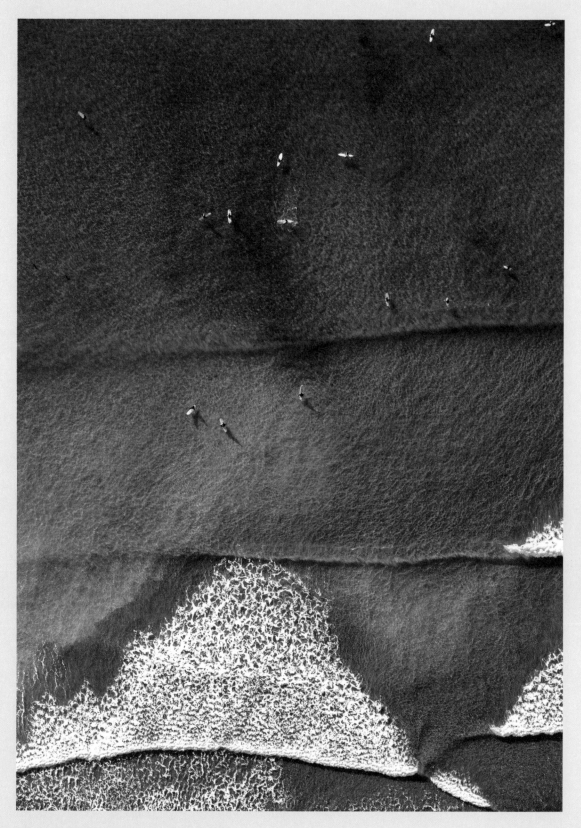

Cox Bay, Tofino, British Columbia, Canada

JEREMY KORESKI

@jeremykoreski

WHO IS JEREMY?

Jeremy Koreski is a waterman. His photography chronicles surf culture, coastal wildlife, and sustainability. He finds happiness by being in, on, and around the water—surfing, fishing, boating. He even spends part of his time living on a hand-built one-room float house. Jeremy grew up in Tofino, a small fishing and resort town on the edge of British Columbia's Vancouver Island. Considering this setting—a landscape of islets at the terminus of Highway 1 surrounded by forests and national park land—it's unsurprising that Jeremy wanted to spend his life outdoors. As a teenager skateboarding with his friends, he was the one to step back and photograph these moments, his images a living document of his life outdoors. The natural photographer in him has always made him keen to capture the everyday moments juxtaposed against Tofino's unique environment.

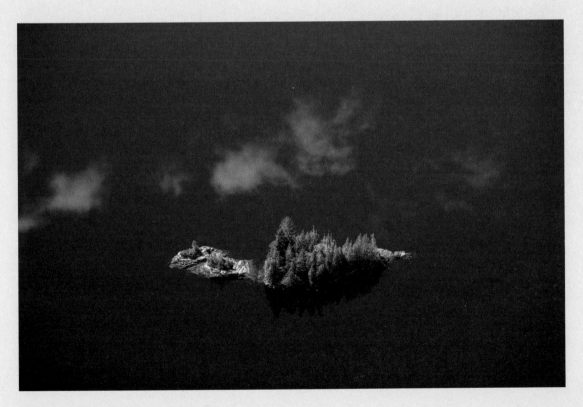

Nimmo Bay, British Columbia, Canada

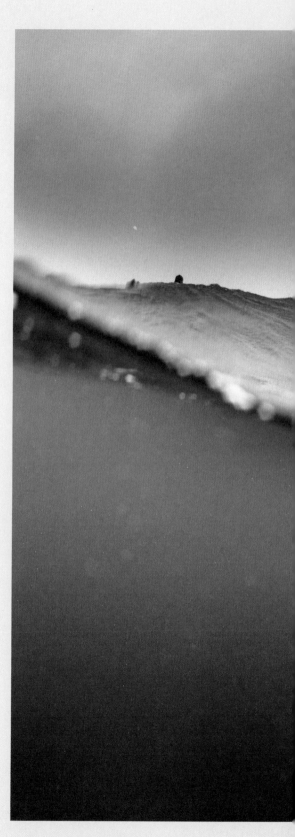

British Columbia, Canada

Jeremy has built his reputation on his insider experience. To create good images of the water, it helps to spend your life in the water, and Jeremy is at home shooting from floatplanes, waist-deep in rivers up and down the coast, or in a thick wetsuit as his friends catch waves around him. To be able to shoot boats, you need to know them. To shoot surfing, it helps if you surf well. People Jeremy met on the water naturally saw his skills and some even transitioned into his clients. Today he shoots for Canon, is an accomplished aerial photographer, is sponsored by waterproof gear brands, and is just the guy if you need to shoot two small water planes in the air from the side of an open helicopter.

JEREMY'S TOFINO

Many days you can find Jeremy on Clayoquot Sound—the water that surrounds the peninsula where Tofino sits and the myriad tiny islands in its vicinity—at the wheel of his aluminum speedboat, camera slung across his chest. Weaving through the cedar-covered islands and inlets or exploring riversides farther inland, he's always keeping an eye out for shots that can only be afforded from his perch in the boat: eagles' nests high in the trees, sea otters and sea lions as they dine on urchins and abalone, and black bears walking their own costal trails.

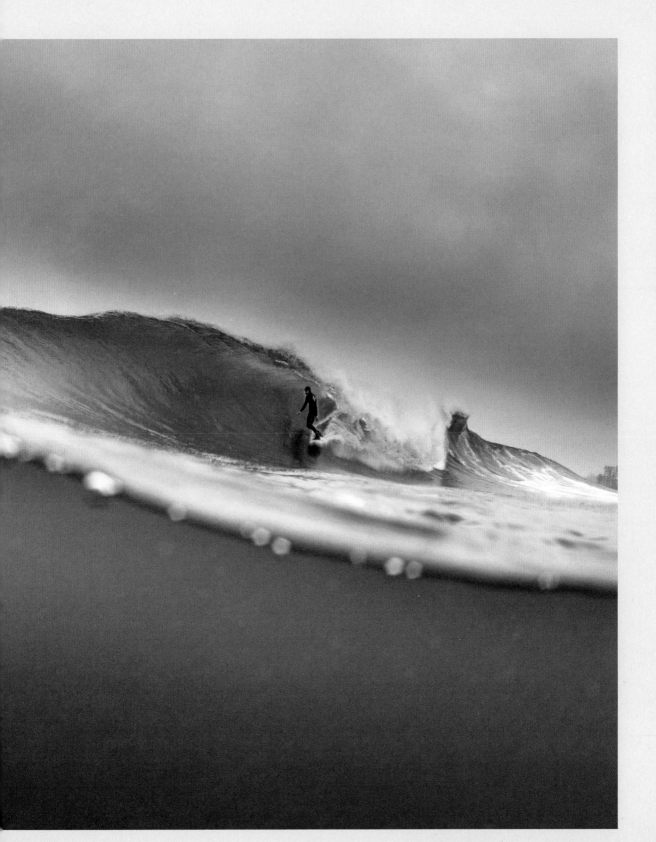

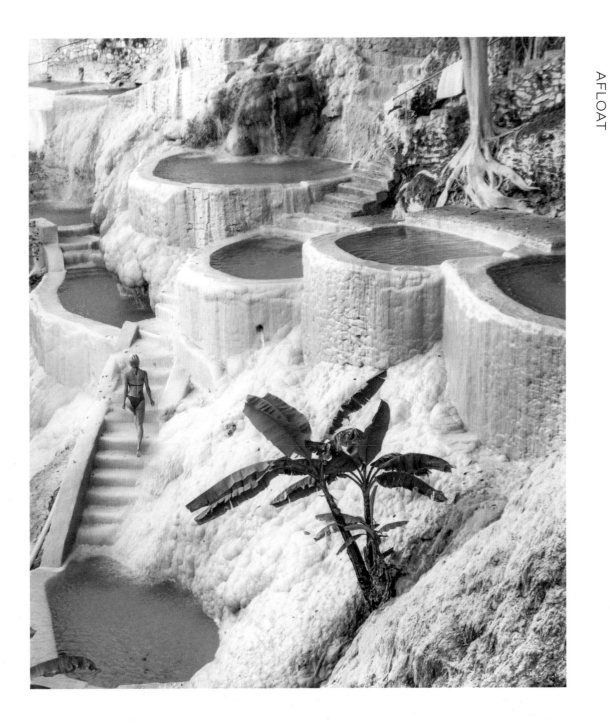

← Adriatic Sea,
Rovinj, Croatia

Gemma Cagnacci
@lineshapecolour

↑ Grutas Tolantongo,
Hidalgo, Mexico

Laura Sausina
@vagablonde_laura

→ North Islands,
Madagascar

Natalia Horinkova
@_nata_

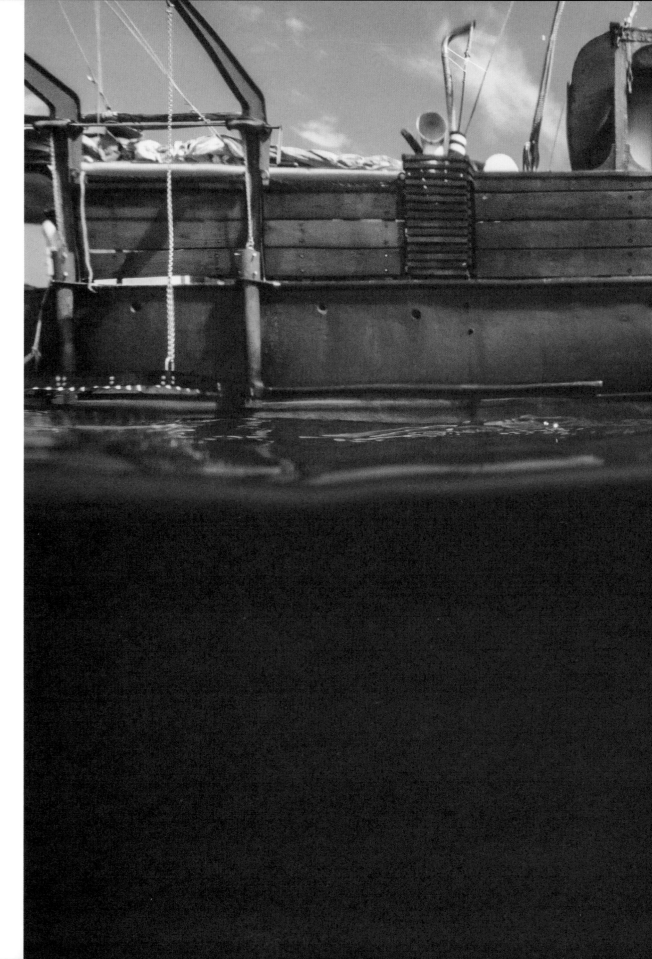

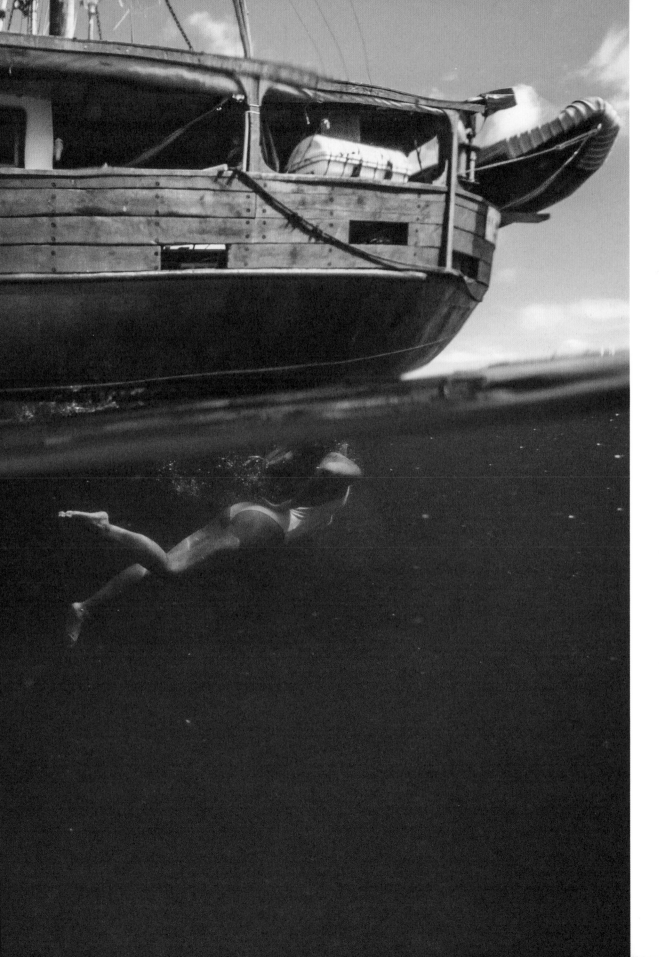

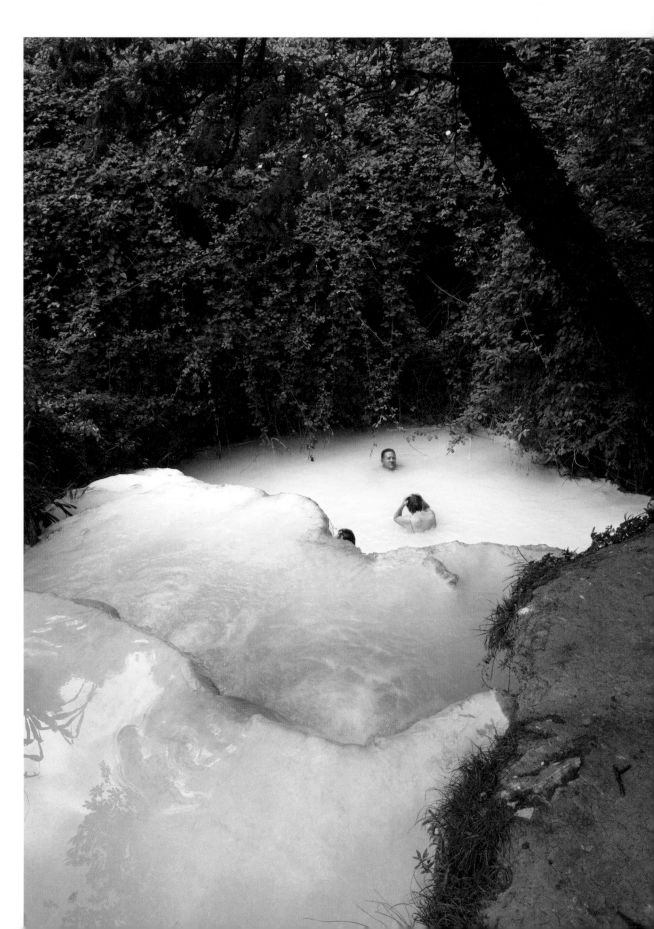

←

SOUTH OF TUSCANY, on a hill above Val d'Orcia, a large basin takes up almost the entire village of Bagno Vignoni—there are less forty permanent residents—known for this once-public healing bath used since antiquity and its still-unspoiled natural hot springs a half-mile walk downhill. Created by runoff from the River Orcia and high in mineral content from a dormant volcano, the sulfurous water is milky blue and, during summer months, hovers around 100 degrees. A hike farther away from the village offers more shaded pools, but visitors—mostly families from nearby countries—in the know come in winter months, when steam rises from slightly cooler water.

**Bagno Vignoni,
Tuscany, Italy**

Aya Brackett
@ayabrackett

↓

**Nantucket,
Massachusetts,
United States**

Kaity Farrell
@fareisle

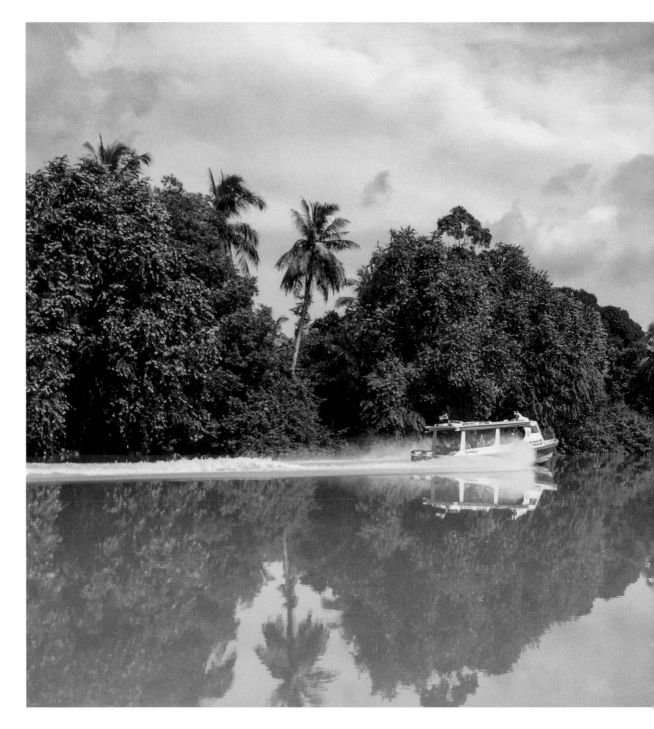

Borneo, Malaysia
Mateusz Cyrankiewicz
@bootl

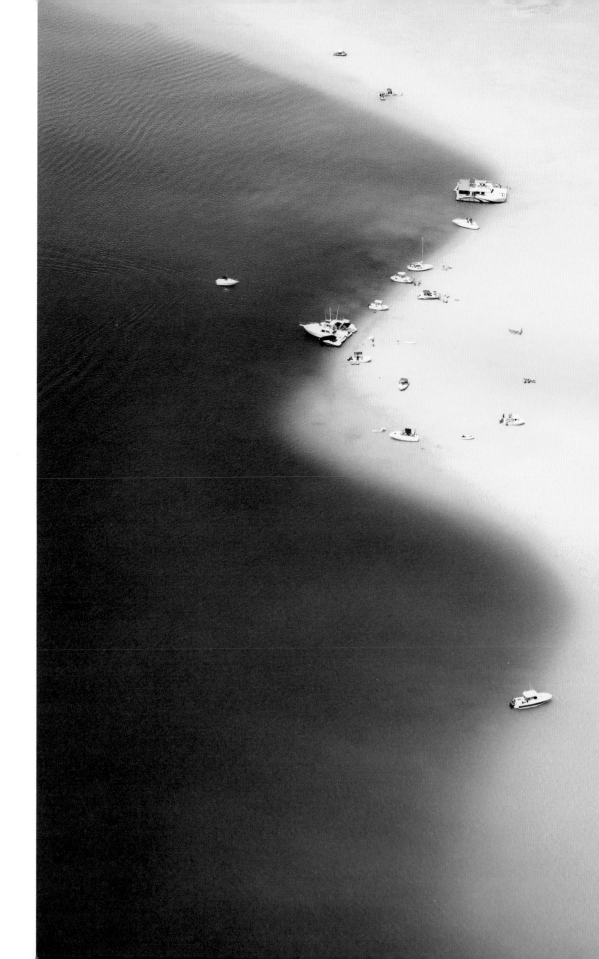

← Oahu, Hawaii,
United States

Andrew Kearns
@andrewtkearns

↓ Tribal Hotel,
Granada, Nicaragua

Anna Pihan
@annapihan

→ Ang Thong National
Marine Park, Ko
Pha-ngan, Surat Thani,
Thailand

Alex Abramowitz
@instagramowitz

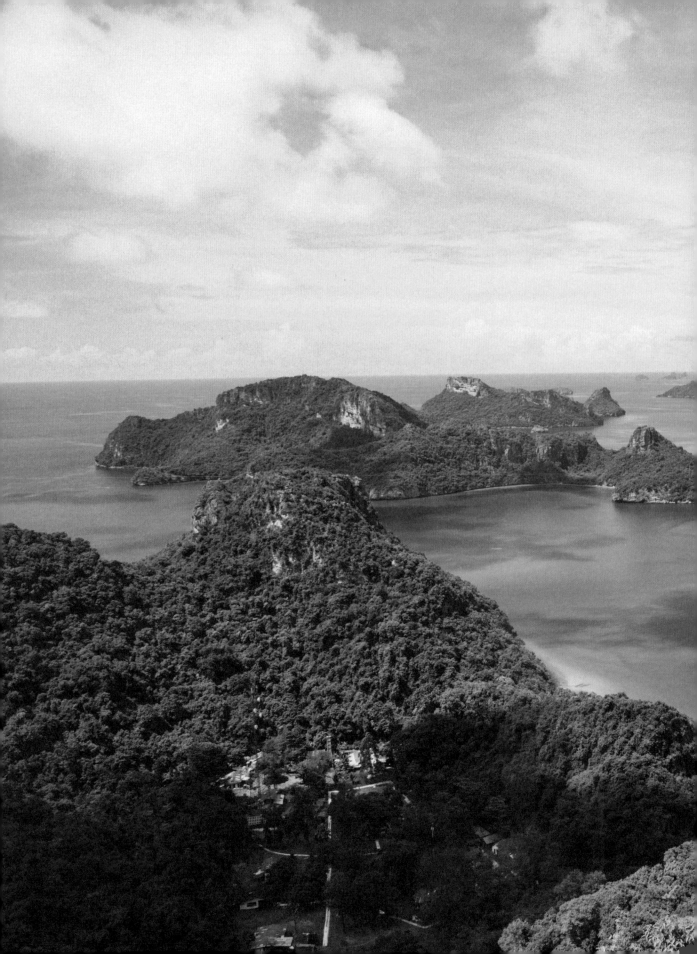

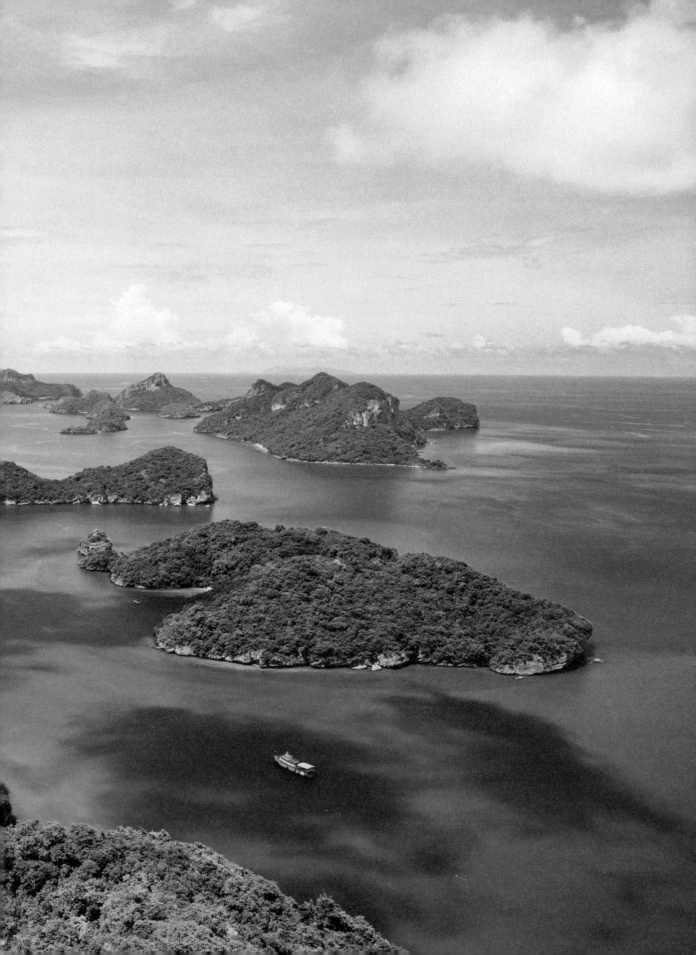

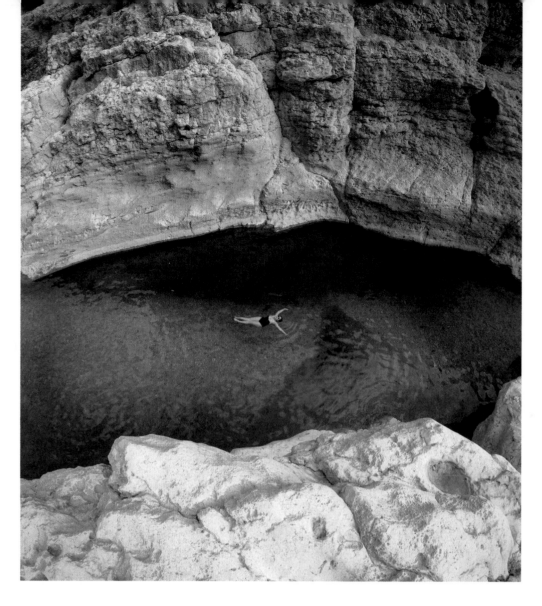

↑

CLEAR TURQUOISE WATERS with pink oleanders
at the water's edge, brown mountains with rough
terrain, palm groves, and a waterfall inside a hollow
cave are all sights to see as you hike and swim
your way through Wadi Shab. This gorge lies
between two cliffs in the Ash Sharqiyah region
of Oman's northeastern coast near the Bimmah
Sinkhole and Wadi Tiwi. To avoid heat exhaustion,
visit between October and April and bring plenty
of water. Take a boat ride to the entrance, hike
for forty minutes along the undulating landscape,
swim through the submerged caves, and cross the
narrow passage to see all Wadi Shab has to offer.

**Wadi Shab, Ash Sharqiyah
North Governorate, Oman**

Thica Plengpanich
@ms_plengpanich

→

**Istanbul Province,
Turkey**

S. Sezgi Olgaç
@sezgiolgac

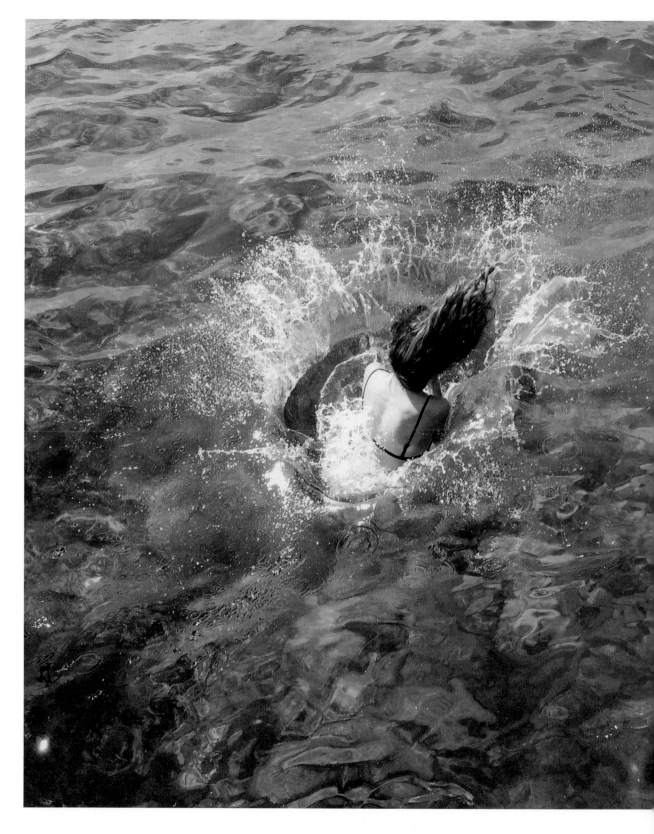

**Adriatic Sea,
Montenegro**

Sonya Khegay
@cupofherbaltea

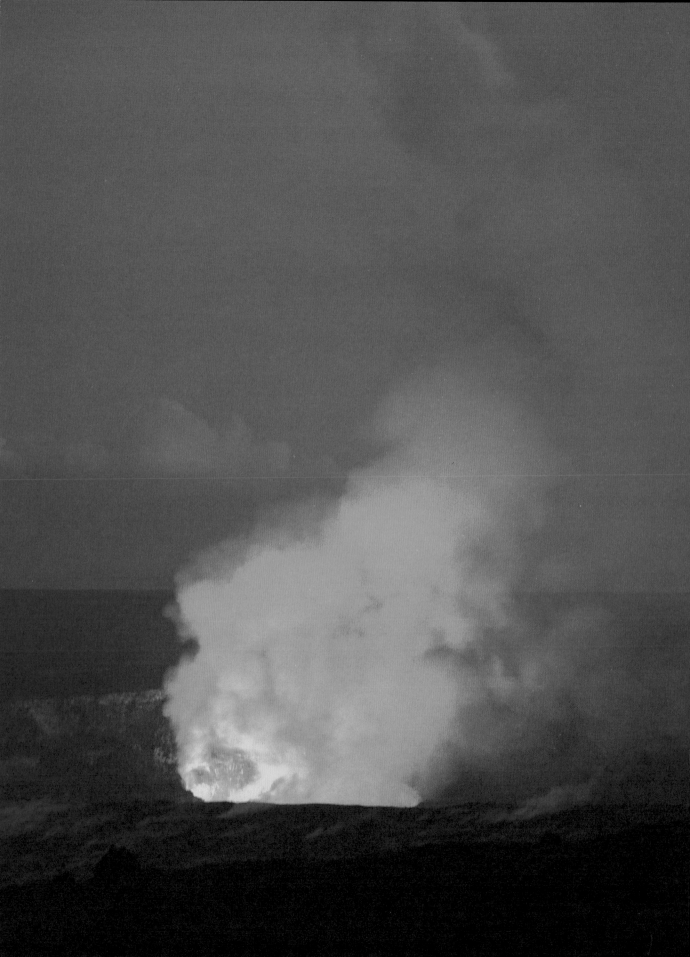

light

37

Light is the photographer's most powerful and least expensive tool. Fundamentally, photography is about capturing light and its absence. Light adds shape, highlights, definition, tone, and emotion to any image. And while many of the pictures in this book may be taken far from home, amazing light is available everywhere. When a waterfall is lit by the sun while the granite cliff behind it remains dark, you can feel the majesty of the rushing water. When you see a silhouette of palm trees in a twilight sky, you can almost hear the leaves rustling.

White Sands National Monument in New Mexico is a place people seek out almost exclusively for the light. By car, it takes only a few moments to drive past White Sands on the highway. Inside the park, though, at a hiker's pace, it is as vast an expanse of fine white sand as you might ever see. If you can plan to be in a place like White Sands at sunset and sunrise when the light is low, there is so much more to see. Without the midday glare flattening the monochrome sands, the softness and incredible detail of rolling gypsum hills comes to life. At these times, it is easy to delight in how unfamiliar it feels there. And unfamiliar territory is something we all love about travel—the experience of being somewhere that distinctly does not feel like home.

For most any traveler, White Sands is a euphoric place, a celebration of seeing but also a nod to what we cannot see or understand. Incredible light reminds us of the divine. A place that celebrates light celebrates living in its most essential form.

←
Halema'uma'u
Kilauea, Hawaii,
United States
Emily Nathan
@ernathan

↖
Maquinna Marine
Provincial Park,
Tofino, British
Columbia, Canada
Emily Nathan
@ernathan

↑
White Sands National
Monument, New
Mexico, United States
Emily Nathan
@ernathan

←
Colombo, Western
Province, Sri Lanka
Gemma Cagnacci
@lineshapecolour

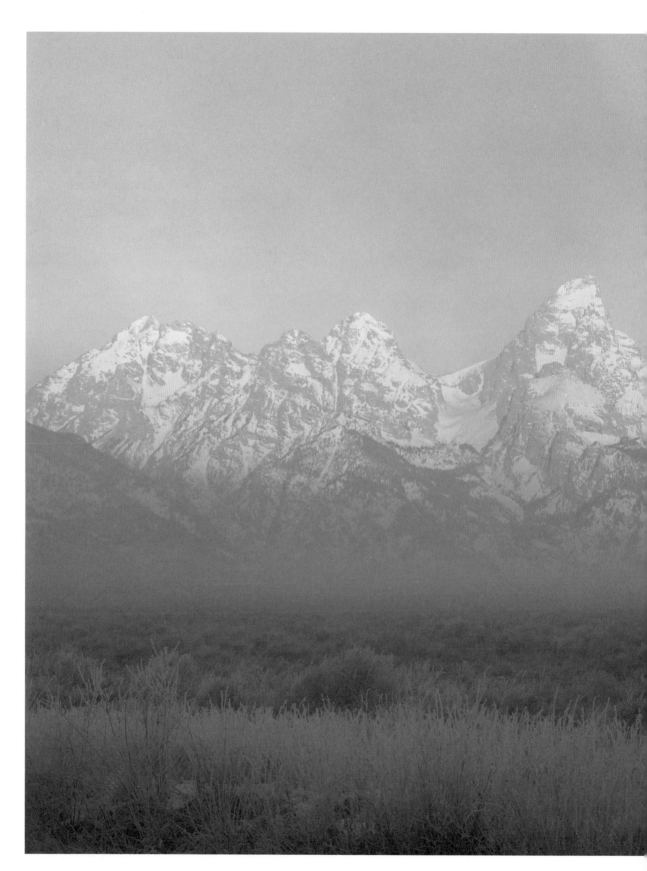

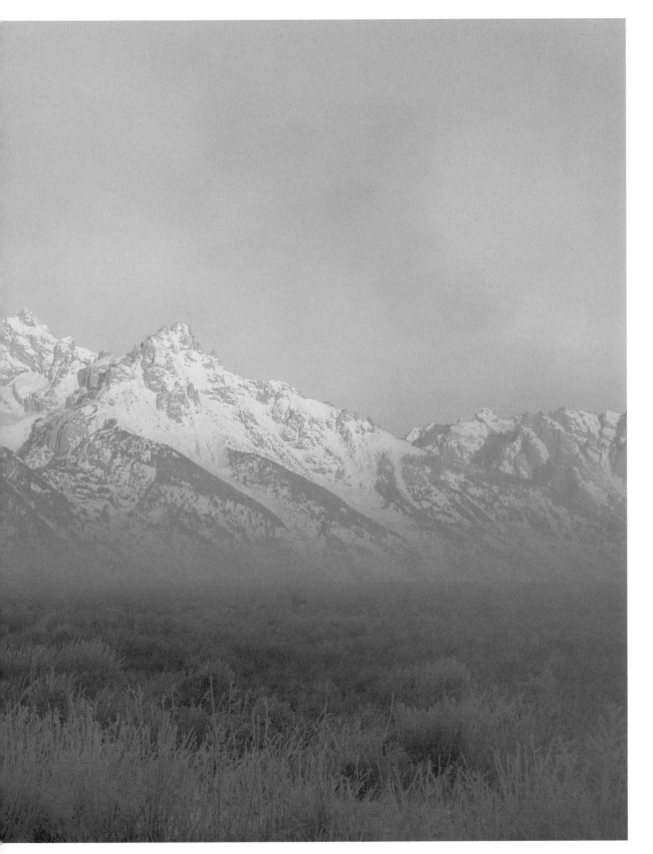

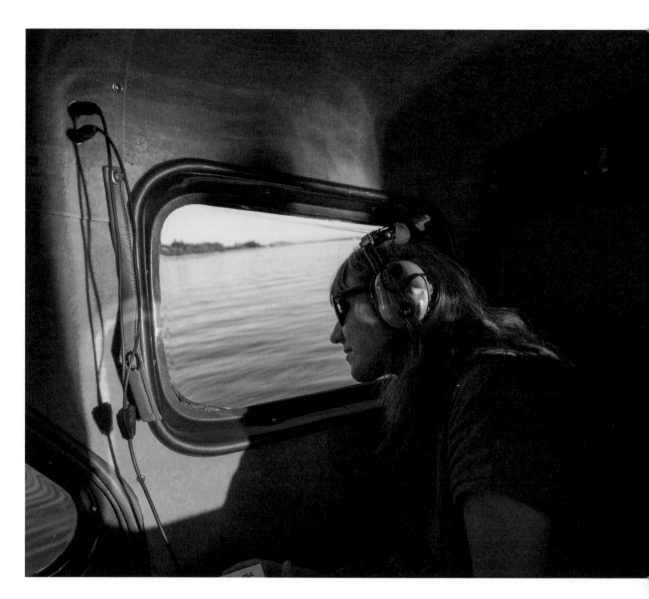

←

**Kelly Warm Spring,
Grand Teton National
Park, Wyoming,
United States**

Michael O'Neal
@mo

↑

**Lopez Island,
Washington,
United States**

Emily Nathan
@ernathan

THE TRONA PINNACLES are east of Ridgecrest, California, and free to visit. Avoid traveling here in the summer months when temperatures can rise above 110 degrees, or after heavy rains in the winter when the roads close. There are over five hundred tufa spires of varying heights up to 140 feet in this California Desert Conservation Area.

**Trona Pinnacles,
California,
United States**

Collin Erie
@collinerie

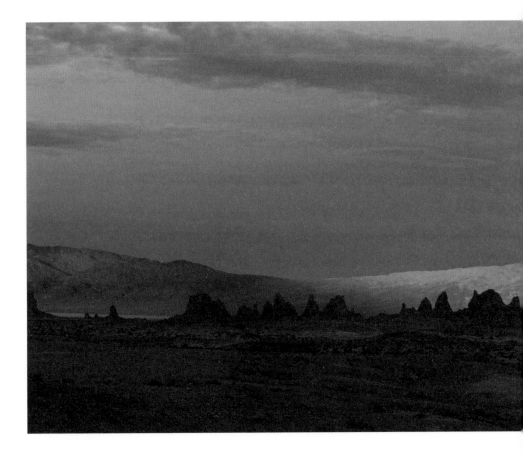

BAKOVEN LIES ON the western coast of
South Africa's Cape Peninsula, along
the Atlantic Seaboard. Since the yearly
water temperature averages 60 degrees,
experienced surfers can catch large waves
year round—check out Glen Beach, located
north of the popular Camps Bay Beach.
Some favorite nearby hikes can be found at
the Lion's Head, Devil's Peak, and Twelve
Apostles, and the Table Mountain aerial
cableway provides panoramic views from
3,500 feet off the ground.

**Bakoven, Western Cape,
South Africa**
Vaughn Wright
@vaughn.wright

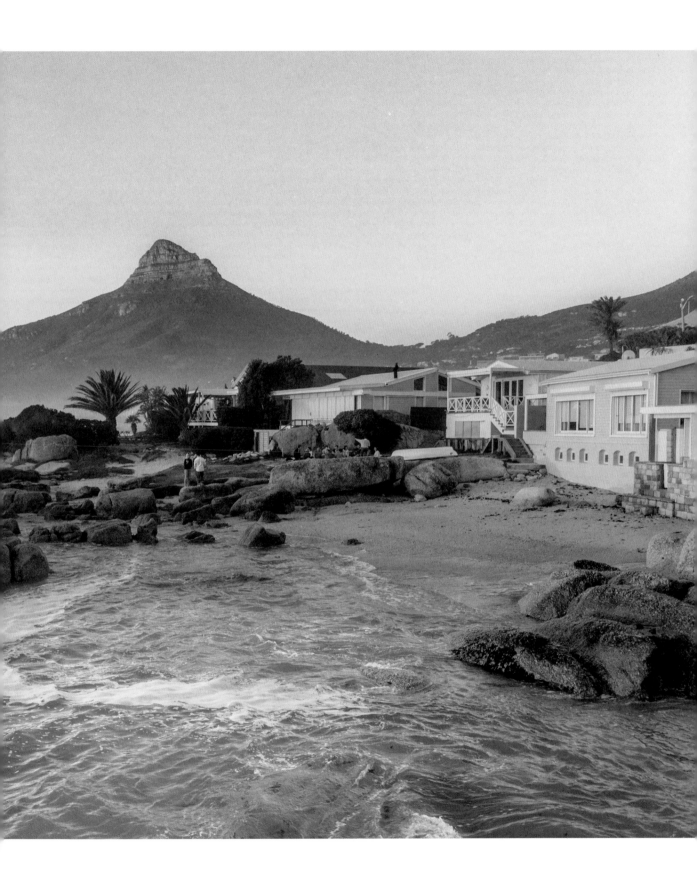

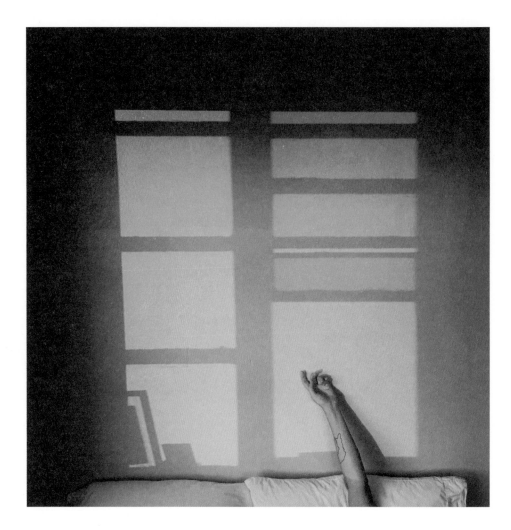

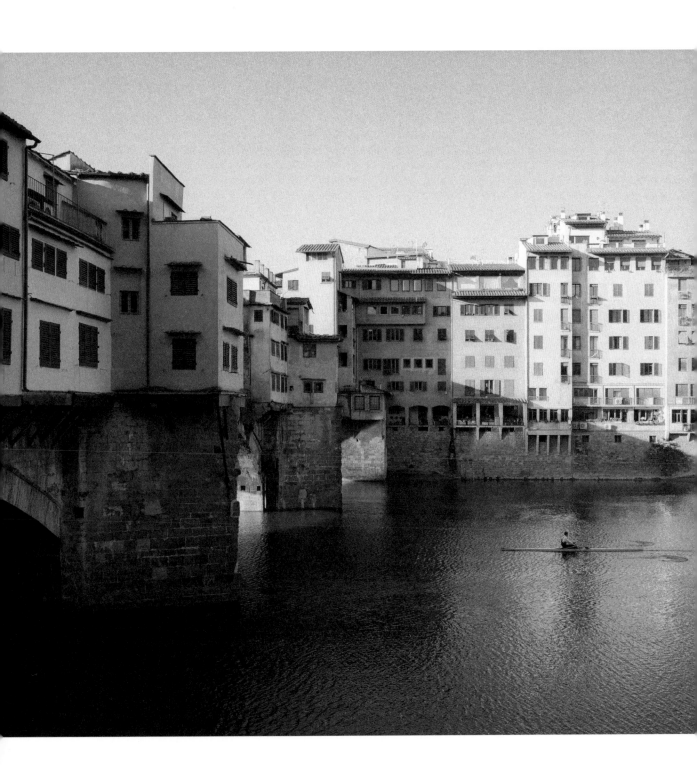

← Long Beach, California,
United States
Marianna Jamadi
@nomadic_habit

↑ Florence,
Tuscany, Italy
Eric Flogny
@ericflogny

→ Ittoqqortoormiit,
Sermersooq,
Greenland
Michael Novotny
@hazy_island

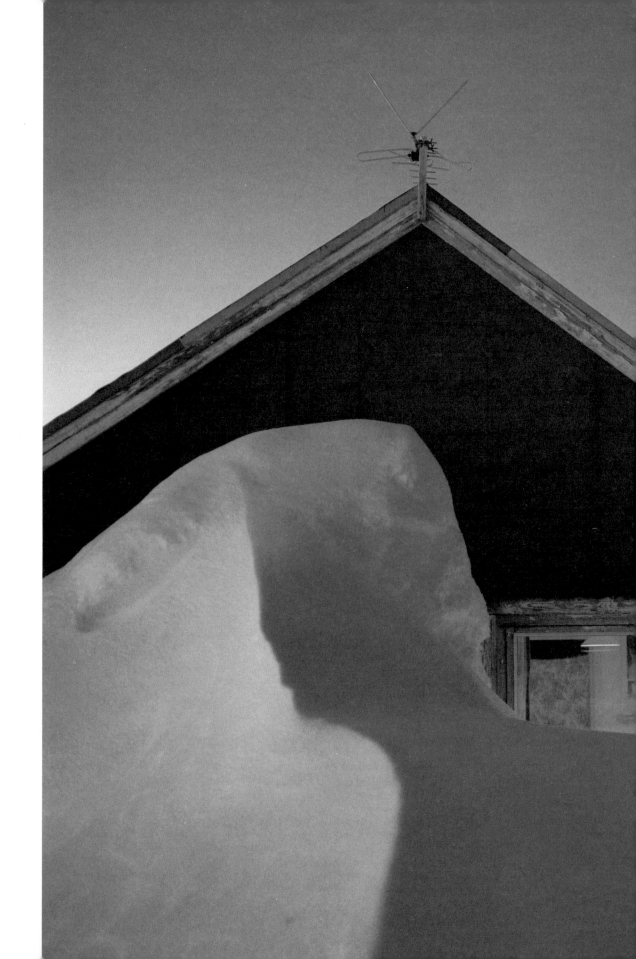

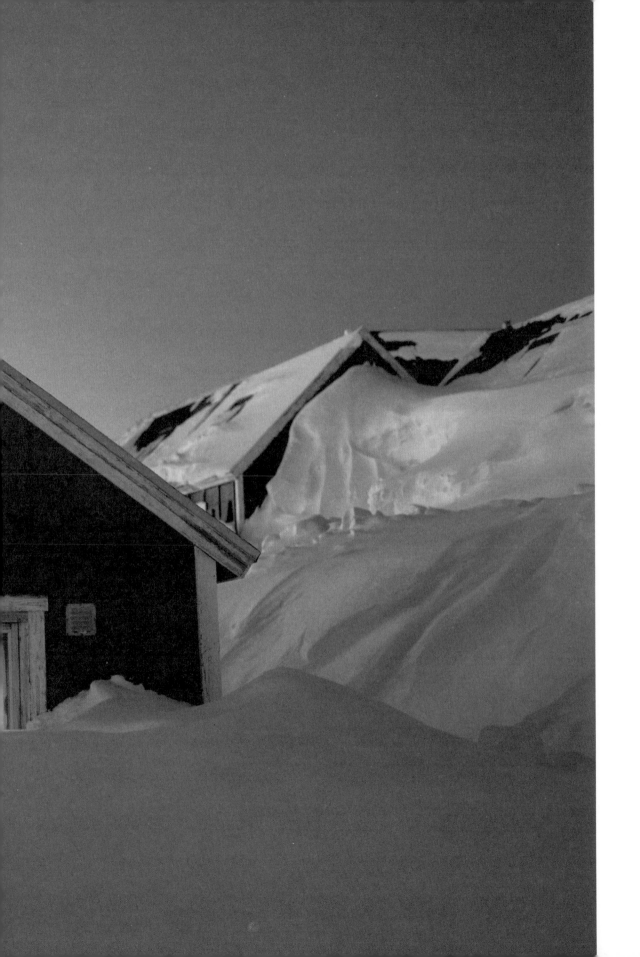

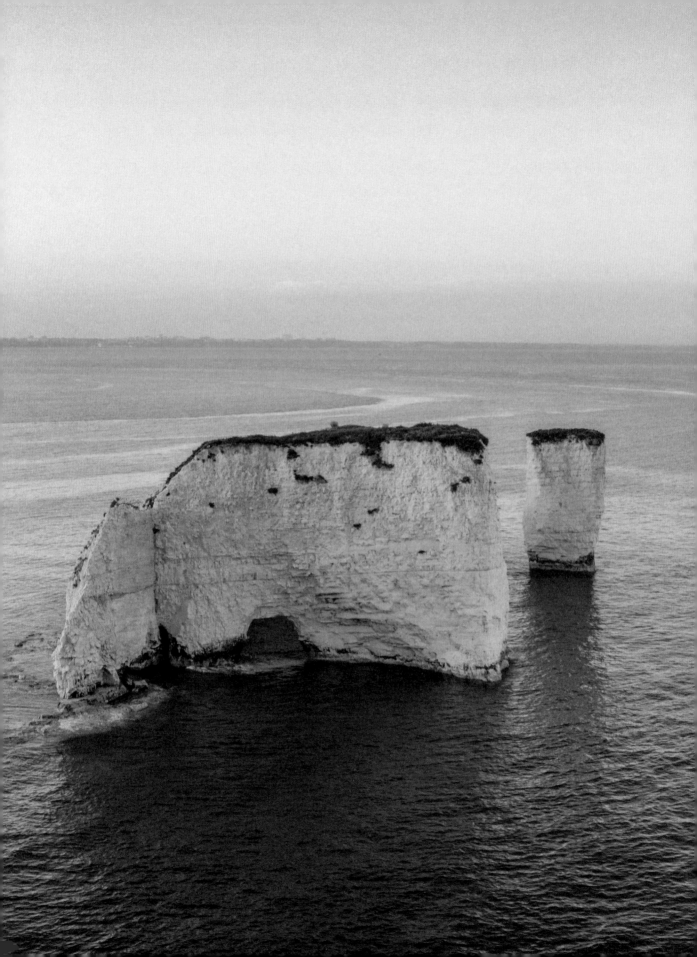

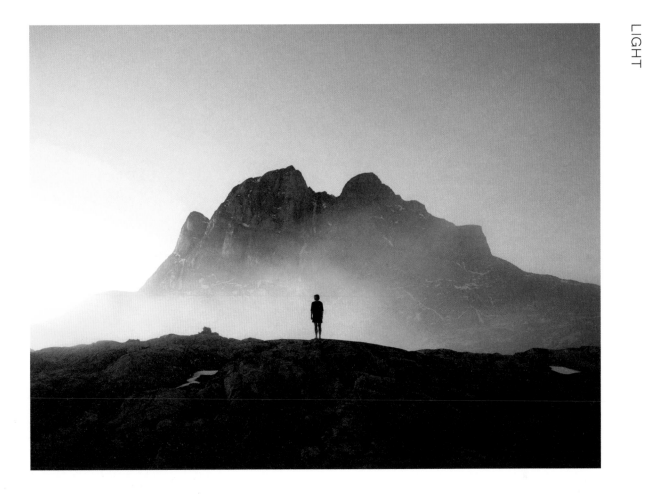

Old Harry Rocks, Jurassic
Coast, Isle of Purbeck,
Dorset, England

Chiara Zonca
@shadowontherun

Uummannaq, Avannaata,
Greenland

Jessie Brinkman Evans
@jebrinks

Hawaii, United States
Andrew Kearns
@andrewtkearns

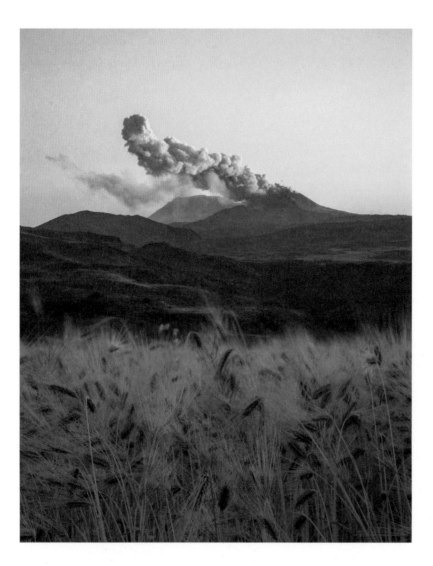

↑

THE CLOSEST TOWN to Sabancaya volcano, seen erupting in the distance, is Chivay, which is about 250 miles from Cusco and home to natural hot springs. *Sabancaya* means "tongue of fire," or "spitting volcano."

Colca Canyon, Chivay, Caylloma, Peru
Jeff Bartlett
@photojbartlett

→

Mexico City, Mexico
Joe Pickard
@josephowen

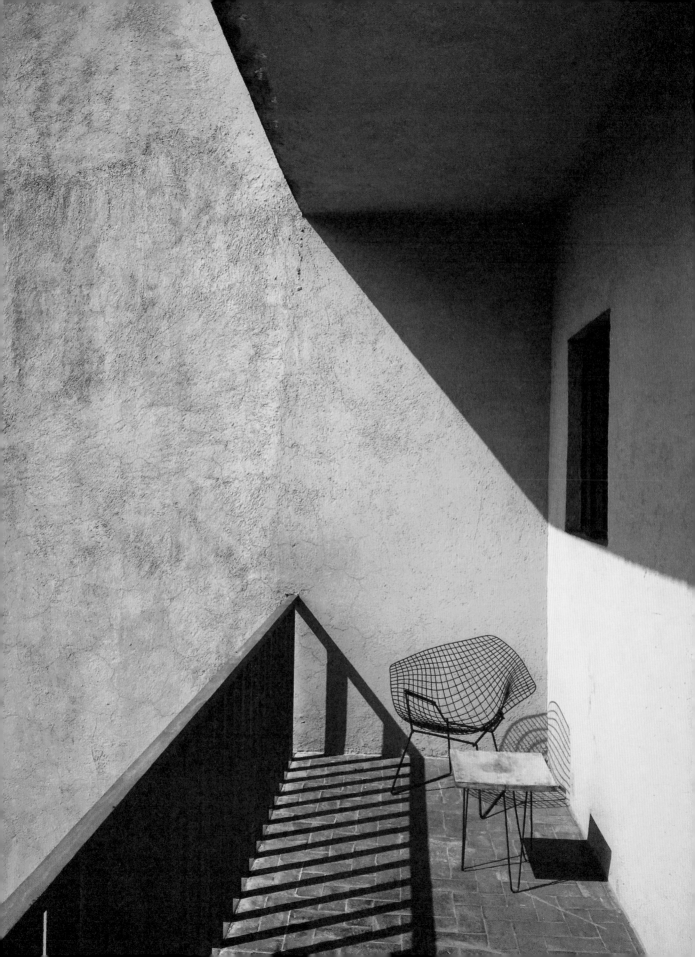

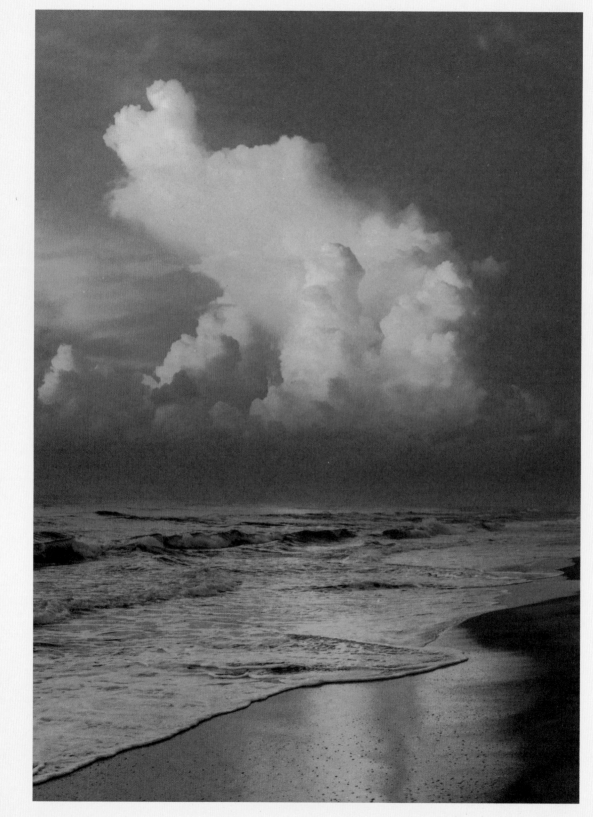

Thavalakuppam, Tamil Nadu, India

PROFILE

DAN TOM

@dantom

WHO IS DAN?

Born and based in San Francisco, Dan Tom has always been drawn to the arts, but he considers himself a late bloomer when it comes to photography. It wasn't until he was in his early twenties that Dan's passion for taking photos and traveling the world flourished.

On his first trip abroad (and without his parents), he traveled on a mission trip with members of his church to Kazakhstan, with an eye-opening layover in London. As a team of only four people, they needed to divide all aspects of the work, and Dan volunteered to shoot. With that self-assignment he began an education by doing. Immediately he noticed that the quality and intensity of light changed everything in an image. Photographing the local kids playing soccer in the shade made better portraits than in the harsh midday sunlight.

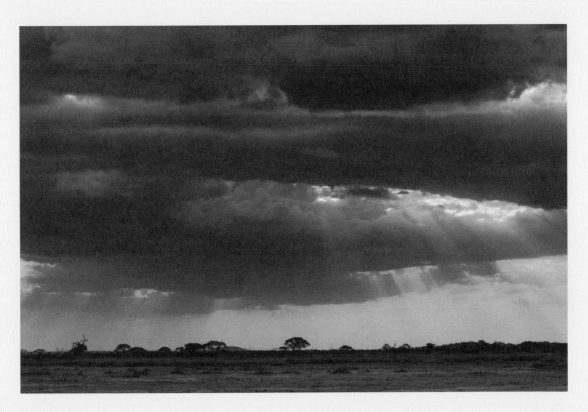

Kenya, Africa

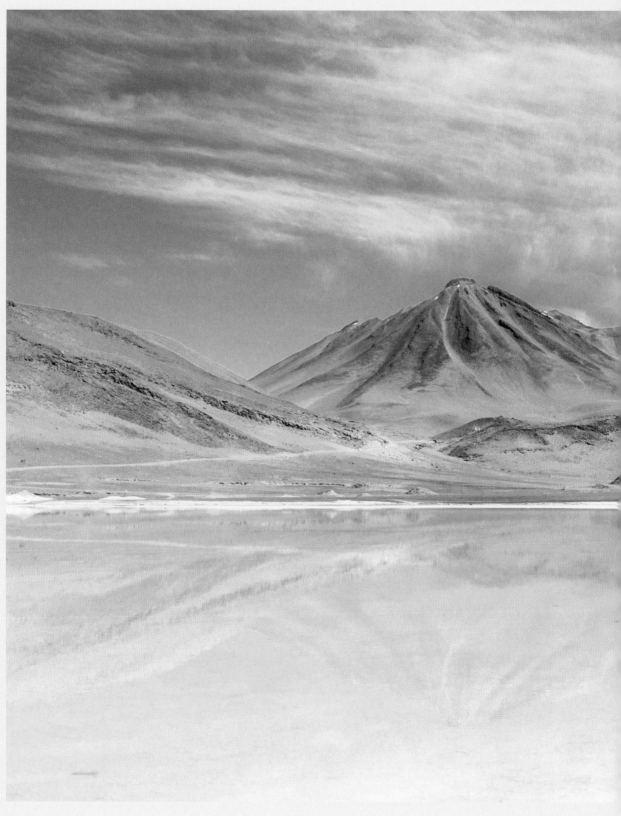

Piedras Rojas, San Pedro de Atacama, Antofagasta Region, Chile

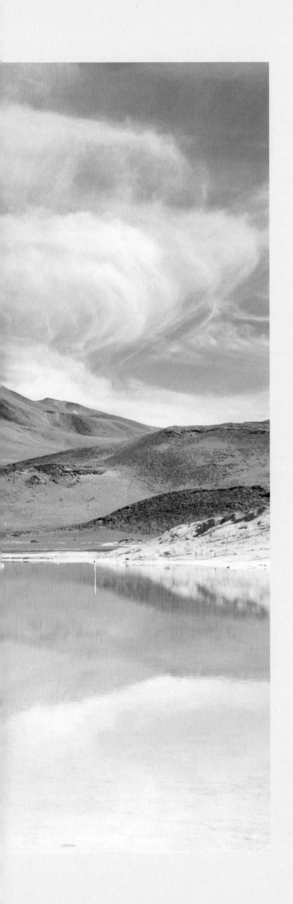

After university in Orange County (and a second mission trip, this time in South Africa), Dan moved to Los Angeles, where he invested in his first SLR camera. He started by photographing his everyday life, from the traffic to what he cooked for dinner, finding inspiration in the light that caught his eye along the way.

During any time off from his day job as a graphic designer, Dan continues to travel the world, now mostly on projects of his own or for editorial and advertising clients, from Chile to Iceland to Tahiti. For Dan, getting lost and traveling without expectations are vital to capturing the emotions and culture of a place. His rich colors highlight sunlit hillsides, glowing sunsets, and vivid portraits, wrapping each image's subject in a story of color and light.

DAN'S SAN FRANCISCO

For Dan, San Francisco is in many ways a city of light. Each of the city's features seems perfectly suited to capture light, and microclimates juxtapose dramatic summer fog with California sunshine. Photographing early in the morning and after work has made Dan an expert in shooting the soft light of daybreak and the dimmer tones of sunset. That said, he doesn't discriminate against beauty at any hour. He captures golden hour light and hard midday sun alike when he finds the saturated colors he is looking for in his pictures.

Sunlight streams through eucalyptus trees in the Presidio (an old and retired military outpost that is now a popular city park), and it defines the direction of the waves at Ocean Beach near Dan's home in the Outer Sunset. And atop Mount Tamalpais, just north of the city in Marin County, when the rolling hills and the golden tones on the horizon light up the top of an incoming fog bank, Dan feels alive, ready to notice the subtle differences as the sun closes out the day.

Ulaanbaatar, Mongolia

Louise Coghill
@louisetakesphotos

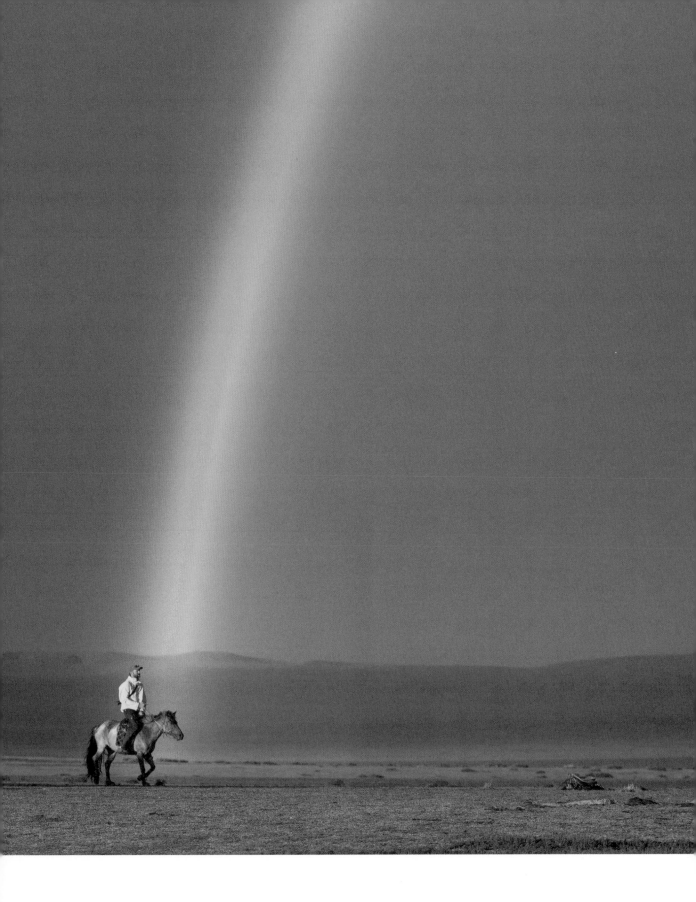

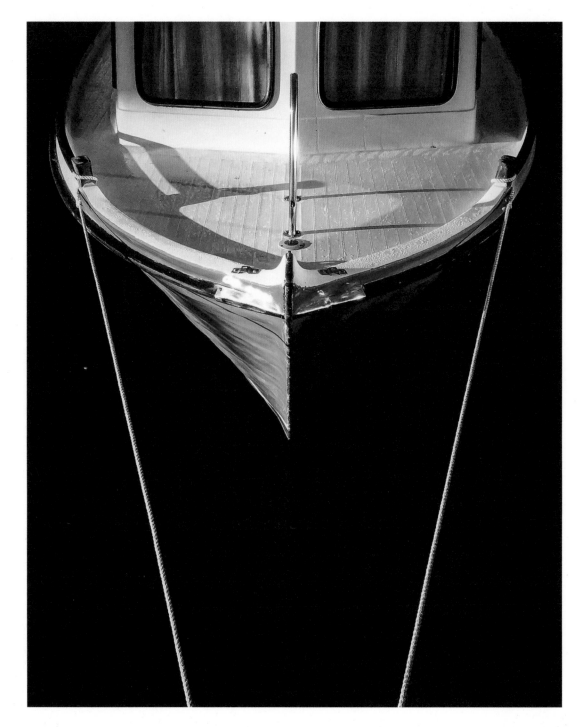

Kungsbacka,
Halland, Sweden

Peter Boman
@absinthemindedswede

Ko Pha-agan, Surat
Thani, Thailand

Burcu Basar
@bizarrejourneys

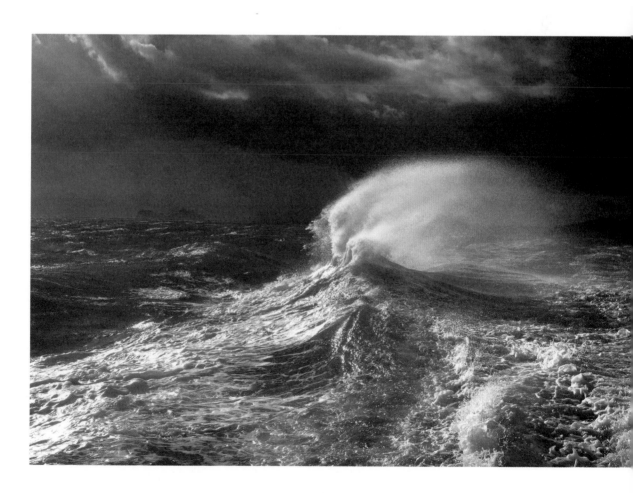

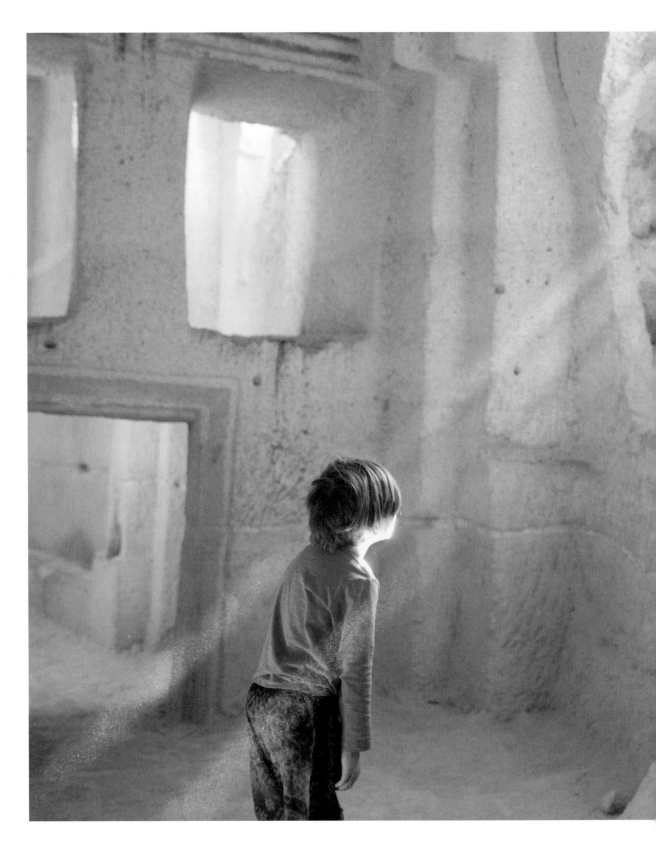

CAPPADOCIA IS FILLED with rich history and unique volcanic landscapes. World Heritage site Göreme National Park is located in central Turkey, bounded on the south and east by extinct volcano ranges and spotted with pinnacles known as "fairy chimneys." Underground towns dating back to the fourth century and cave churches, tucked between valleys and mountain ridges, carved nine hundred years ago and adorned with frescos have all been exposed due to erosion.

Cappadocia, Turkey
Taryn Kent Jenkinson
@tarynkentphoto

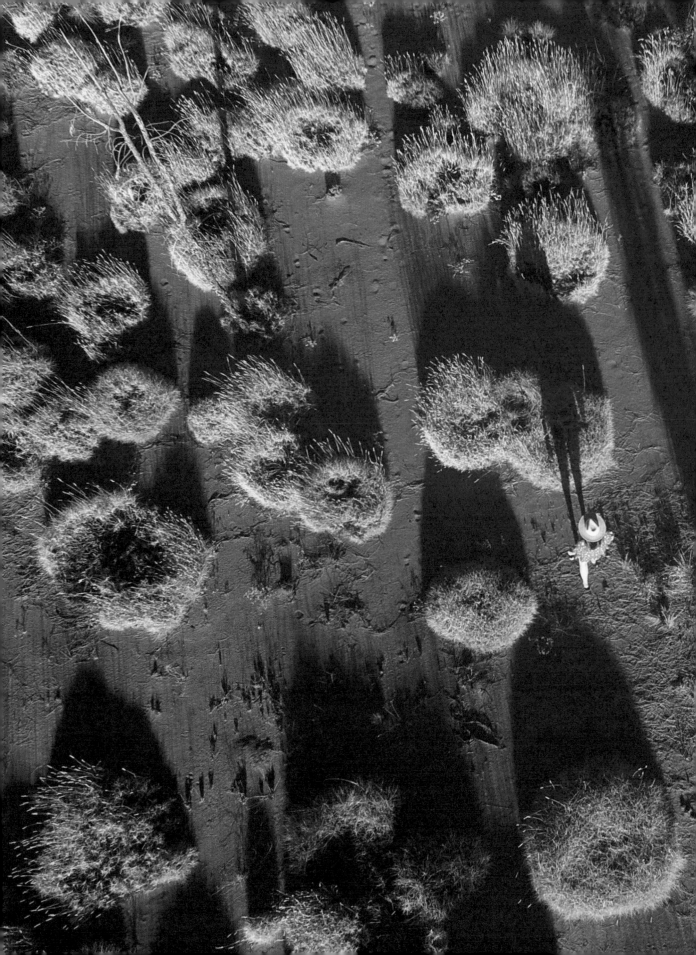

curious

67

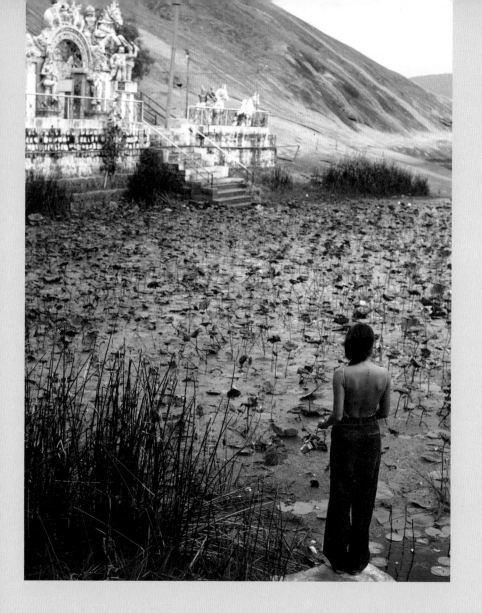

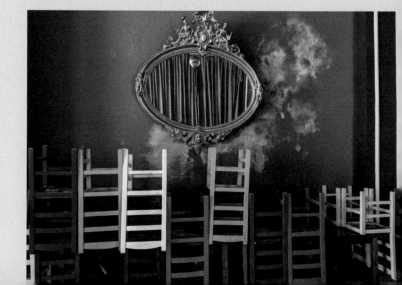

The human condition for many of us is one of curiosity, and even a tiny moment can be a point of entry to a new place or culture. In New York, when you walk by an apartment window at dusk and suddenly glimpse a bit of the life within; in India, when you watch a chai vendor juggle hot tea from metal cup to metal cup to reach the perfect temperature; and every time you strike up conversations with strangers you encounter on a hiking trail, the joy in unfamiliarity is heightened by an insider's point of view. Curiosity is a primary driver for travelers, and travel fulfills this desire. Especially when traveling, we intuitively seek to soak in information and recontextualize it with everything else we have experienced in our lives so far, comparing and contrasting cities and landscapes as we go. Think of it as filling in your own map of the world and, to some extent, only truly securing a place in your mind once you have seen it with your own eyes.

When *Tiny Atlas* traveled to Madurai, India, no one from our group had ever been there before. Language was a barrier, heat was a barrier, some smells were unpleasant. I asked the guides from Kamalan, our travel partner there, to take us anywhere with a view for sunrise—a place where we could back away from the intense heat and energy of the city and yet get a sense of its entirety. We left our hotel in the dark and arrived at the Samanar Hills and this otherworldly landscape before dawn. Standing on the edge of a massive lotus pond with the faded colors of Karuppasamy temple and its colorful gods just out of reach, our discomfort was forgotten. Our human need to discover was humming. All of our senses were alight. As we took it in, we tumbled questions at our guides, who had brought us to this place specifically so that our minds would crack open to yet another wonder in their beautiful motherland.

← Longitude 131°, Uluru-Kata Tjuta National Park, North Territory, Australia
Rhiannon Taylor
@inbedwith.me

↖ Samanar Hills, Keelakuyilkudi, Tamil Nadu, India
Emily Nathan
@ernathan

↑ Kaya Kilims, Kayseri, Turkey
Emily Katz
@emily_katz

← Havana, Cuba
Emily Nathan
@ernathan

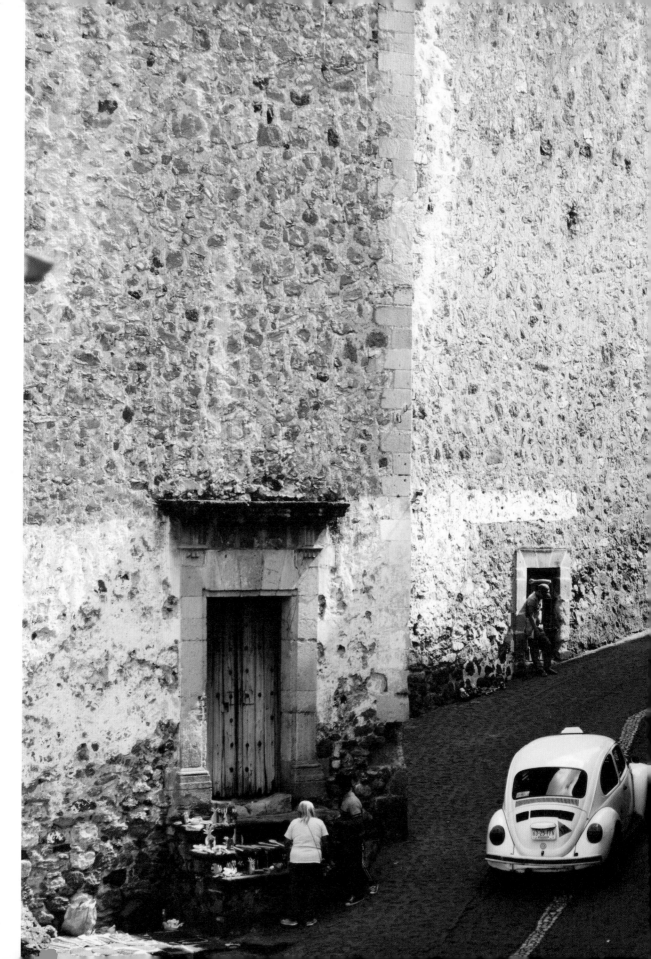

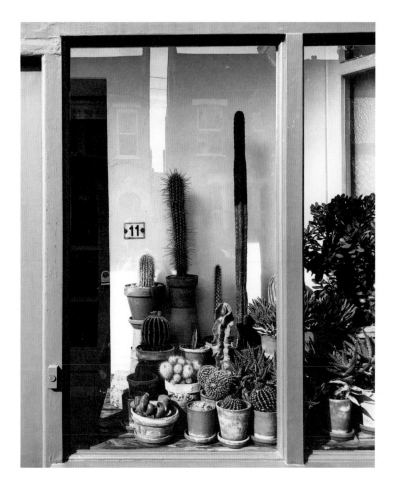

←

TAXCO, WITH ITS perserved colonial architecture
surrounded by mountains, is located in south-
central Mexico about a three-hour drive from
Mexico City. The town is known for silversmiths,
handmade jewelry, and cobblestone streets. Taxco
is a part of the "Triángulo del Sol," or Sun Triangle,
which also includes popular beach and sport
fishing destinations Ixtapa and Zihuatanejo.

Taxco, Guerrero, Mexico
Romana Lilic
@romanalilic

↑

London, England
Elke Frotscher
@elice_f

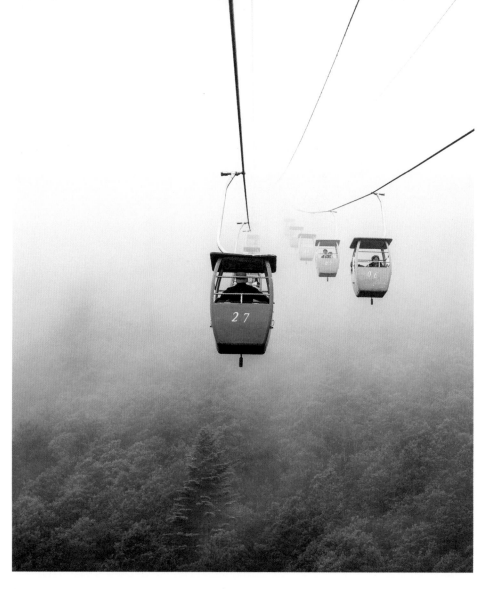

↑

TAKE A TAXI or bus ten miles from downtown
Lijiang to Jade Dragon Snow Mountain and ride
one of three cable cars for incredible views of the
snow-covered peaks. The mountains are known
for being shrouded in fog and snow year-round,
though the best snow and clearest skies come
between November and April. After taking in the
panoramic views, stop at Tiger Leaping Gorge, one
of the deepest gorges in the world and a UNESCO
World Heritage site, for a short hike or spend two
days to hike the whole area. Three Parallel Rivers
National Park, where three of Asia's major rivers
flow next to each other, is nearby.

**Jade Dragon Snow
Mountain, Lijiang,
Yunnan, China**

Anne Cui
@anneparavion

→

**Lake Hillier, Western
Australia**

Michael Goetze and
Jampal Williamson
@saltywings

⟶

Cappadocia, Turkey

David Leøng
@d.leong

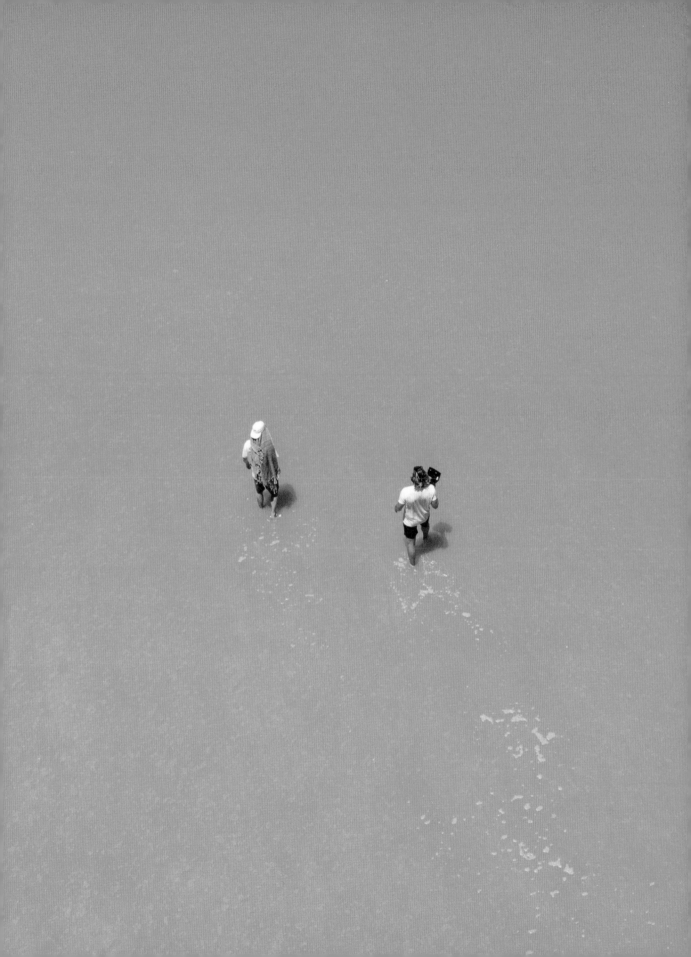

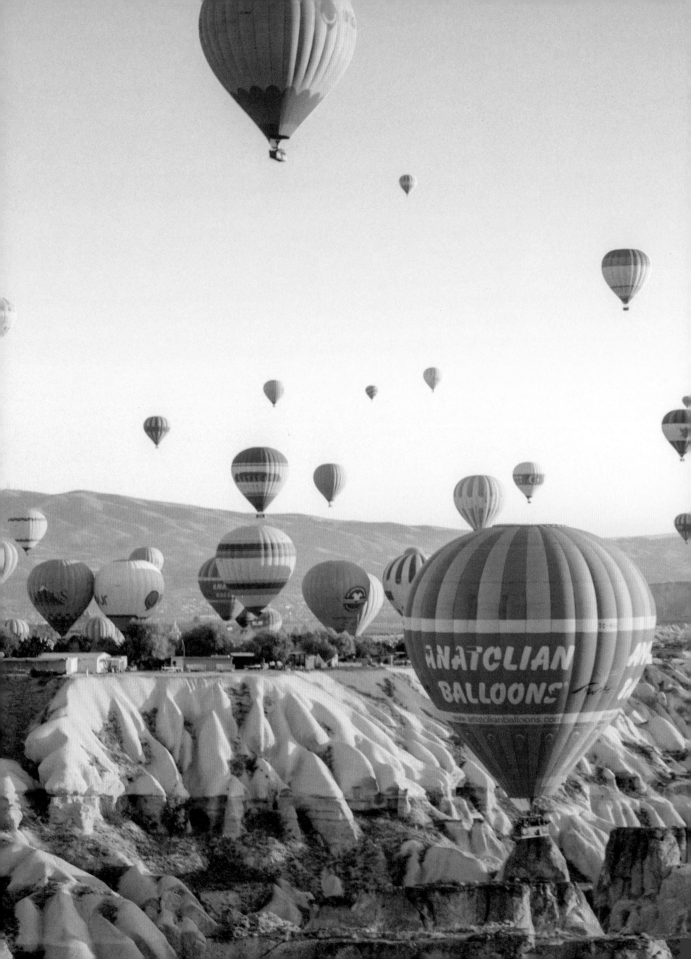

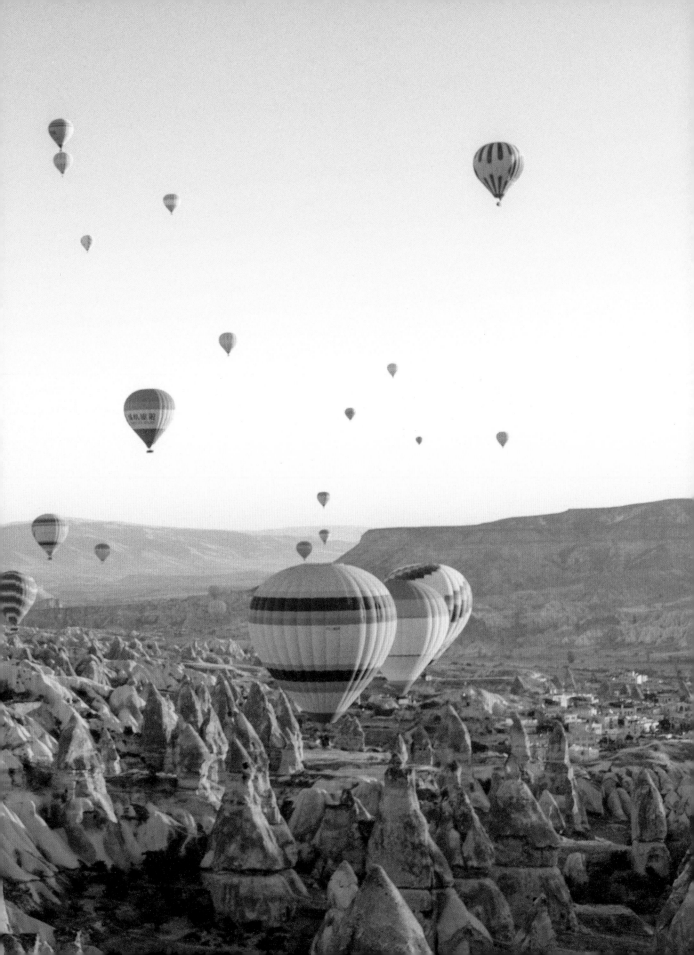

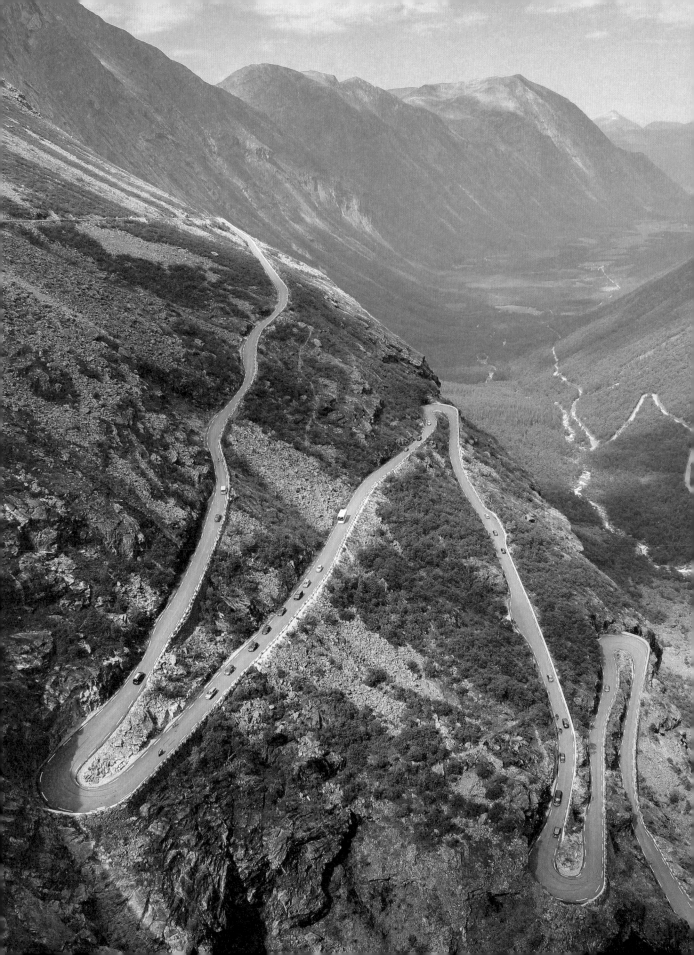

TROLLSTIGEN IS ON Norway's western coast and is the most famous part of the two-hour National Tourist Route Geiranger-Trollstigen. The Trollstigen drive is just over 7.5 miles, includes eleven hairpin turns, and is open only from around late May to October or November depending on snowfall. While you can drive or bike either direction on this road, the lanes are very narrow and buses must make three-point turns in order to navigate some of the tight corners. Stop at the viewpoints and the visitor's center or fly a drone above the winding road to capture an image like this. The National Tourist Route leads to the bottom of the famous Geirangerfjord, whose waterfalls are best seen by boat.

Trollstigen, Norway
Felix Sandmann
@felixsnd

**Rundetaarn,
Copenhagen, Denmark**
Monia Hamdy
@empiretraveller

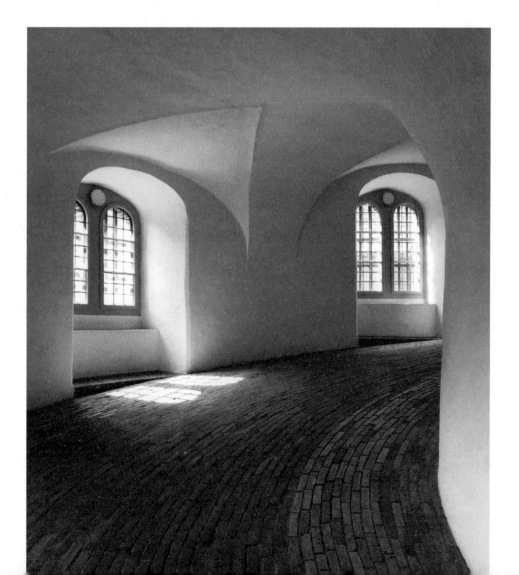

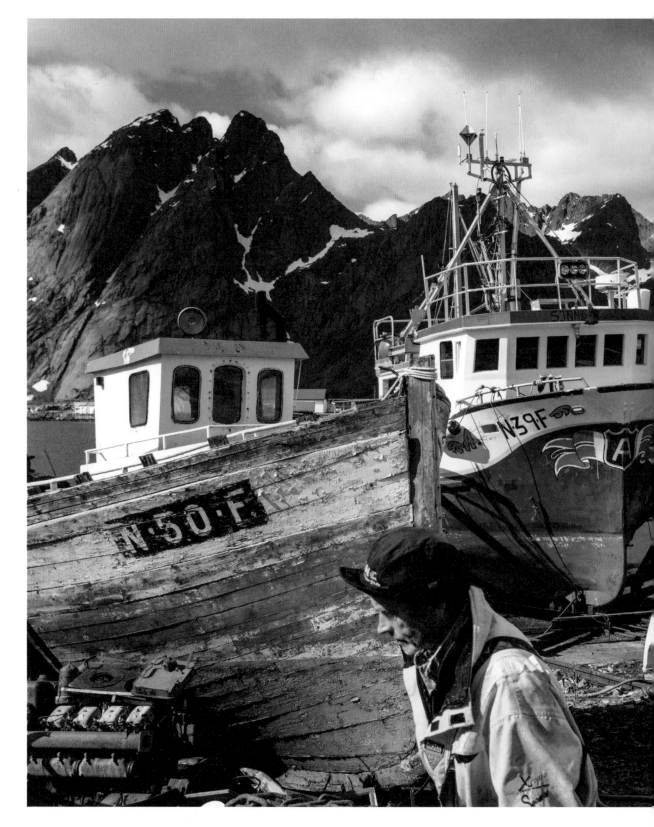

NORWAY'S NORTHWESTERN COAST is sprinkled with Lofoten's six principle islands and hundreds of uninhabited ones. The four-hour ferry ride is well worth the time for the experience of exploring the brightly colored fishing villages and fjords, and beaches visited by surfers year-round. Visit Sund's harbors in June to spot fisherman hard at work. Pick up a souvenir from the blacksmith of Sund before venturing off to other islands. If you are visiting in mid- to late winter, check out one of Lofoten's most important fishing villages, Henningsvær, to see the fjords filled with cod.

Lofoten, Norway
Jennifer Emerling
@jemerling

↓
**Le Jardin Majorelle,
Marrakech, Morocco**

Perry Graham
@perrygraham

→
Lake Titicaca, Peru

Jennifer Emerling
@jemerling

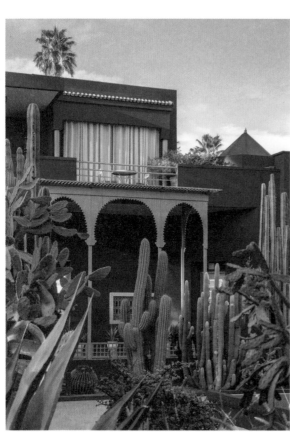

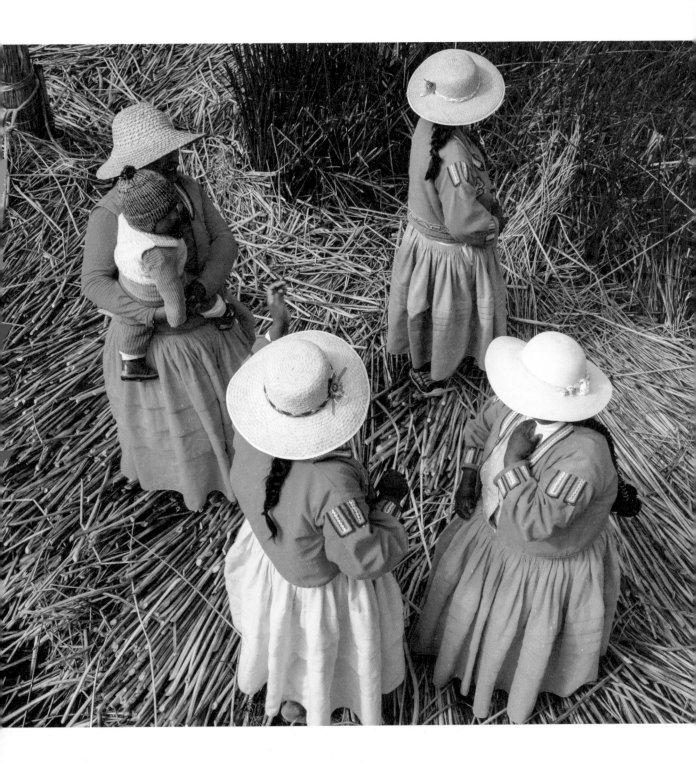

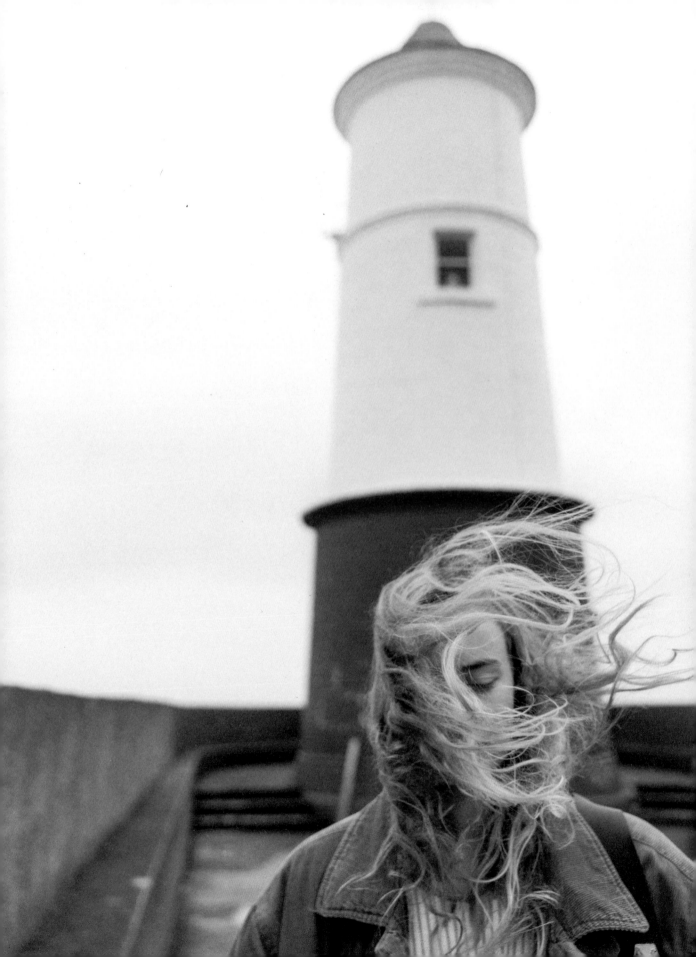

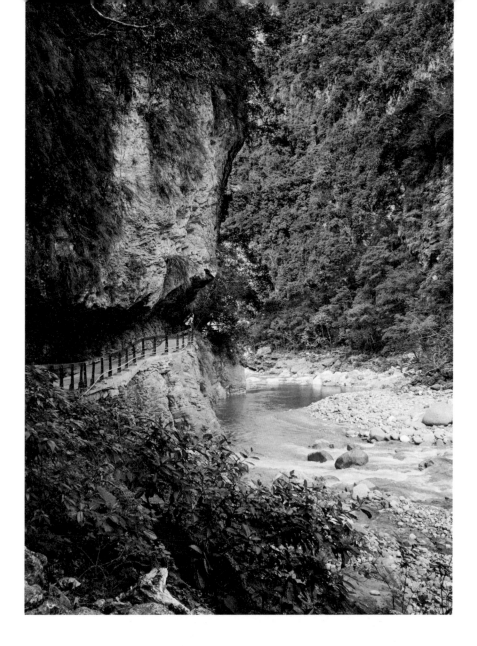

↑

THE JOURNEY FROM Taipei to Taroko National Park—a worthwhile day trip—takes about three hours. Once in the park, head west on the Central Cross-Island Highway to arrive at Swallow Grotto about one third of a mile after exiting the Xipan Tunnel. Hiking Swallow Grotto Trail takes about thirty minutes through caves and tunnels and provides the best viewing point for the Taroko Gorge.

←

Berwick upon Tweed, Northumberland, England

Annapurna Mellor
@annapurnauna

Taroko Gorge, Taroko National Park, Taiwan

Jessica Wright
@bontraveler

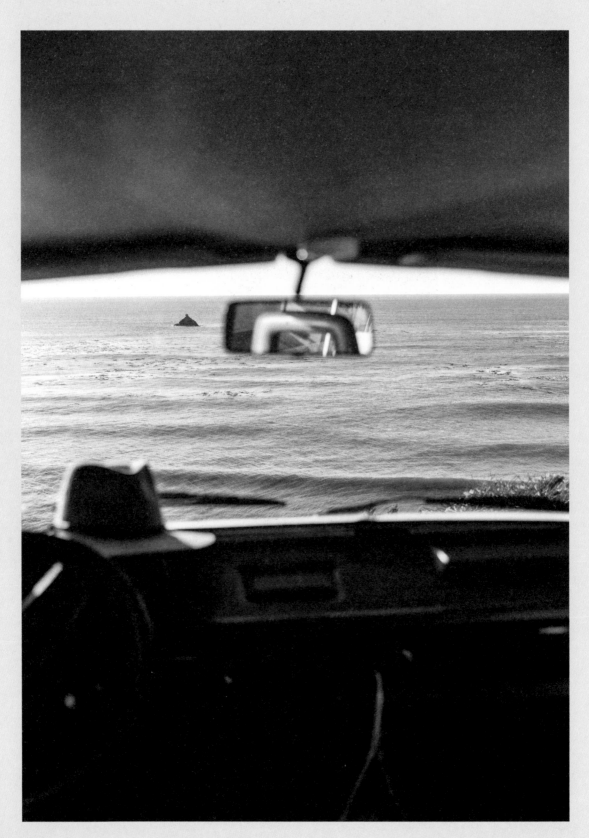

Big Sur, California, United States

PROFILE

LUCY LAUCHT

@lucylaucht

Praiano, Salerno, Italy

WHO IS LUCY?

Lucy Laucht has always been driven by curiosity. Years ago, it led her to leave behind the rainy skies of Birmingham, England, on an around-the-world trip through Europe and Asia. It was on that trip—specifically, on the beaches of Bali—that she met her now husband. Later, it was curiosity about life abroad that drove them both to move to New York. And, again, six years later, to quit their jobs, leave the city, and explore the United States in a 1985 Westfalia Volkswagen van.

Seeking new horizons and creative challenges has driven Lucy's professional pursuits, too. From her career as a lifestyle and travel photographer to the travel guides she curates on her website These Foreign Lands (www.theseforeignlands.com), Lucy's creative streak and her quest for newness run through just about everything she does. Her most recent endeavor is cofounding Tio y Tia, a line of hats handmade in the United States by the same family that crafted the one Georgia O'Keeffe wore.

LUCY'S CURIOSITY

There are few things Lucy loves more than the feeling travel gives her. For Lucy, being on the road and in transit always conjures up a sense of peace. Exploring a new place—wandering through the streets, experiencing the surrounding natural landscape, witnessing little moments and ways of life—never fails to reinvigorate her. Finding calm in unusual and new situations is a key to Lucy's photography. It leaves her open to seeing unexpected moments and unique views, and she creates images that make the foreign feel intimate and familiar.

Photography brings Lucy around the world, from the desert plains of Atacama in Chile to the beaches of Praiano on Italy's Amalfi Coast. When Lucy's not living out of a suitcase, she calls Melbourne, Australia, home.

85

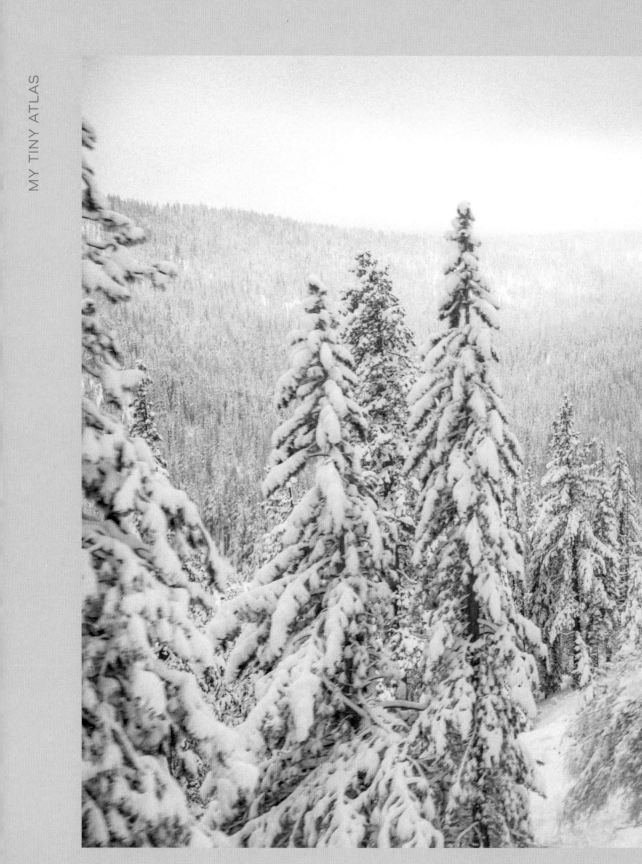

California Zephyr Train, Nebraska, United States

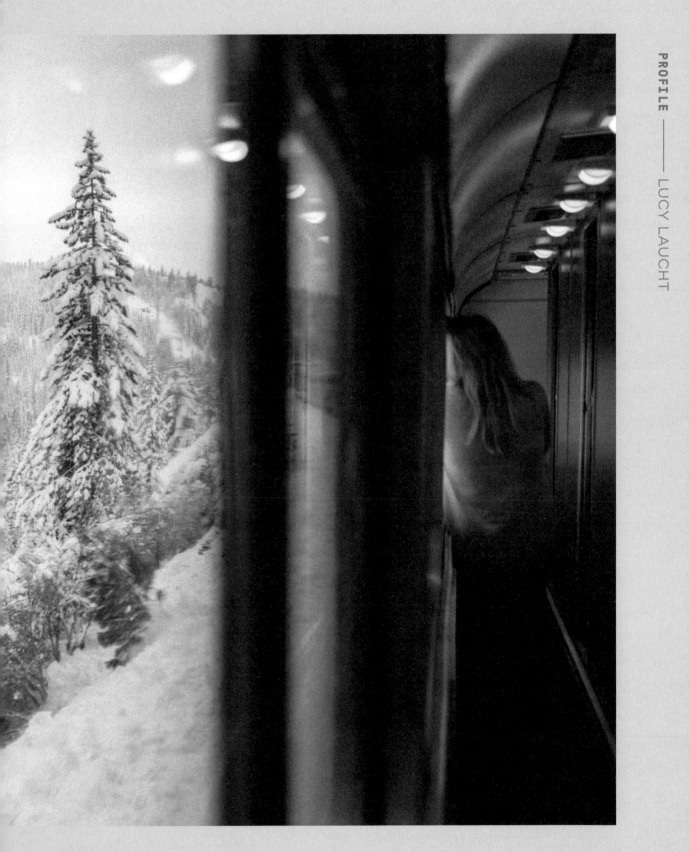

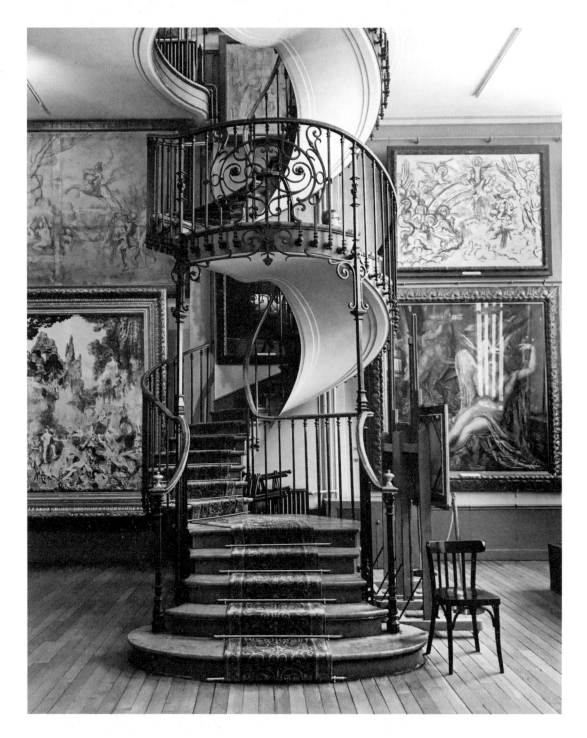

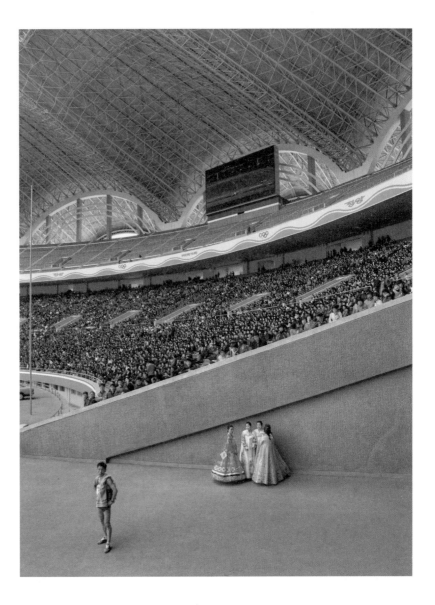

← Musée National Gustave
Moreau, Paris, France

Monia Hamdy
@empiretraveller

↑ Pyongyang Marathon,
Estadio Rungrado Primero
de Mayo, Pyongyang,
North Korea

Tyson Wheatley
@twheat

⟶ Golden Gate Bridge, San
Francisco, California,
United States

David Leøng
@d.leong

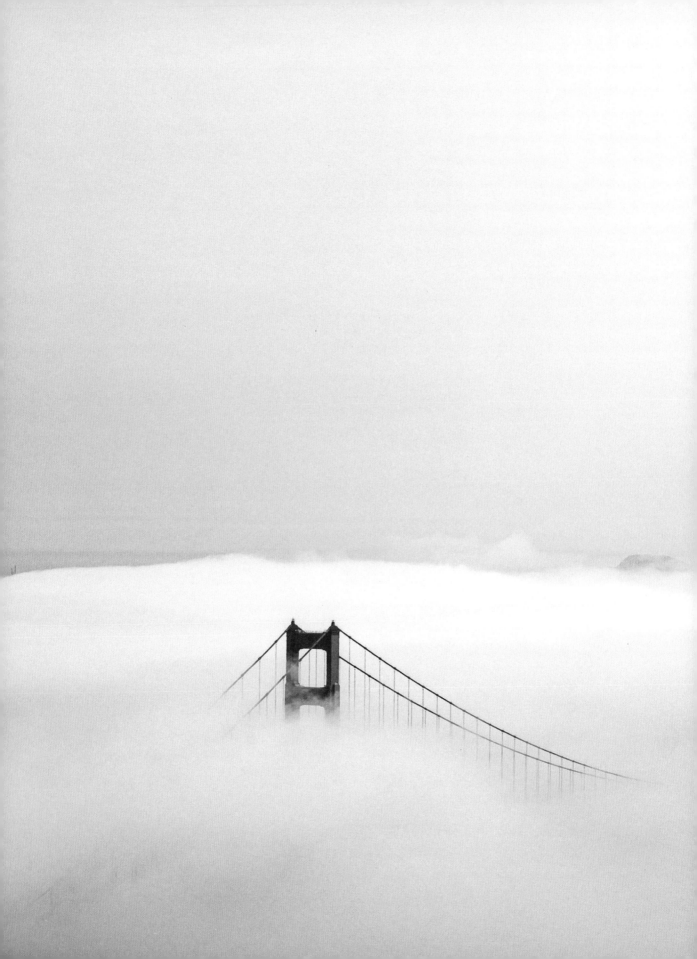

↓

BUILT IN 1973 by architect Ricardo Bofill, La
Muralla Roja, or "The Red Wall," is now an iconic
complex of fifty apartments overlooking the
Mediterranean Sea and Peñón de Ifach, Calpe's
towering limestone outcrop. This bold structure
of pink, purple, blue, and red stands in contrast
to the Calpe cliffs on which it stands. Lounge on
the beaches below, check out the rooftop pool, or
take a drive to Fuentes del Algar to swim in the
waterfalls.

**La Muralla Roja, Calpe,
Alicante, Spain**

Perry Graham
@perrygraham

→

**Pueblo de Chivay, Valle del
Colca, Arequipa, Peru**

Michaela Trimble
@michaelatrimble

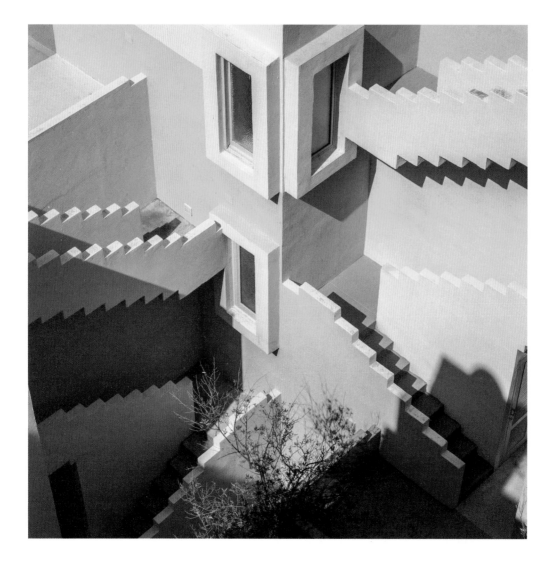

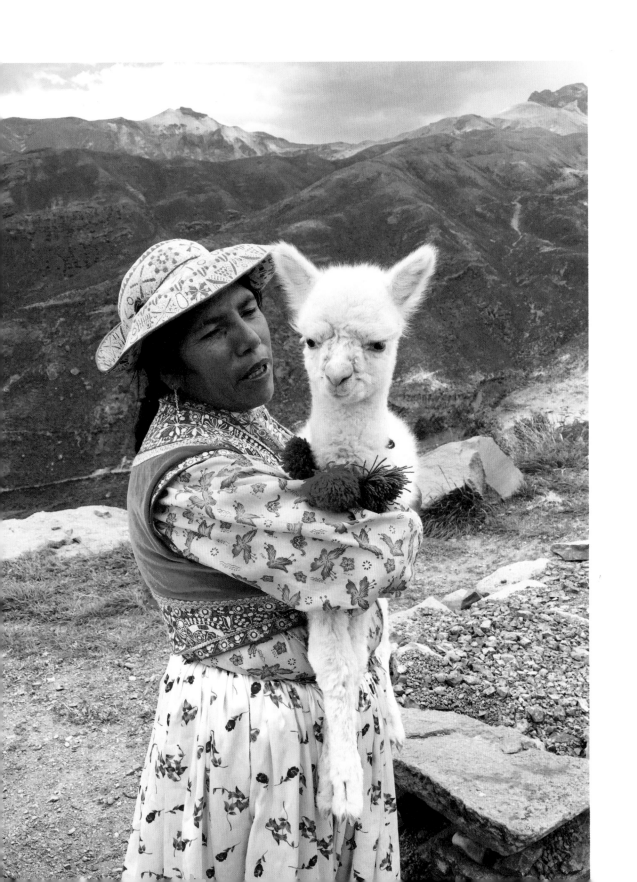

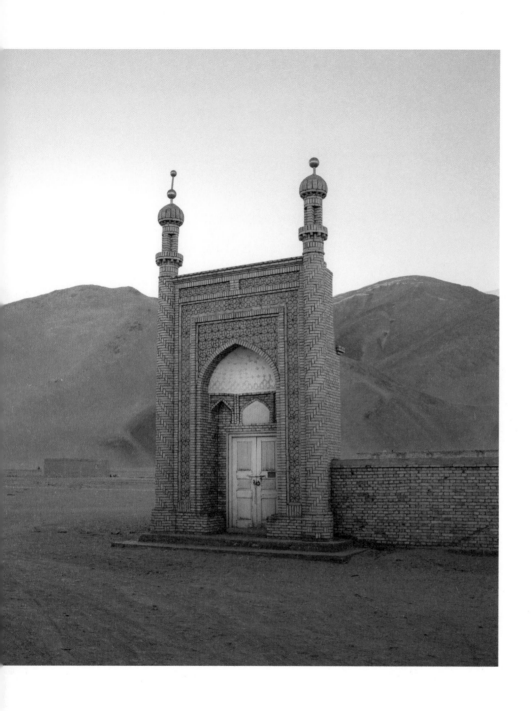

←
Xinjiang mosque, Xinjiang
Uyghur Autonomous
Region, China
Grant Harder
@grantharder

↓
Havana, Cuba
Emily Nathan
@ernathan

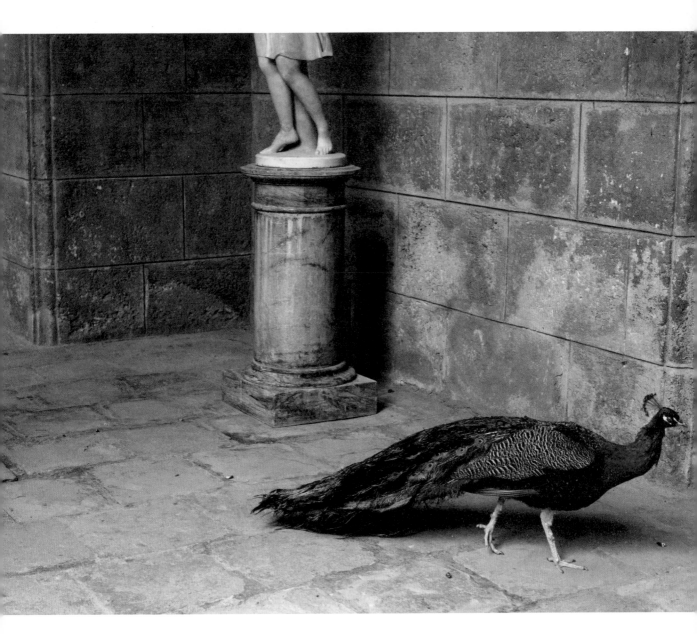

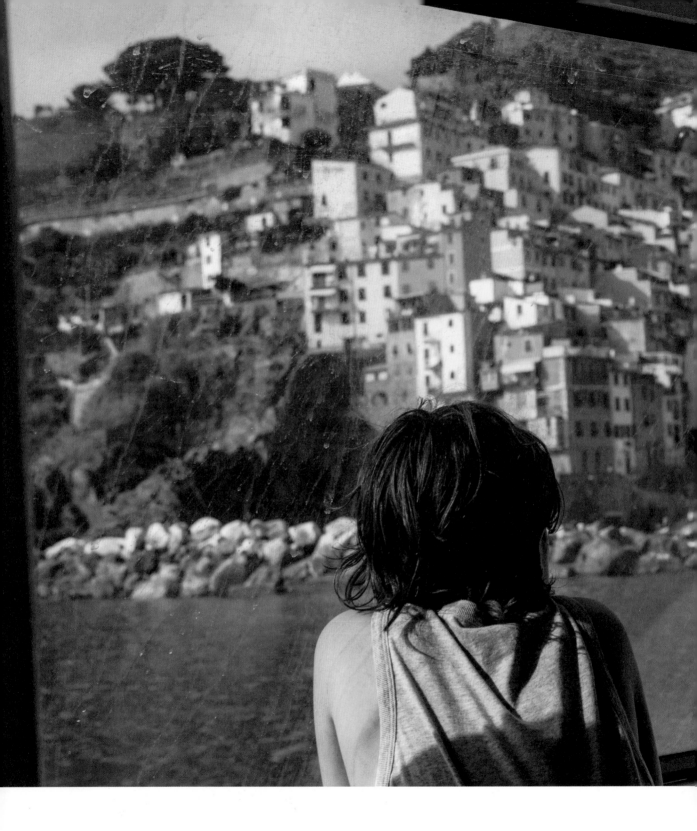

**Cinque Terre,
Riomaggiore, Italy**
Adrienne Pitts
@hellopoe

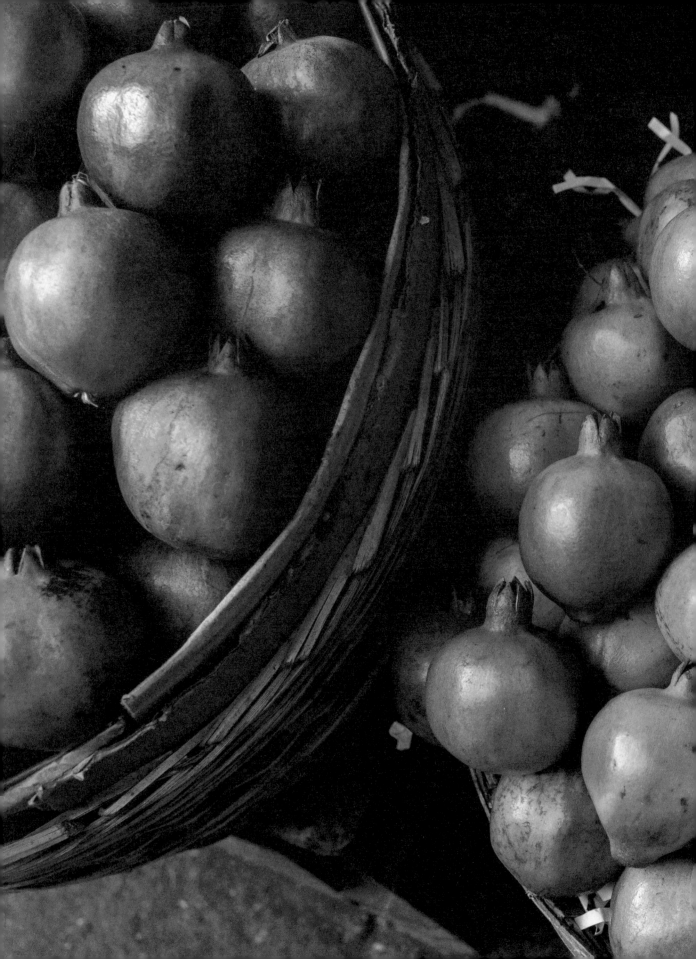

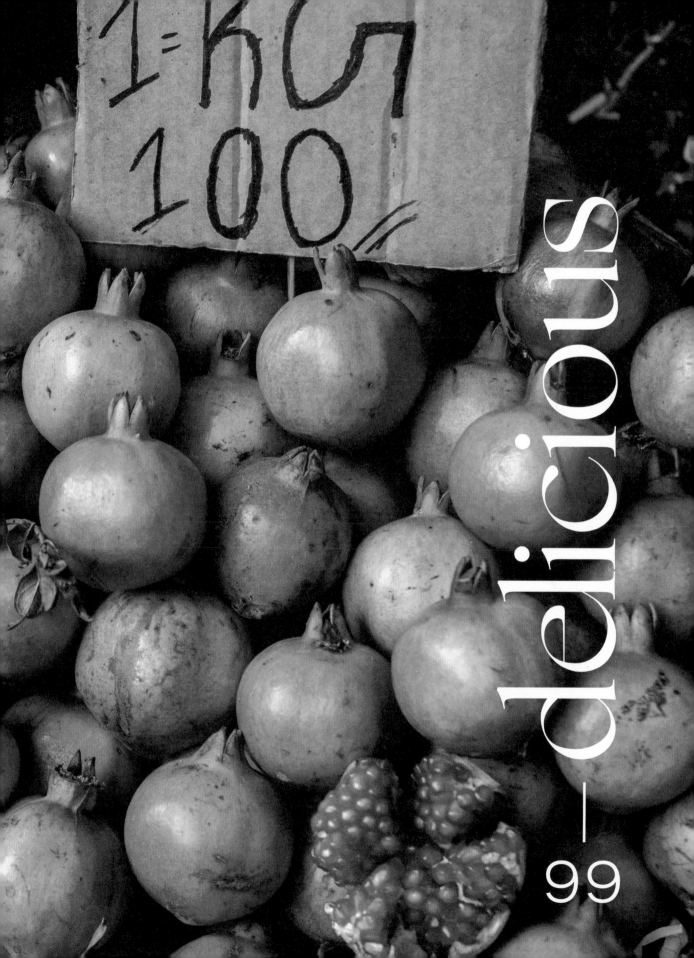

1=KG
100

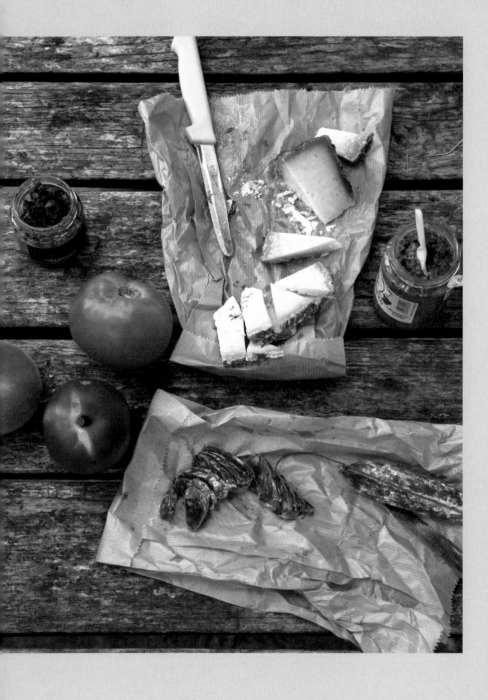

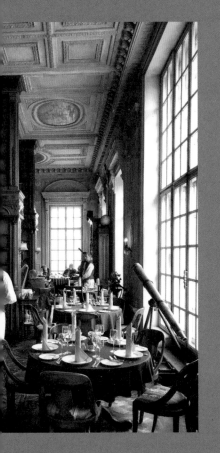

Often our strongest impressions of a new place are formed by what we eat and who we eat with. Steaming hot noodle soup for breakfast, purchased with a language of points and nods in Luang Prabang at sunrise as monks silently walk through town, is a story of the whole city in one experience. A smooth espresso in Italy is so complex it's like drinking a full novel in a sip. The taste of cool, sweet watermelon at a roadside stand in the sweltering heat of Tamil Nadu later becomes a sensory key to unlocking memories from that place and time. The ritual of eating and drinking does not need translating, so taking part in a local meal is such an easy and delicious way to learn about and gain entry into a culture.

In Cuba, leaving Havana Vieja, a *Tiny Atlas* group took a day trip to see Viñales. We crossed the valley on horseback, through waves of green tobacco leaves growing at the base of the rounded limestone cliffs. Midday we stopped at the home of a local farmer for lunch. Silvio casually wielded his giant machete to whack down a stalk of sugarcane from his yard and showed our group how to wrench it twice through a hand-cranked steel wringer. The sweet juice that gushed out was then served in *criollo* oranges and spiked with local *guayabita* rum, which is made from small guava fruit rather than sugarcane. We sucked up the liquid through straws, squeezing the fruit to add additional citrus to taste. By sharing this experience with locals, we emerged from the valley knowing a side of daily life taught in that special way that only a meal can.

←
Chennai flower market, Tamil Nadu, India
Emily Nathan
@ernathan

↖
Tuscany, Italy
Aya Brackett
@ayabrackett

↑
Cafe Pushkin, Moscow, Russia
Jessica Bride
@belleannee

←
Galveston, Texas, United States
Wynn Myers
@wynnmyers

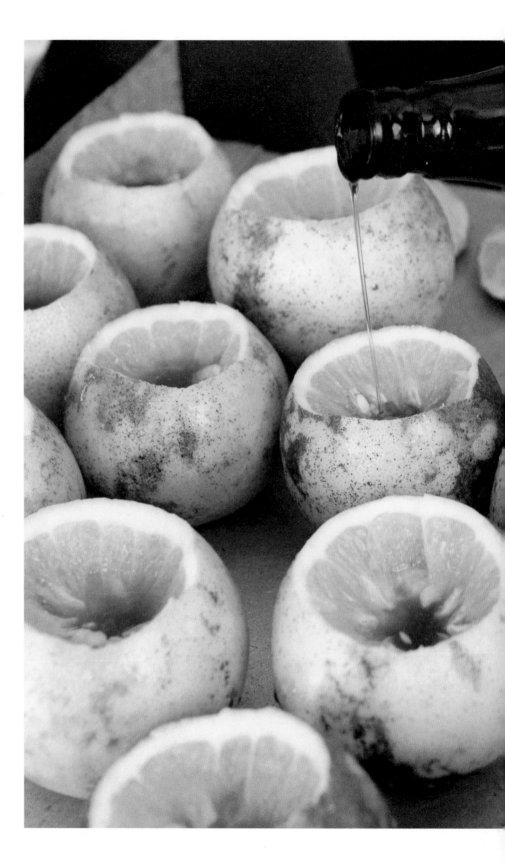

**Viñales, Pinar
del Río, Cuba**

Emily Nathan
@ernathan

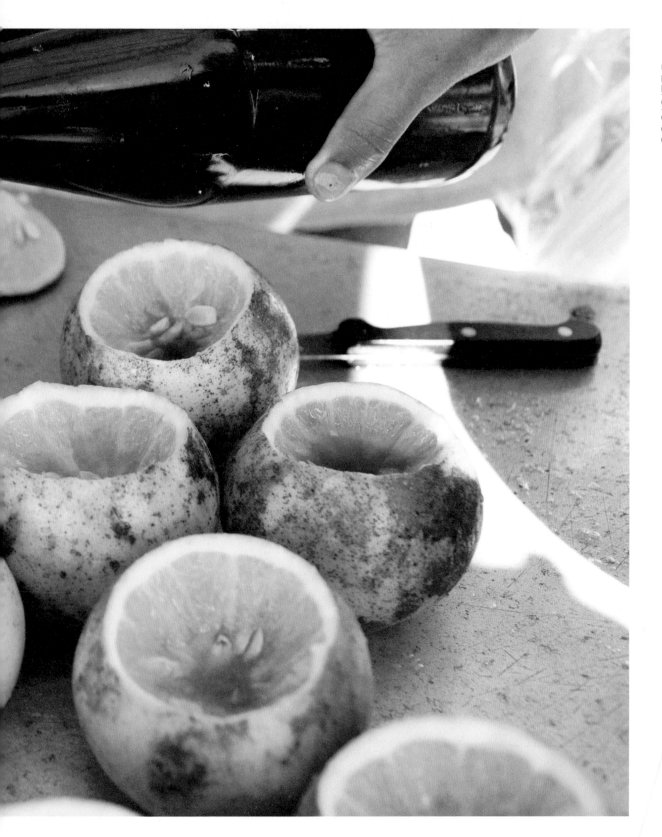

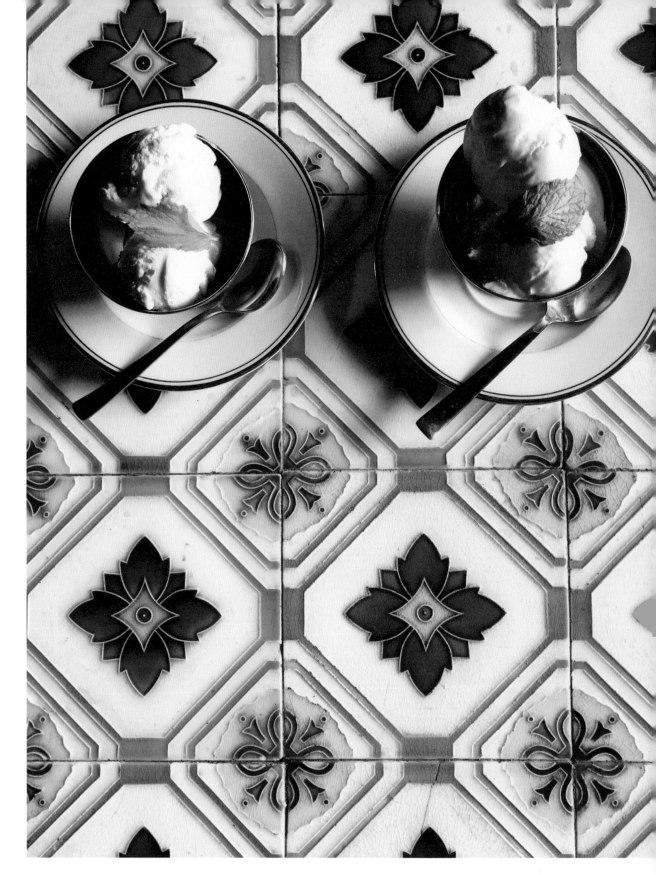

KALYANA KOTTAGAI SERVES up Chettinad cuisine inside the Chidambara Vilas and is known for re-creating the British-era fine-dining experience. When you have finished your meal, wander through the nearby antique markets to find pieces from the Chettinade times, watch a saree being woven, or visit the tile factory where the famous Athankudi tiles are made.

**Kalyana Kottagai,
Chidambara Vilas,
Pudukkottai,
Tamil Nadu, India**

Emily Nathan
@ernathan

**Leila's Shop,
London, England**

Dagmara Chwalowska
@dagmara_ch

↓

Sant Ambroeus,
Palm Beach, Florida,
United States

Maleeha Sambur
@challomallo

→

Lummi Island,
Washington,
United States

Stephanie Eburah
@seburah

⟶

Soho House
Istanbul, Istanbul,
Turkey

Cécile Herlet-Molinié
@cecilemoli

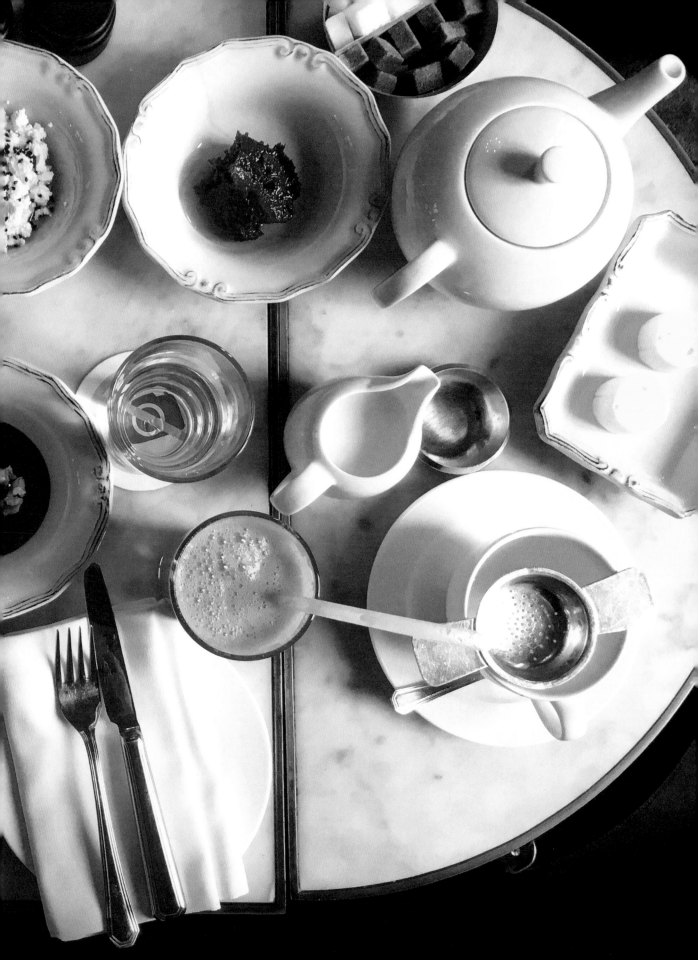

Copenhagen Coffee Lab, Copenhagen, Denmark

All Day, Miami, Florida, United States

EMILY ELYSE MILLER

@emilyelysemiller

WHO IS EMILY?

Emily Elyse Miller's calling in life is food. Specifically, breakfast food. Her work is inspired by real, delicious recipes from locals around the world, from toast with coconut pandan jam in Singapore to man'oushe, a Lebanese flatbread traditionally eaten in the morning. Raised between Arizona and Hawaii, she now bases herself in Brooklyn, New York, where she runs BreakfastClub, a creative event agency devoted to her favorite meal of the day.

Through BreakfastClub, Emily organizes morning pop-up events with restaurants that aren't otherwise open for breakfast (see the following spread for an image shot by a Breakfast Club participant), as well as walking food tours through culture-rich neighborhoods around the world, from Mexico City to Los Angeles to Glasgow. Each of her events highlights the food as well as the people behind both popular restaurants you may have heard of and ones that might be otherwise overlooked, bringing not just the food, but also the culture, of these cities and their cuisines to light.

EMILY'S TABLE

Breakfast is special to Emily for a reason: when you enjoy breakfast, you sacrifice personal time that could be spent sleeping or working. Her food walks through New York's Lower East Side emphasize the many local, immigrant-run restaurants found in the neighborhood. Her writing highlights morning food traditions from around the world, where she pays homage to traditional recipes as well as the community behind the food and the people who enjoy it. Although Emily is not a professional photographer, as a creative director immersed in food, she achieves images that feel both immediate and fresh.

Brunette, Kingston, New York, United States
Katie June Burton
@katiefresca for @heybreakfastclub

Lisbon, Portugal

Chez Richard,
Brussels, Belgium

Lavinia Cernău
@lavinia_cernau

Kuala Lumpur,
Malaysia

Davina Tan
@heydavina

KYOTO IS KNOWN for matcha—from hot green tea to parfaits and soft-serve ice cream. To get a photo like this, visit Kyoto in mid-November as the fall foliage reaches its peak and the maple leaves turn bright red and orange.

Kyoto, Japan
Karen Doolittle
@karendoolittle

Bakeri, Brooklyn, New York, United States

Davina Tan
@heydavina

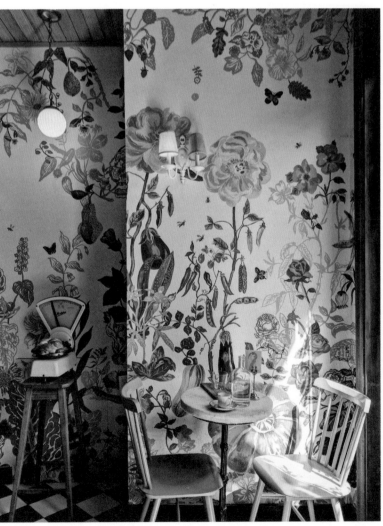

IN NORTHERN KENYA, Samburu warrior-guides from Sasaab Lodge, a Moroccan-styled safari camp in the Samburu National Reserve, set up a breakfast of farm eggs, coffee, and fruit in a scenic location of their choice. While guests enjoy bush breakfast, prides of lions are often spotted only a stone's throw away.

Samburu National Reserve, Kenya
Wynn Myers
@wynnmyers

↑

Istanbul, Turkey
S. Sezgi Olgaç
@sezgiolgac

→

Middle Atlas market, Morocco

Jill Livingston
@jlblivingston

Protégeons la planète
AB
AGRICULTURE
BIOLOGIQUE

SOIT LE KG

3 € pièce

PRODUIT MELON

VARIÉTÉ

ORIGINE PRODUCTE

CATÉGORIE

CALIBRE

↑

WALK ALONG THE arched alleyways, narrow streets, and lemon groves of Atrani, the smallest municipality in Italy, or enjoy a *caffé lungo* on a patio overlooking the Amalfi Coast.

Atrani, Salerno, Italy
Nazar Melconian
@nazfilms

←

**Le Moulleau,
Arcachon, France**
Cécile Herlet-Molinié
@cecilemoli

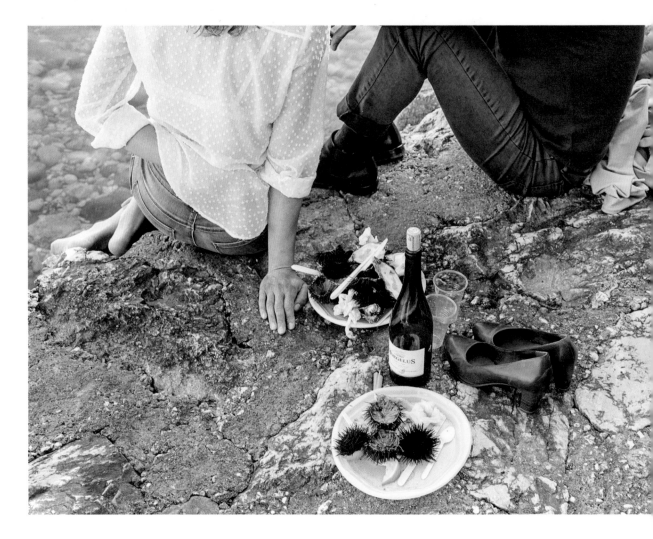

Carry-le-Rouet, Provence-
Alpes-Côte d'Azur, France

Alexandra Kryaneva
@shurupchik

Borough Market,
London, England

Dagmara Chwalowska
@dagmara_ch

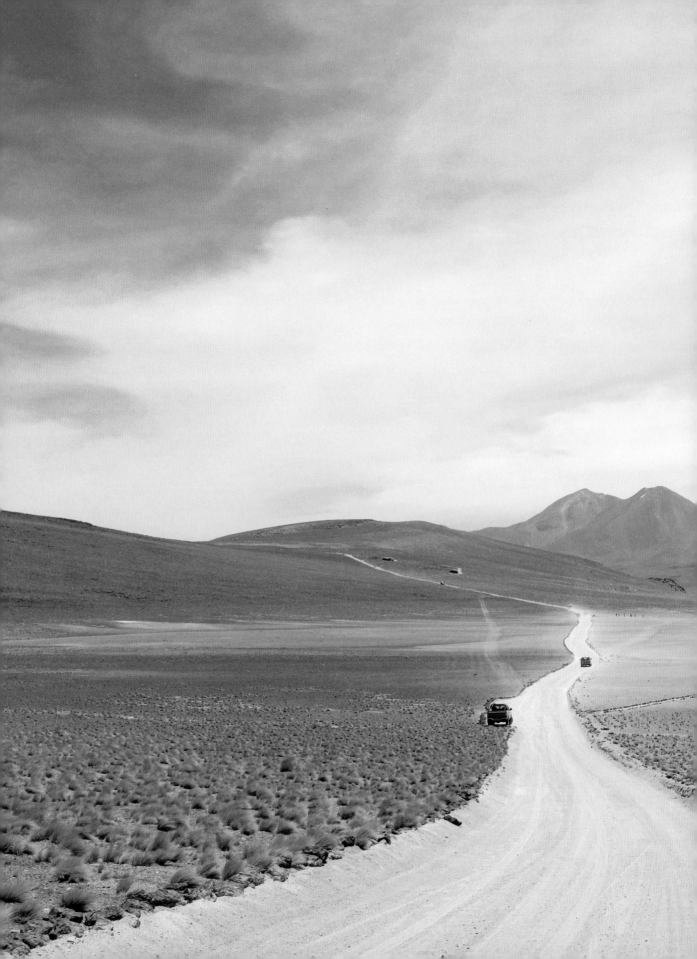

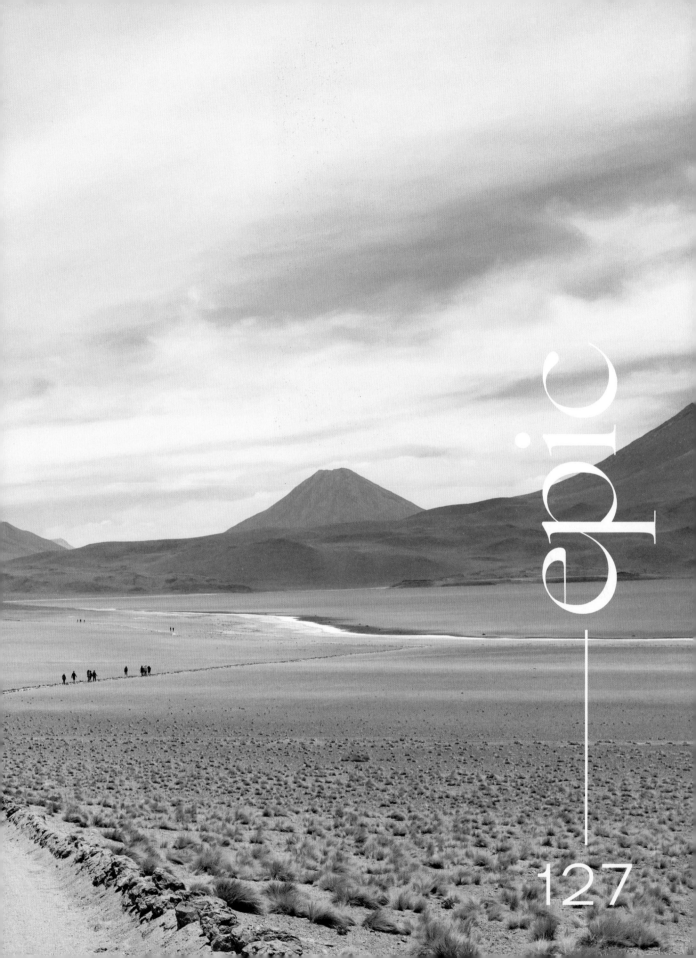

epic

127

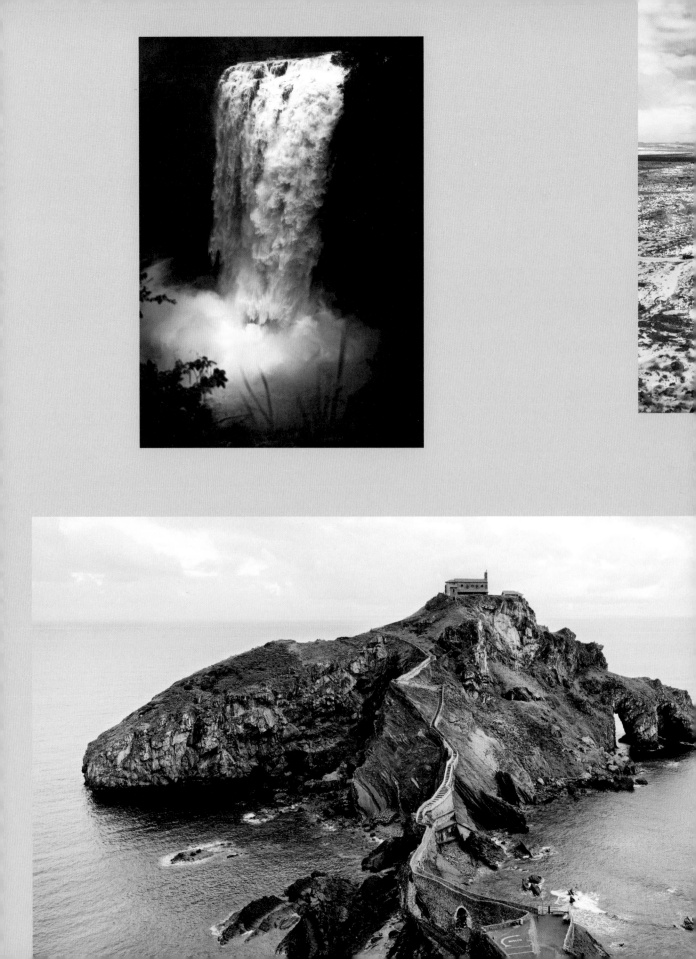

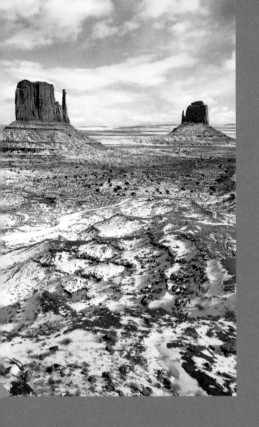

Traveler, beware. It's possible that visiting these places may change you for good. The reverence and reflection brought on at some of the world's most ecstatic places may reveal changes you want to make in the direction of your life. The sites featured in Epic can make the small stories we tell of ourselves feel dwarfed by time. The wearing away of the cliffs is clocked in eons, not in life spans. These locations are larger than life, and all they do is sit there, being shaped by millennia. The small frustrations of daily life become meaningless in comparison. In their presence, you may be moved to see yourself differently. The beauty and the awe inspired by each place will outlive you.

Epic images are a visual shortcut that stand for everything leading up to the moments when we take these stunner pictures. The preparation for the travel that led to each image in this chapter requires a fair amount of saving of money and sequestering of time. But, while our lenses will never convey the wind on our cheeks, the burn in our muscles, or the quiet of a valley creeping into dusk, the scale of the place can do the talking for us. Even though a moment on a cliff looking upon a roaring waterfall is not quite containable in an image, photography can capture how small we feel standing there and serve to remind us why we have made the pilgrimage.

←

Atacama, Chile
Alena Paramita
@aparramitta

↖

Victoria Falls, Zimbabwe
Allison McCarthy
@aquinnm

↑

Monument Valley, Arizona, United States
Diane Tsai
@dianetsai_

←

Gaztelugatxe Islet, Bermeo, Biscay, Basque Country, Spain
Grant Harder
@grantharder

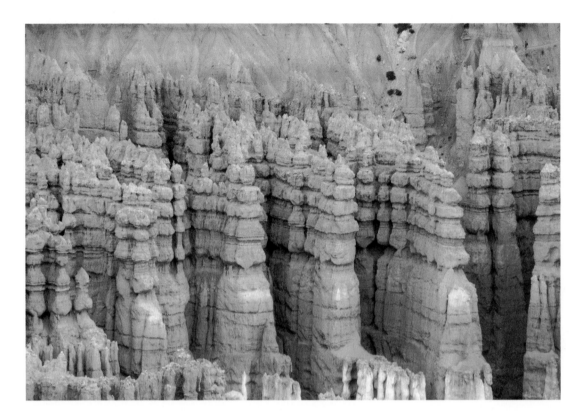

↑

JUST NORTHEAST OF Zion National Park and northwest of Grand Staircase-Escalante, Bryce Canyon is one of five National Parks in southern Utah. It's home to the world's largest collection of hoodoos, the odd-shaped pillars of rock left from erosion seen here.

Bryce Canyon National Park, Utah, United States
Kathrine Zembera
@k_zembera

→

Los Cuernos, Torres del Paine National Park, Magallanes and the Antarctic Region, Chile
Dan Tom
@dantom

→

FOR A FEW days each year around the second week of February, Horsetail Falls, on the eastern side of El Capitan in Yosemite, can turn into what is known colloquially as "firefall." When the sky is clear, and there has been good snowfall—and also sunshine to melt it—the rays of the setting sun illuminate the falling water, making it glow red and orange against the darkened cliffs. Even when the conditions are perfect, the phenomenon lasts for only about ten minutes.

Horsetail Fall, Yosemite National Park, California, United States
Madeline Lu
@lumadeline

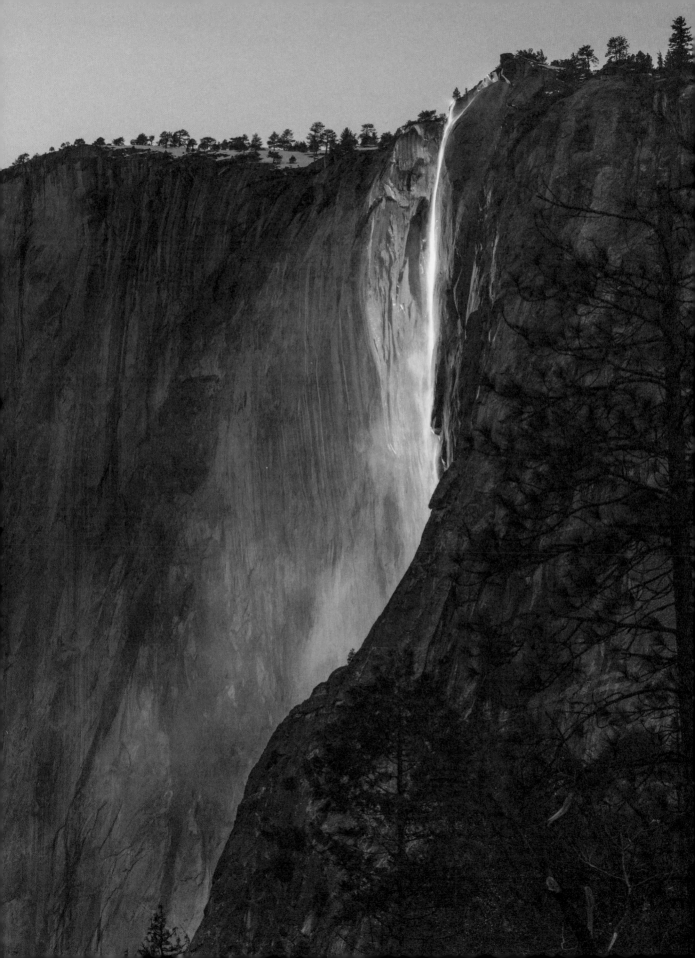

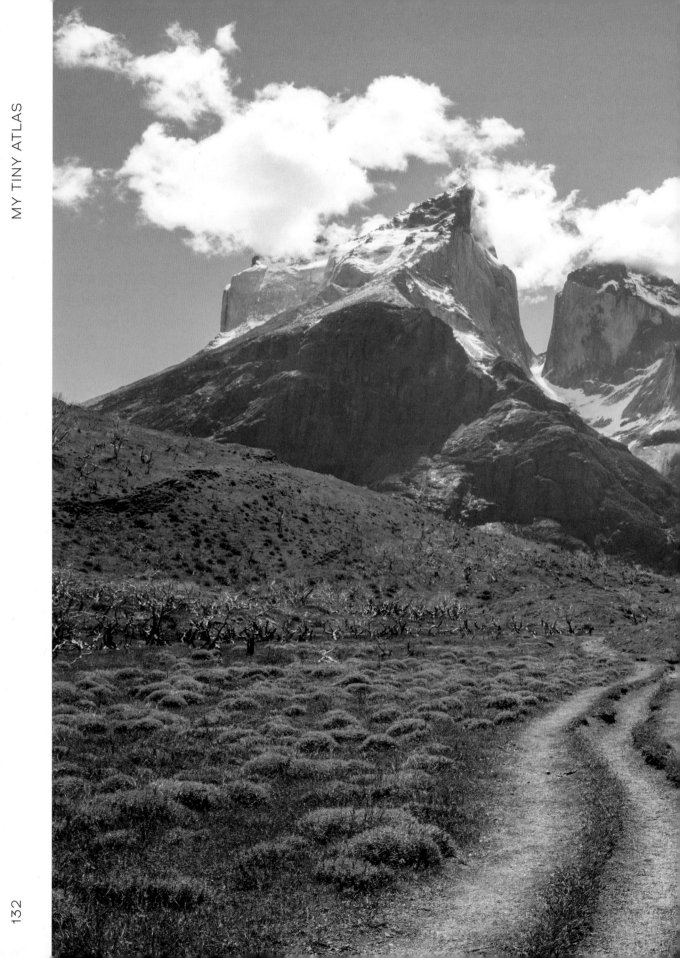

↑

THE COLOR OF this water is attributed to the presence of aluminum hydroxide, which reflects the shorter-wavelength blue light. Park at the Blue Pond and walk along the path to get to the river.

Shirahige Waterfall, Biei, Hokkaido, Japan

Conor MacNeill
@thefella

⟶

Mount Everest, Nepal

Louise Coghill
@louisetakesphotos

→

THE DOLOMITES OF northern Italy are a UNESCO World Heritage site featuring eighteen peaks renowned for their dramatic vertical walls and sheer cliffs. The town of Ortisei is often visited by road bike, but you can also hop on a cable car, head up over 4,000 feet, and traverse the 3 miles to Seceda.

Seceda, Val Gardena, South Tyrol, Italy

Meagan Lindsey Bourne
@mlbourne

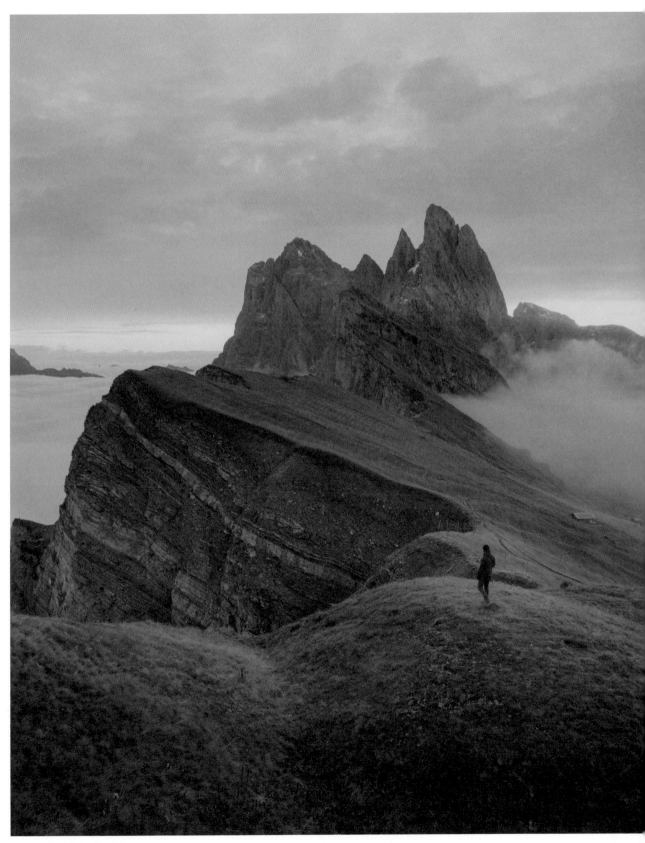

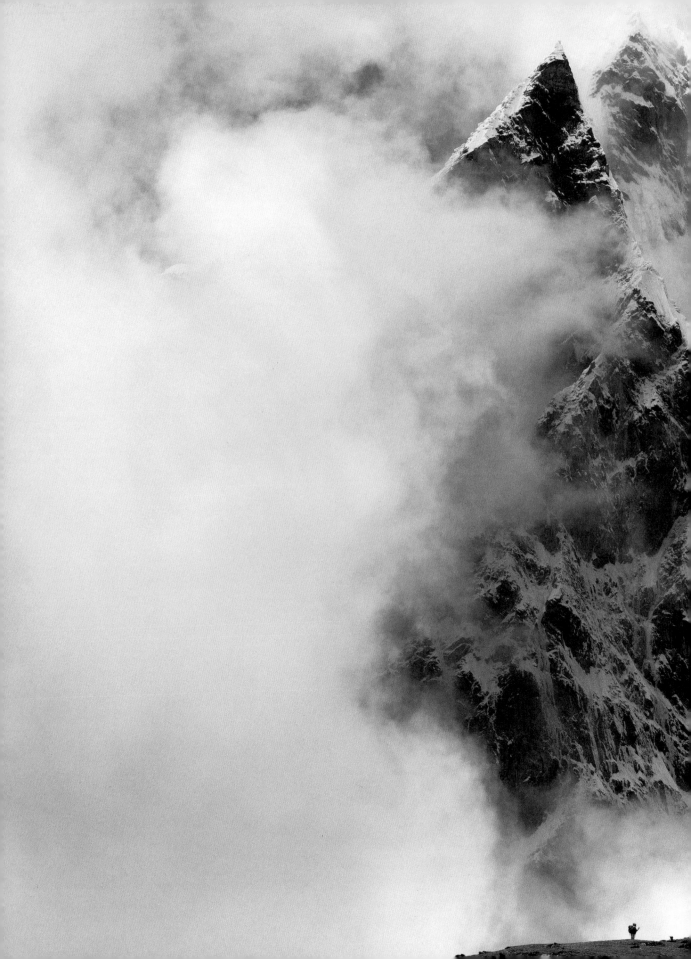

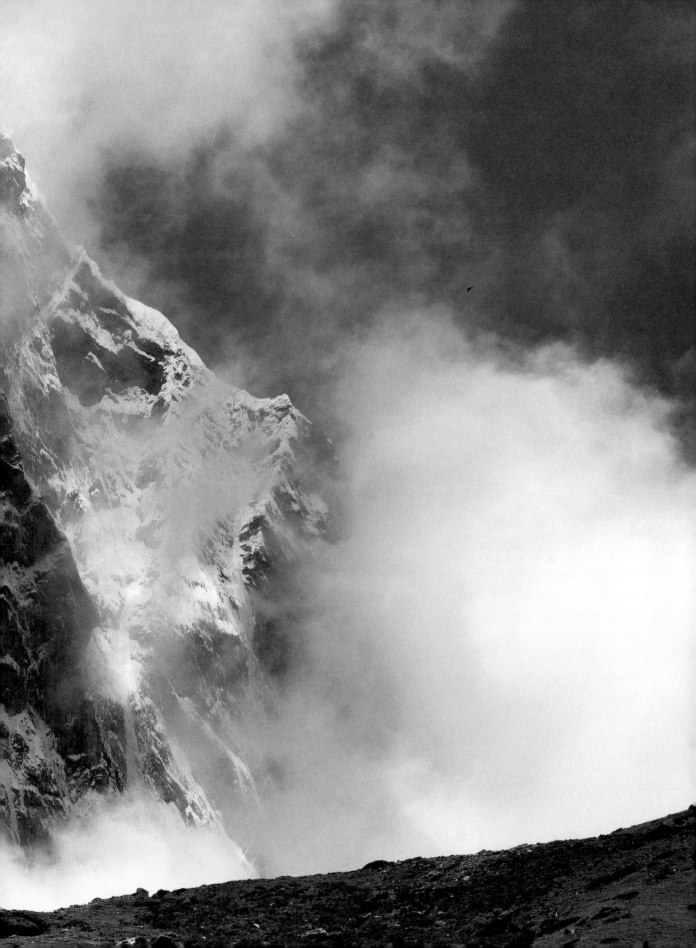

WHAT WAS A major trading hub in the eighteenth century and then was reduced to a humble fishing village just decades later has become a huge holiday destination. Positano lies on the Amalfi Coast of southern Italy and is home to Spiaggia Grande, the coast's largest beach. The region is known for its colorful cliffside buildings, narrow streets lined with quaint boutiques and cafes, and the brilliant blue sea contrasted with gray pebbled beachfronts.

Positano, Salerno, Italy
Madeline Lu
@lumadeline

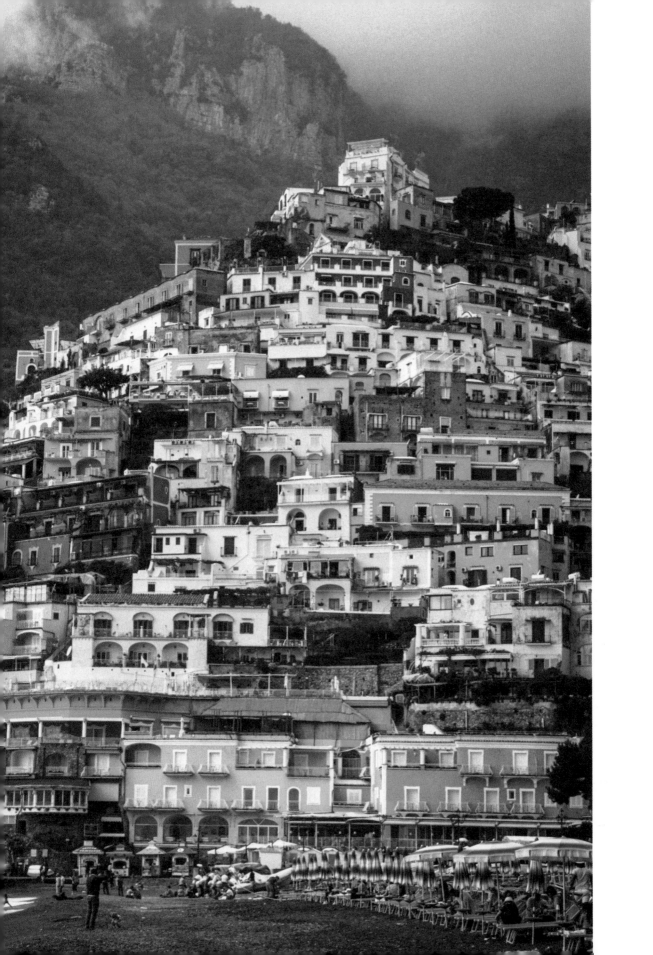

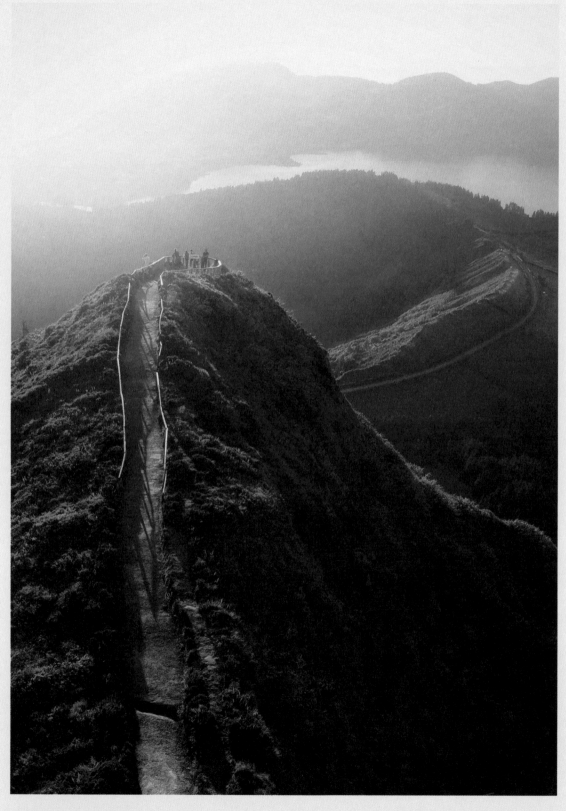

Sete Cidades, Azores, Portugal

TYSON WHEATLY

@twheat

WHO IS TYSON?

Tyson Wheatley is many things: a father of four, photographer, filmmaker, podcast host, traveler, and community advocate. He's lived around the world, from Germany to Italy, from Atlanta to New York City. Tyson also spent a few years living in Hong Kong, and it was there, at the dawn of the Instagram era, that he began making tiny images that could speak to a world coming online and falling in love with sharing photography as a universal language.

Tyson first learned to shoot on a cell phone while working as a newsroom producer. An early adopter of Instagram, he spent years organizing meet-ups (including Hong Kong's first-ever InstaMeet) for amateur and professional photographers to come together and take pictures. With an early understanding of the platform, Tyson sought to show the busy global city in a way that captured the scale of the place. Using careful crops, Tyson put the immense architecture of Hong Kong on display in a tiny format for millions of viewers.

TYSON'S SCALE

Tyson's photography often organizes itself around a sense of scale and magnitude, as he captures vast landscapes by finding the leading lines, symmetrical patterns, and aerial views of tiny islands and towering mountains. He has a passion for travel and sharing stories of places both rural and urban, from Patagonia to the skyscrapers of his current hometown, New York City. For Tyson, any good photo is one that evokes an emotion, and with his photography that is often awe.

Hitachi Seaside Park, Hitachinaka, Ibaraki Prefecture, Japan

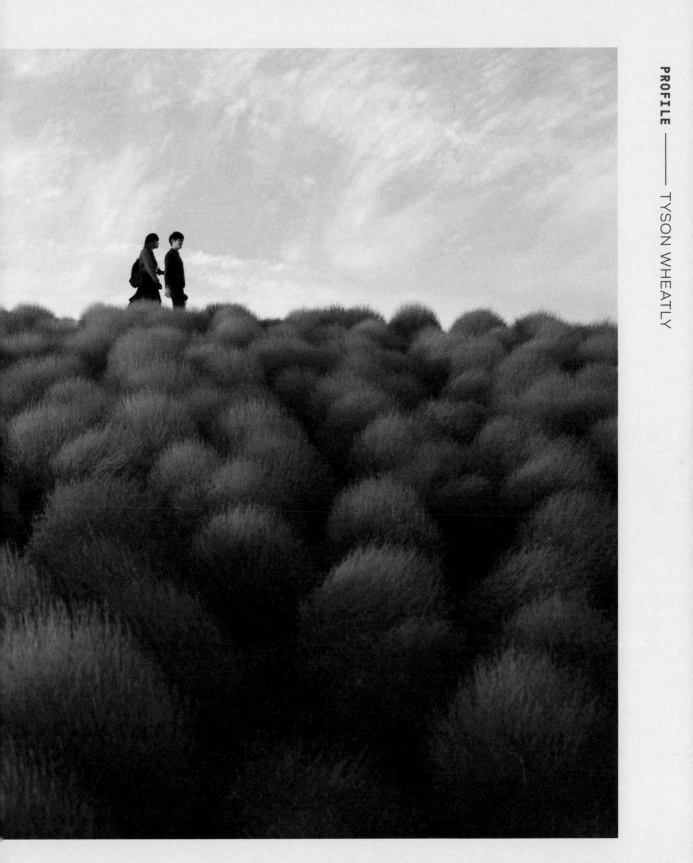

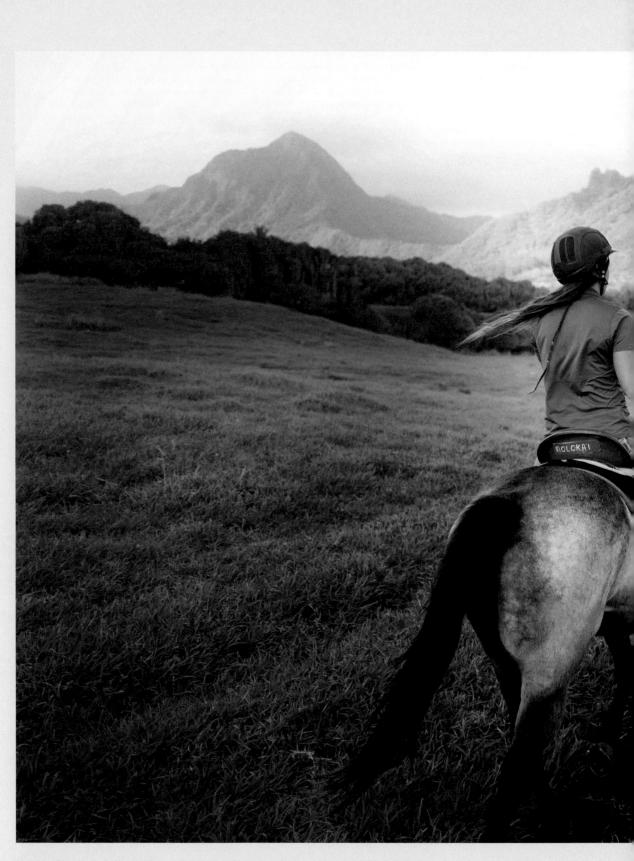

Kualoa Ranch & Private Nature Reserve, Kaneohe, Oahu, Hawaii, United States

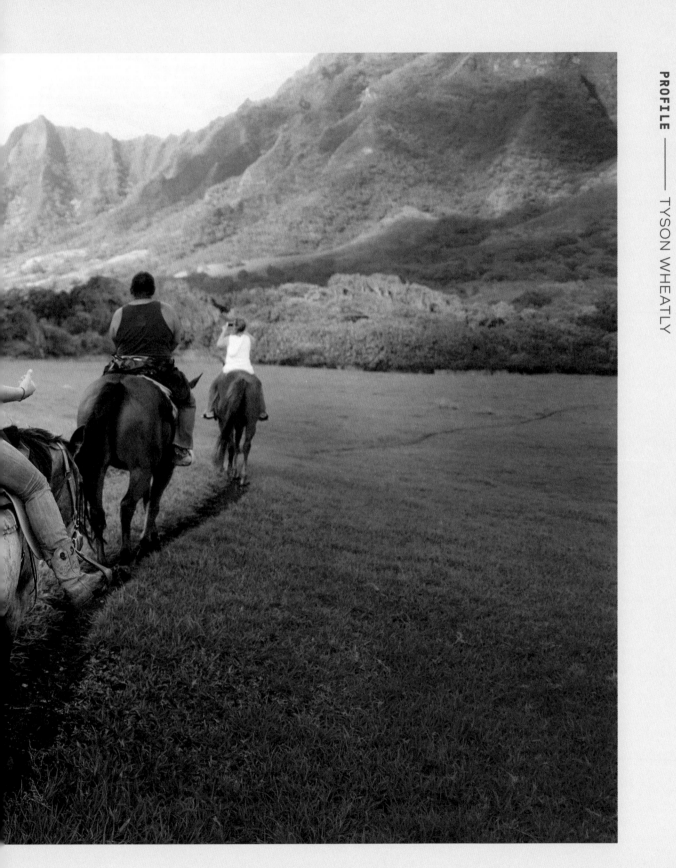

AS THE OSPREY or drone flies along West Cape Howe National Park to Shelley Beach on Australia's western coast, you can see the curvatures of Shelley Beach Road, the clear blue waters of Swan River, the bright white sandy coastline, and the huge granite boulders that mark the ends of the beach.

**Shelley Beach,
West Cape Howe
National Park,
Albany, Western
Australia**

Michael Goetze and
Jampal Williamson
@saltywings

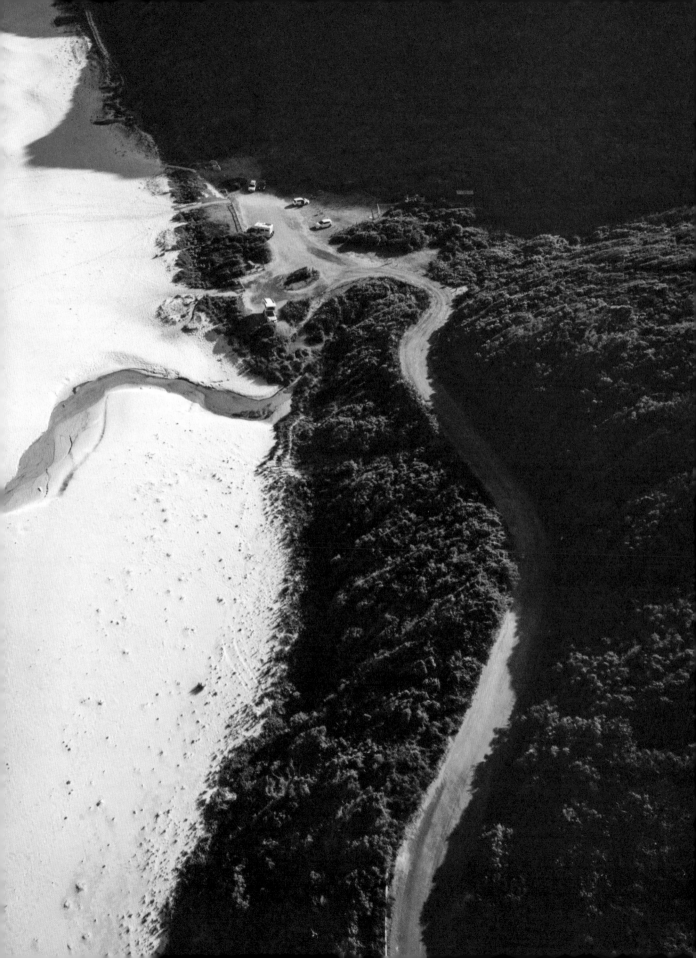

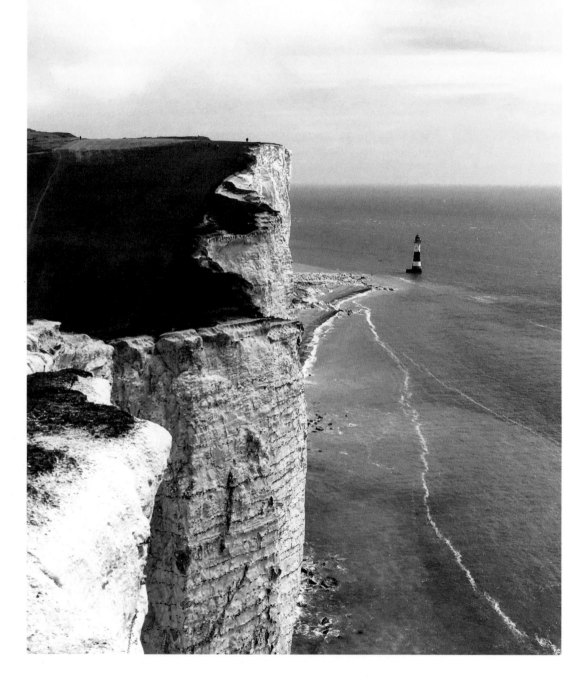

←

Beachy Head, East
Sussex, England

Elke Frotscher
@elice_f

↓

Prince George,
British Columbia,
Canada

Jeremy Koreski
@jeremykoreski

⟶

Gullfoss, Iceland

Finn Beales
@finn

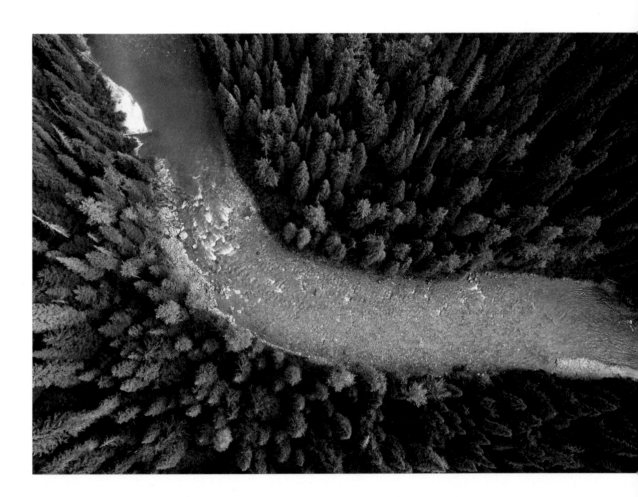

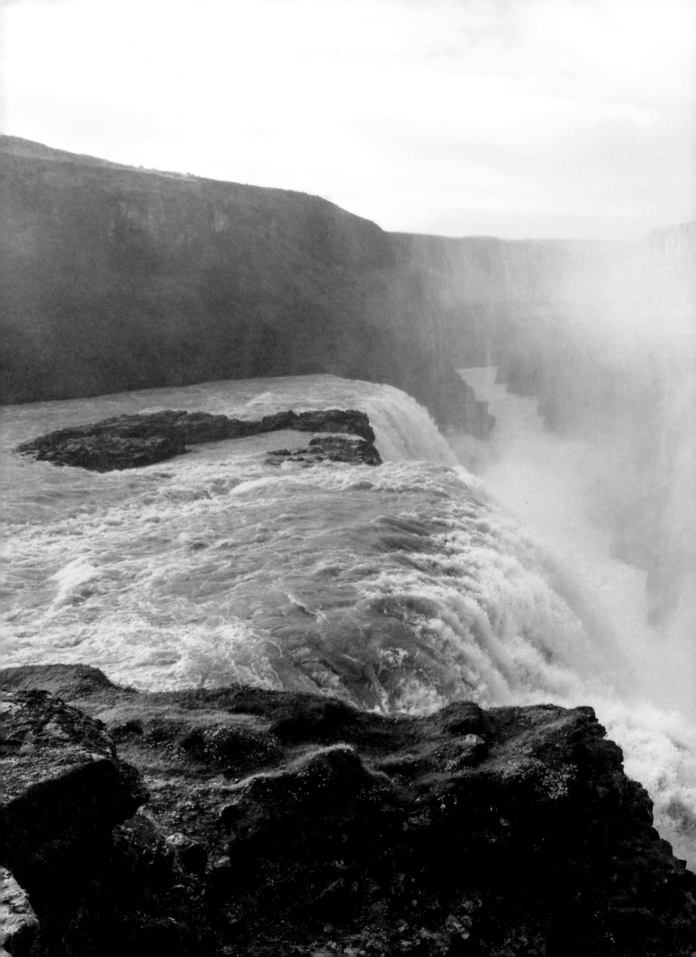

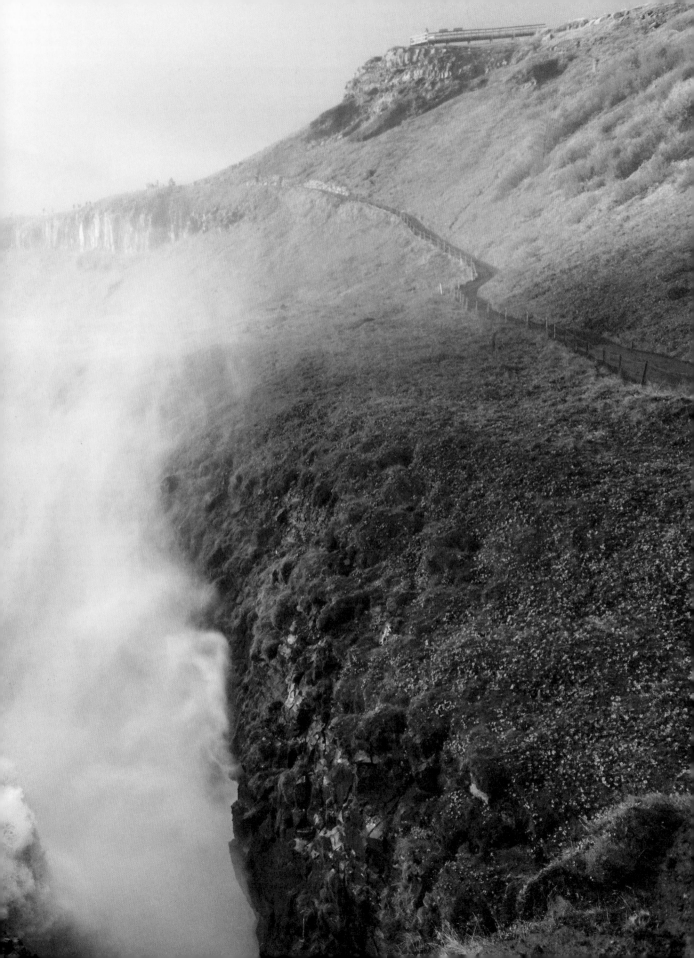

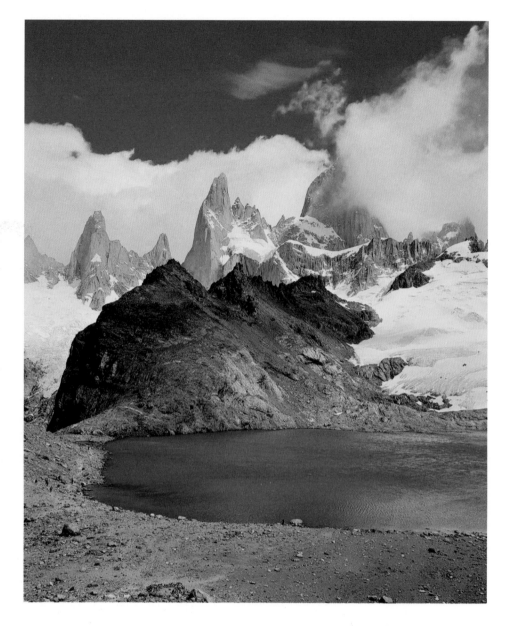

↑
**El Chaltén, Laguna de
los Tres, Patagonia,
Argentina**

Anita Brechbühl
@travelita

→
**Sahara Desert,
Morocco**

Alena Paramita
@aparramitta

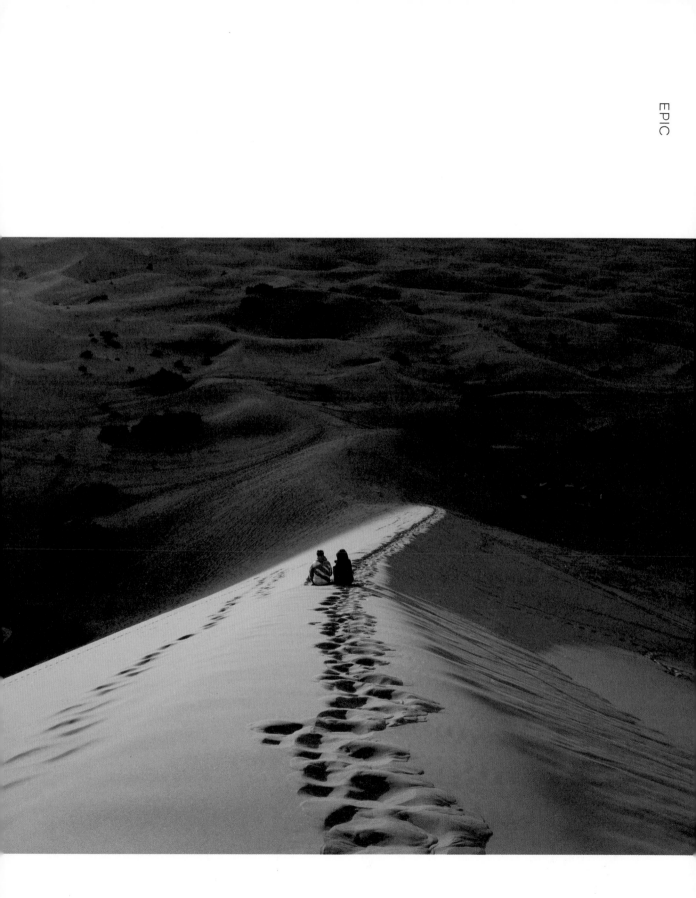

intimate

155

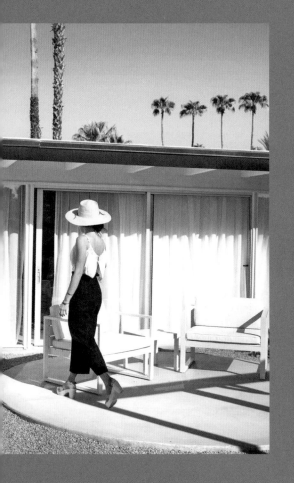

Images of the spaces we live in and travel to can be seen as a form of self-portraits. They speak to who we are, and sometimes, to who we want to be. For a traveler, one of the magical facets of being on the road is the surprise of personal revelations that surface when we are away from our usual context. The images in Intimate speak to the quiet moments, sometimes solitary, when something unexpected is revealed, either about oneself or about the people who live there.

An image of an outdoor shower reminds us of how good it feels to be warm and bathe outside, and for most of us adds a sharp contrast to our everyday routine. A window frame pictured inside a room above a bustling city below reminds us of the time that travel gives us to really think and explore.

Looking more closely at the spaces where we spend time is a good way to record how a place makes us feel, and why we have come. In the image here from Palm Springs, even though it's just a peek, you get a sense of the sun, the clean desert air, and the relaxed atmosphere that drives so many visitors from neighboring LA to this mid-century modern gem.

←

Habana Vieja, Havana, Cuba

Emily Nathan
@ernathan

↖

Taj Lake Palace, Pichola, Udaipur, Rajasthan, India

Rhiannon Taylor
@inbedwith.me

↑

L'Horizon Resort & Spa, Palm Springs, California, United States

Emily Nathan
@ernathan

←

North Shore, Oahu, Hawaii, United States

Tyson Wheatley
@twheat

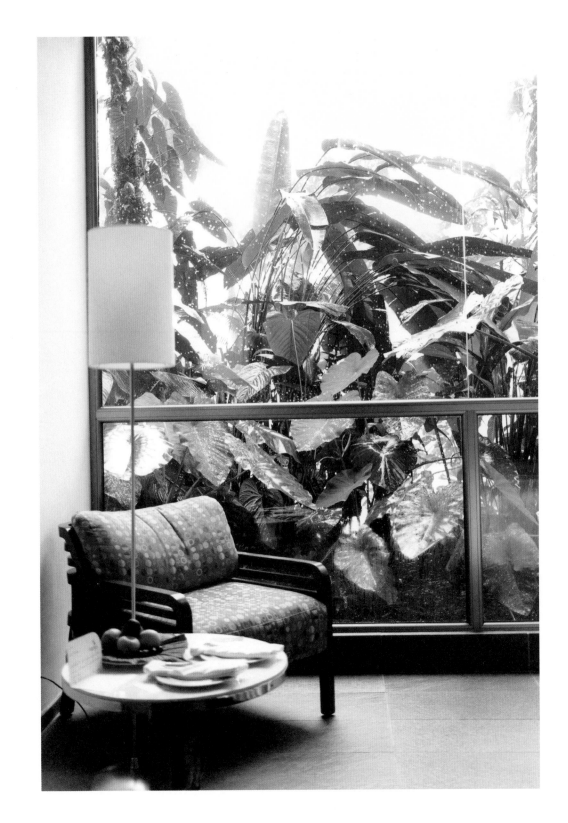

THREE HOURS FROM downtown Quito, set on 200 acres of cloud forest, this is one of *National Geographic*'s Unique Lodges of the World. Look out for howler monkeys from the floor-to-ceiling window in your room, view rare butterflies, and swim in natural pools formed by a nearby waterfall.

**Mashpi Lodge,
Mashpi, Ecuador**

Marianna Jamadi
@nomadic_habit

**14th Arrondissement,
Paris, France**

Jules Davies
@julesville_

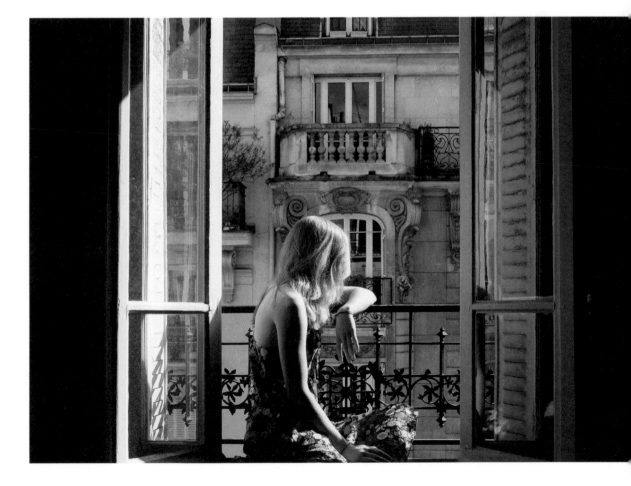

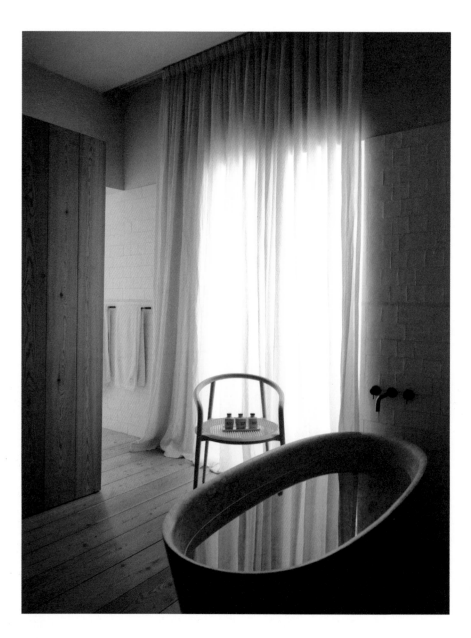

↑

THE SANTA CLARA, an eighteenth century palace-turned-luxury-hotel, sits high above this relaxed coastal capital of Lisbon. The spacious house, which survived a devastating earthquake in 1755, feels even more expansive with minimalist furniture and panoramic views of the neighborhoods and Tagus River below. The bustle of town comes to the steps of the hotel every Tuesday for the Feira de Ladra flea market.

**Santa Clara 1728,
Lisbon, Portugal**

Kara Mercer
@_karamercer

→

**Orange Hotel, Jujuy,
Argentina**

Tyson Wheatley
@twheat

⟶

**Encuentro Guadalupe,
Valle de Guadalupe,
Ensenada, Baja
California, Mexico**

Emily Nathan
@ernathan

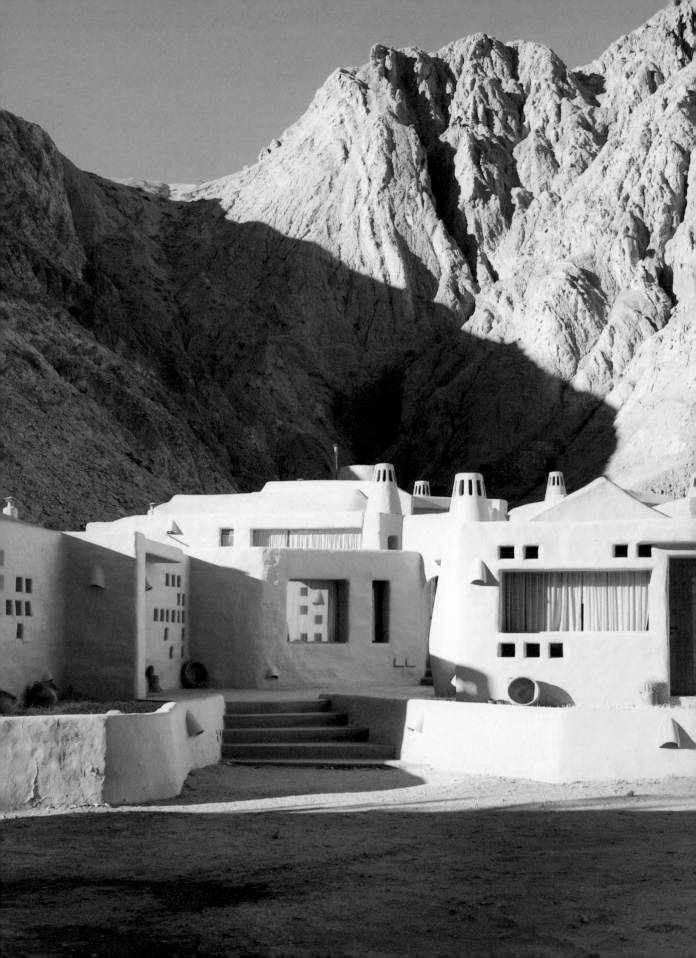

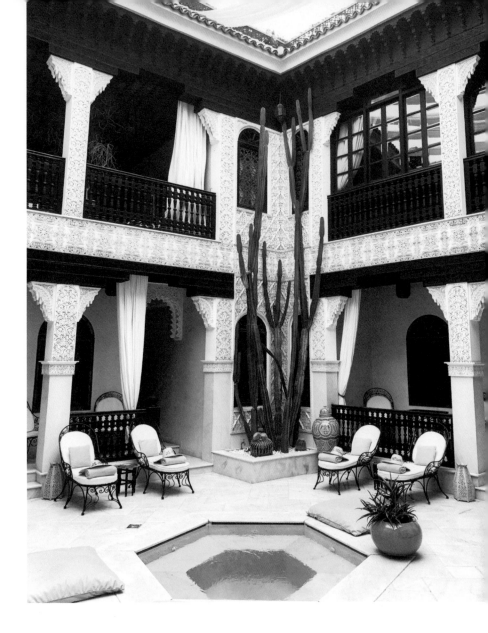

←

THE YURTS AT Wya Point on First Nation traditional land sit in a wild beach cove surrounded by hundreds of acres of old-growth forest, just minutes from the Pacific Rim National Park, and the resort town of Tofino.

**Wya Point Resort,
Ucluelet, British
Columbia, Canada**

Emily Nathan
@ernathan

↑

THE CITY OF Marrakech lies in western Morocco, and is a treasure chest of palaces, souks, gardens, and mosques. La Sultana is organized in several different style *riads*, and also houses a spa boasting a traditional *hammam*. An oasis of calm amidst the bustling and winding souks of the old city, La Sultana sits inside the thousand year-old walled medina, just around the corner from Djemaa el Fna square.

**La Sultana, Marrakech,
Morocco**

Emily Nathan
@ernathan

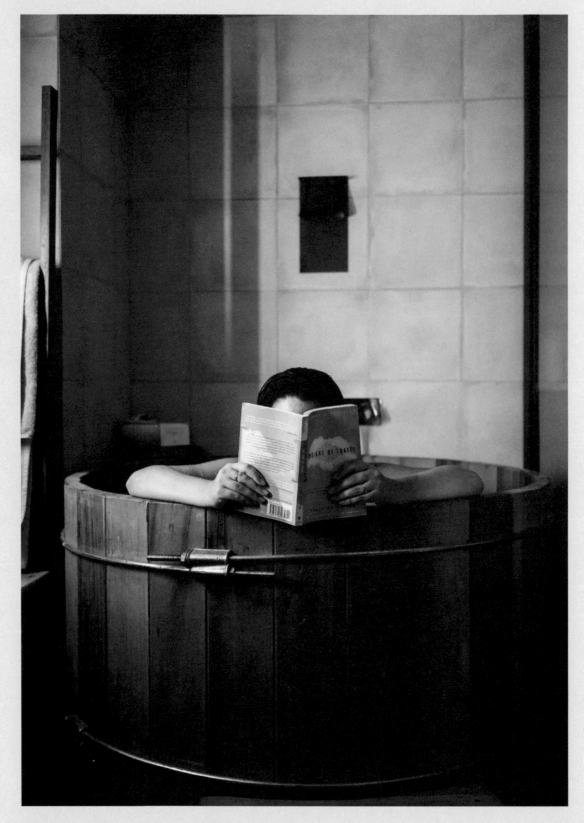

Bisma Eight, Ubud, Bali, Indonesia

JESSICA WRIGHT

@bontraveler

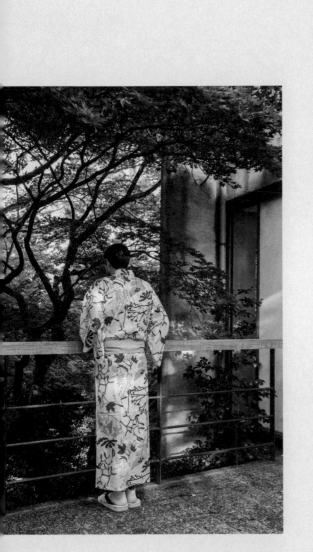

Beniya Mukayu, Kaga,
Ishikawa Prefecture, Japan

WHO IS JESSICA?

Travel blogger Jessica Wright grew up in the foothills of the Sierra Nevada in Auburn, California, but spent her summers visiting her mother's family in a different countryside—that of Poitiers, France. The two small towns, while across the ocean, have a strong sense of local culture, one with fireworks and the other with thousand-year-old architecture lining the streets. Today, Jessica is on the road more than two hundred nights a year, making home wherever she is that week.

As a full-time blogger, Jessica knows that part of each new travel experience is about letting her readers join her through her imagery and writing. Because her photos feel real, we trust her words. Her pictures are intimate, although her writing doesn't overshare on personal details. Because Jessica is always on the road and moving so quickly, she's successful in taking in the details of a place. She keeps close counsel with her community, telling them about what she is seeing and feeling along the way, and sparking meaningful conversations about the places she visits.

JESSICA'S ROOMS

Jessica's favorite places to stay often enfold the natural surroundings and local resources into their interior design: walls built from hand-pressed bricks in Bali, rooms decorated with locally woven textiles in Marrakech, thatched roofs made out of dried palm leaves in Sri Lanka. She finds inspiration in places that bridge the gap between outdoors and in. Jessica's images often take place in luxury hotels and yet they feel approachable and down-to-earth. She is frequently in the pictures, a small person in a doorway or a pool, providing humanity in spaces that are usually shown without people. Her images themselves are mostly shot on a wide-enough lens to get in a good amount of the space, the "pulled-back" perspective travelers so often thirst for.

When she wants to truly get away, Jessica goes to her favorite modern self-service cabins in Winthrop, Washington. Here, she disconnects from her community, and doesn't bring her laptop. Sitting on the porch, surrounded by low mountains and grassy fields in a landscape not unlike those where she grew up, she feels truly relaxed because for the moment there is no device and no assignment. The tourist in her can come alive while the journalist takes in a moment of quiet.

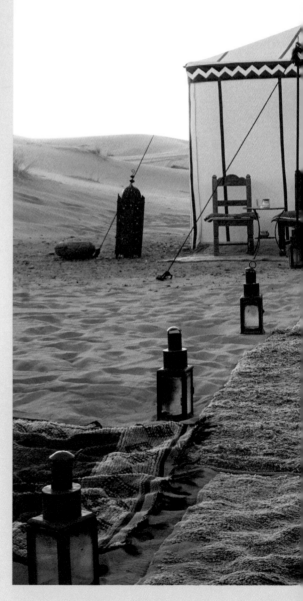

Desert Luxury Camp, Merzouga, Morocco

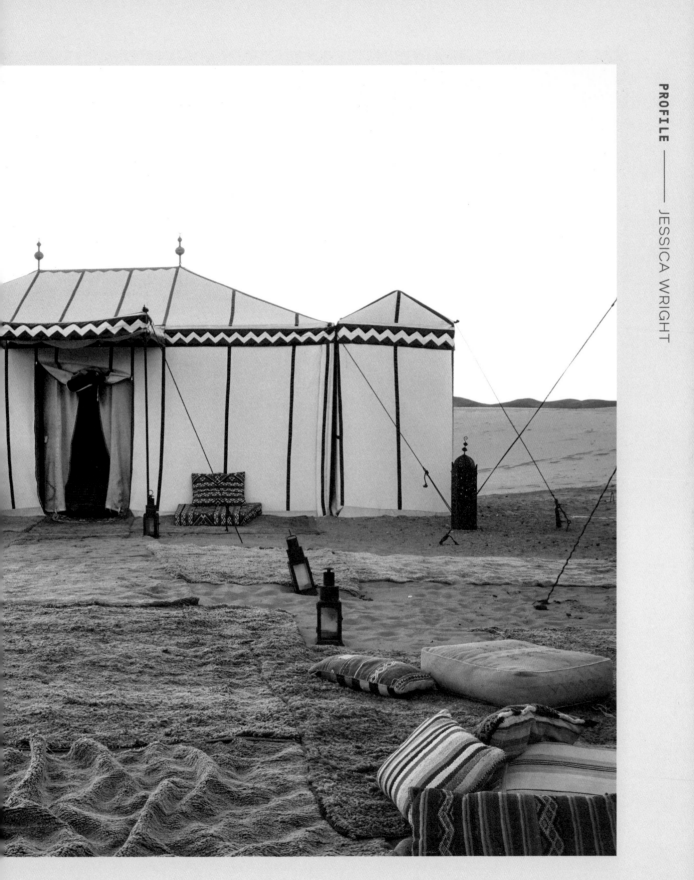

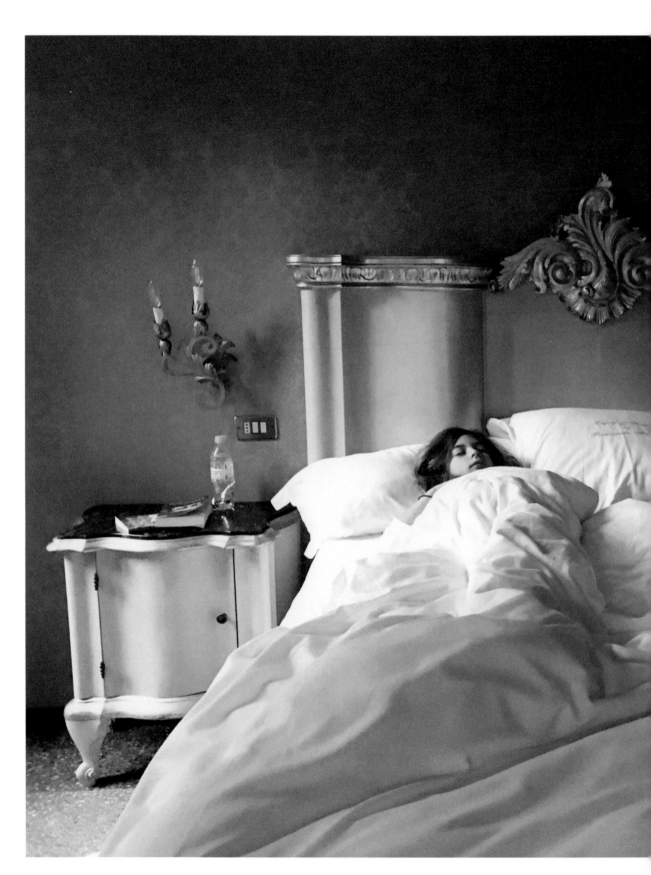

Hotel Flora,
Venice, Italy

Cécile Herlet-Molinié
@cecilemoli

OSTUNI IS A medieval town along the eastern coast of Italy's boot, famous for its whitewashed old town and architecture reminiscent of its neighbor just across the Adriatic Sea: Greece. Nearby beaches vary from slices of sand to Lecce's sandstone towers and famous rocky urban wonders like Polignano a Mare. The region is beloved for its rolling hills and the fertile soil below them. Wine here is often delicious and inexpensive, and over 40 percent of the country's olive oil is made in the region.

Ostuni, Puglia, Italy
Nicola Millbank
@millycookbook

Melbourne, Victoria, Australia
Emily Blake
@emilylaurenblake

Hacienda El Porvenir, Cotopaxi National Park, Machachi, Ecuador
Marianna Jamadi
@nomadic_habit

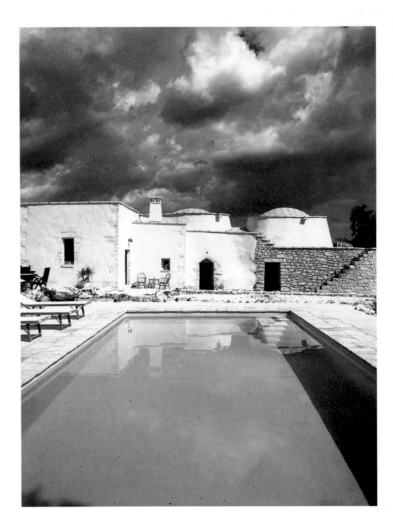

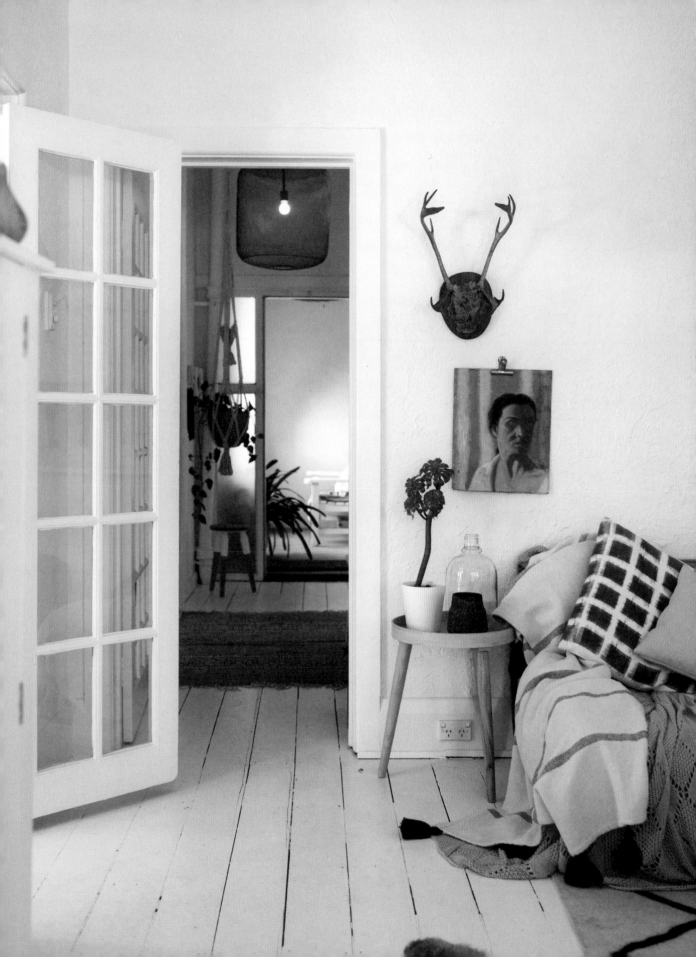

CENTRAL VIRGINIA'S GETAWAY house includes thirty-four isolated cabins spread across 80 acres of woods, two hours from DC. The cabins provide views of the Blue Ridge Mountains, while Shenandoah River State Park lies just outside with 200,000 acres of hiking trails, waterfalls, and forests.

Getaway House, Stanardsville, Virginia, United States

Michelle Solobay
@michellesolobay

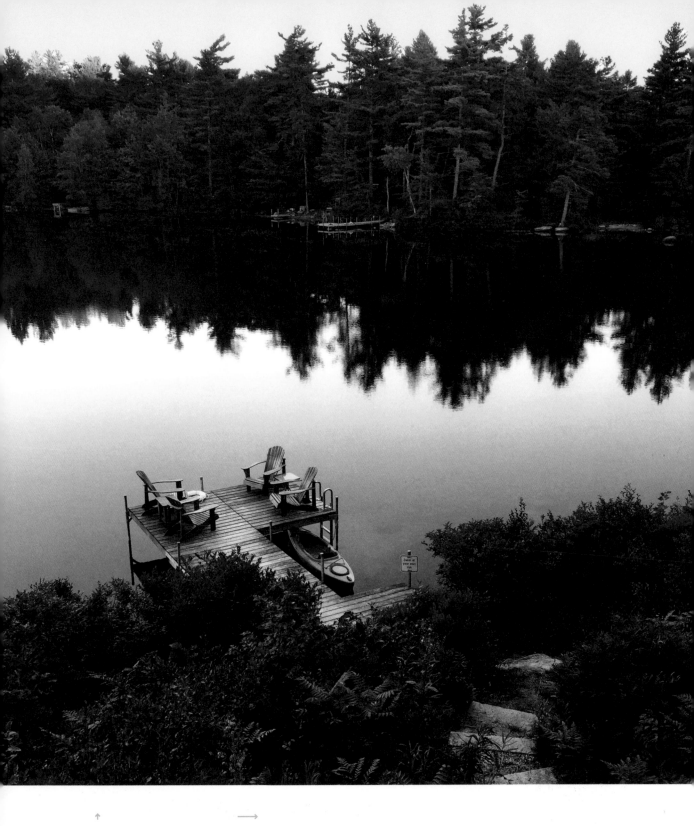

↑

Maine, United States

Joanna Yee
@candidsbyjo

→

**Svatma, Tanjavur,
Tamil Nadu, India**

Emily Nathan
@ernathan

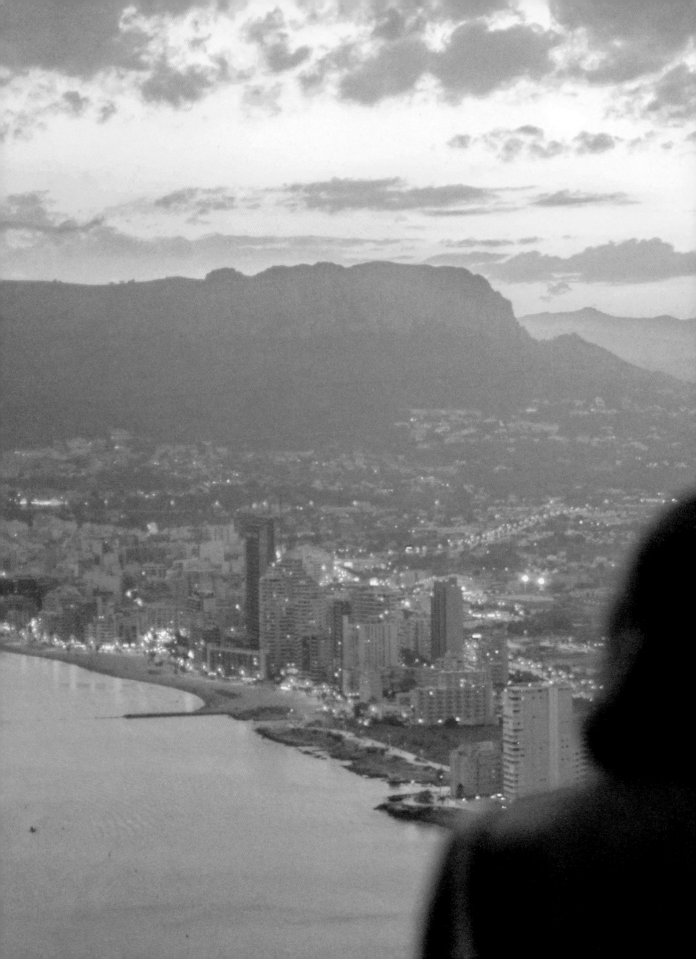

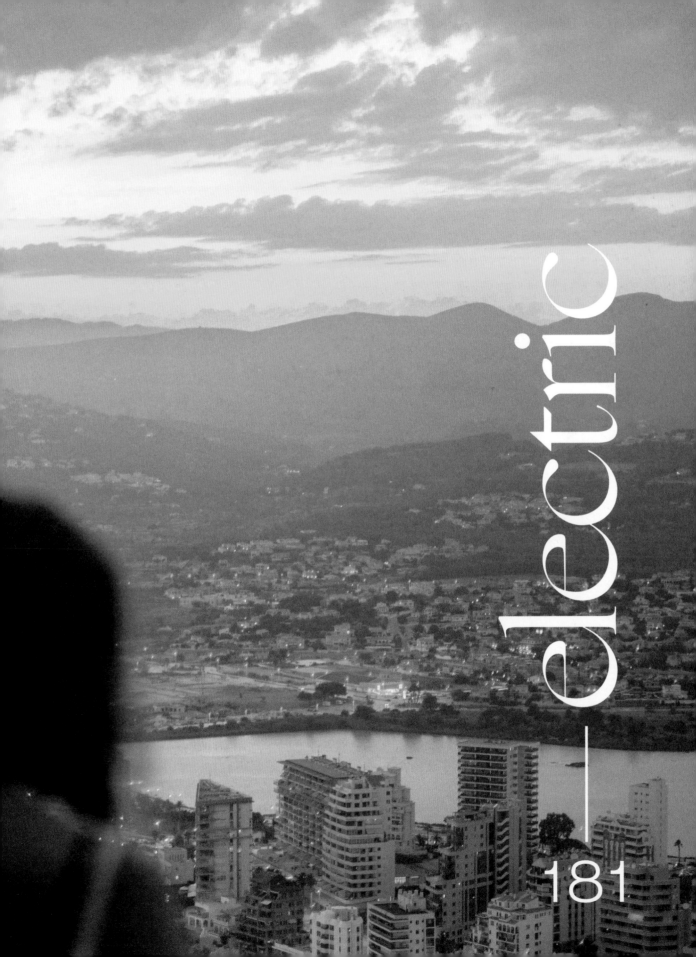

electric

181

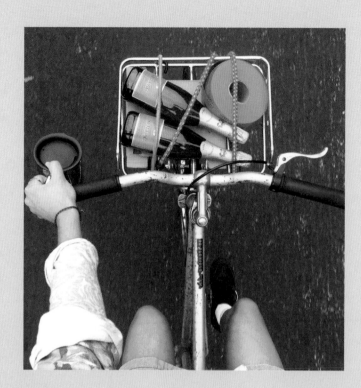

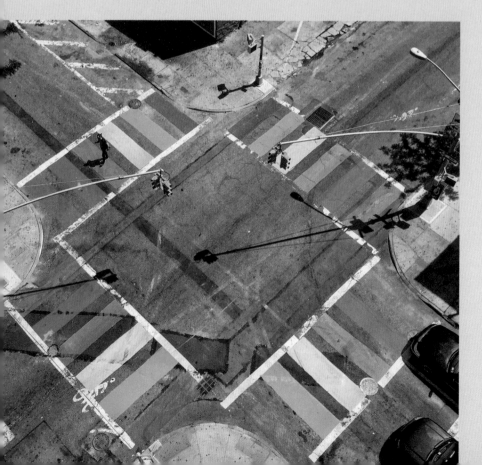

The lights, speed, and creativity in the cities most of us inhabit are the kinetic links to the culture of a place. If you travel to San Francisco, you will learn the keening sound a streetcar makes as it turns a tight corner, and thereafter you'll know what to expect when you hit the streets of Lisbon. Once you have been to Cuba, you will always recognize the smell of diesel engines, internalized from the rebuilt 1950s cars that blast Reggaeton through the narrow streets of Habana Vieja. If you have seen whole families pile onto mopeds in Bali, you will recognize this common form of transportation when you get to India. Once you learn to navigate one subway system, you are pretty much set to get around on any subway (if the letters are in an alphabet you understand, anyway).

The more you travel, the more forms of transportation you experience, and each experience we have in one city informs all of our future travels. From cab, to plane, to subway and streetcar, these modes are a point of entry to the world they carry you through. They are a beginning to not feeling alienated in a new place, a step on the road to becoming a local. To know a city is to know how to navigate it, and once you know how to navigate one, you can easily drop into the flow of others.

←
Calpe, Alicante, Spain
Perry Graham
@perrygraham

↖
Alite Outpost, San Francisco, California, United States
Kenzie Benesh
@kenziekirk

↑
Fragments, Paris, France
Alexa Miller Gallo
@alexaphoto

←
Brooklyn, New York, United States
Guerin Blask
@guerinblask

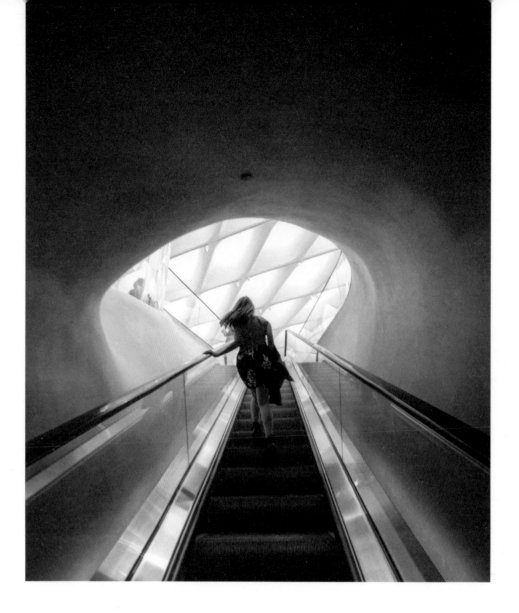

↑

The Broad, Los Angeles, California, United States

Corinne Rice
@_nomadicmom

→

Ken Ken Ramen, San Francisco, California, United States

Sara Diamond
@sara_diamond

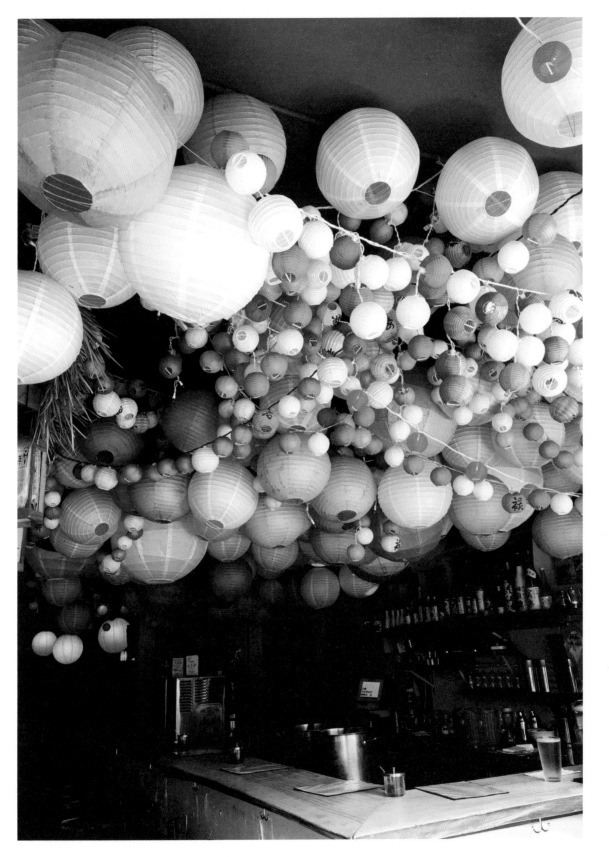

→

Huntington Beach, California, United States

Dirk Dallas
@dirka

↓

Philadelphia Museum of Art, Philadelphia, Pennsylvania, United States

Emily Nathan
@ernathan

⟶

Brihadeeswarar Temple, Thanjavur, Tamil-Nadu, India

Emily Nathan
@ernathan

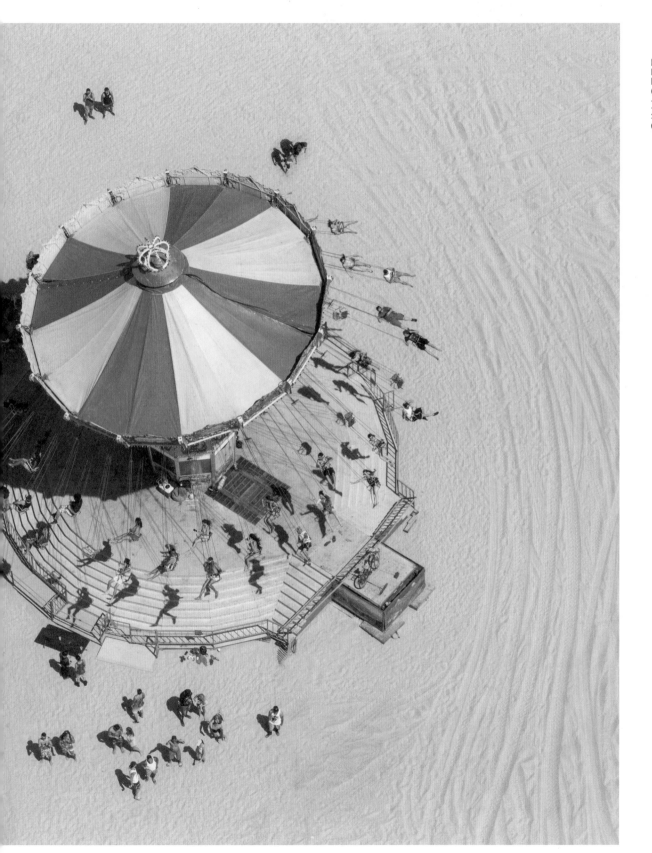

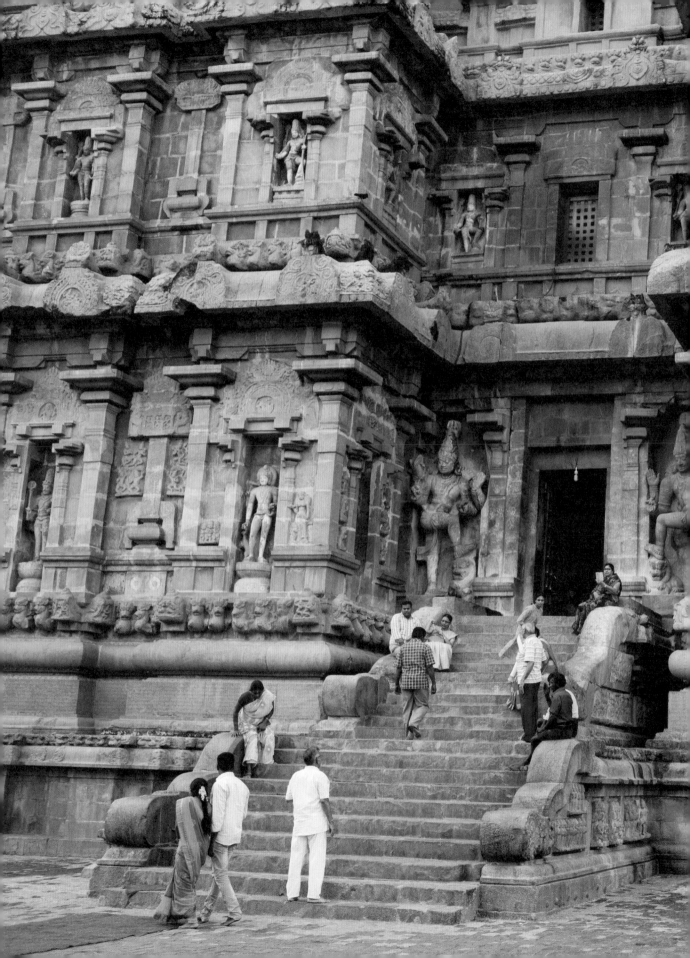

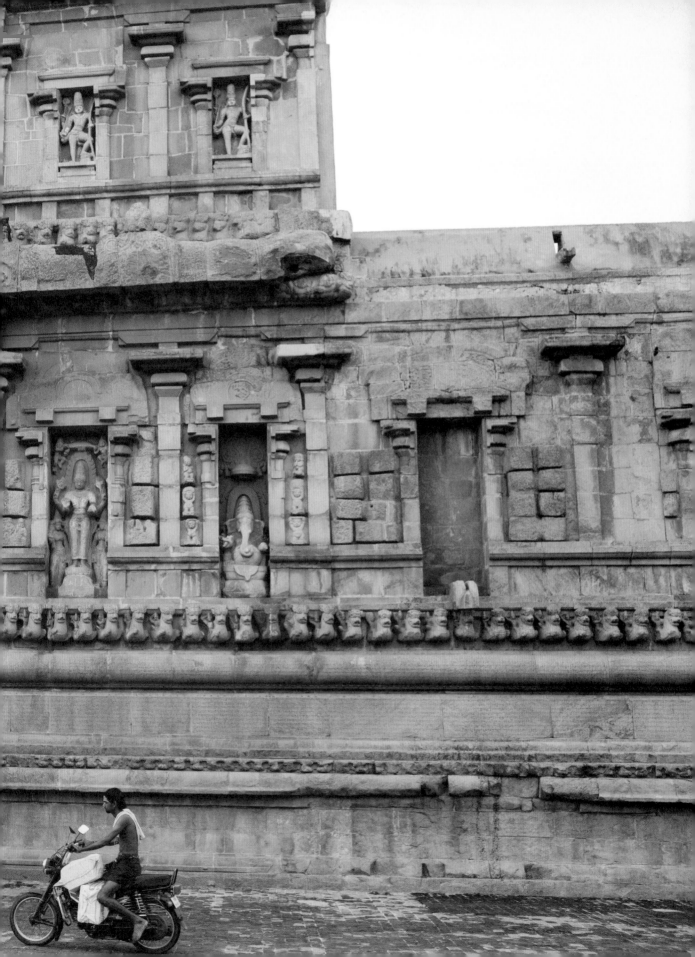

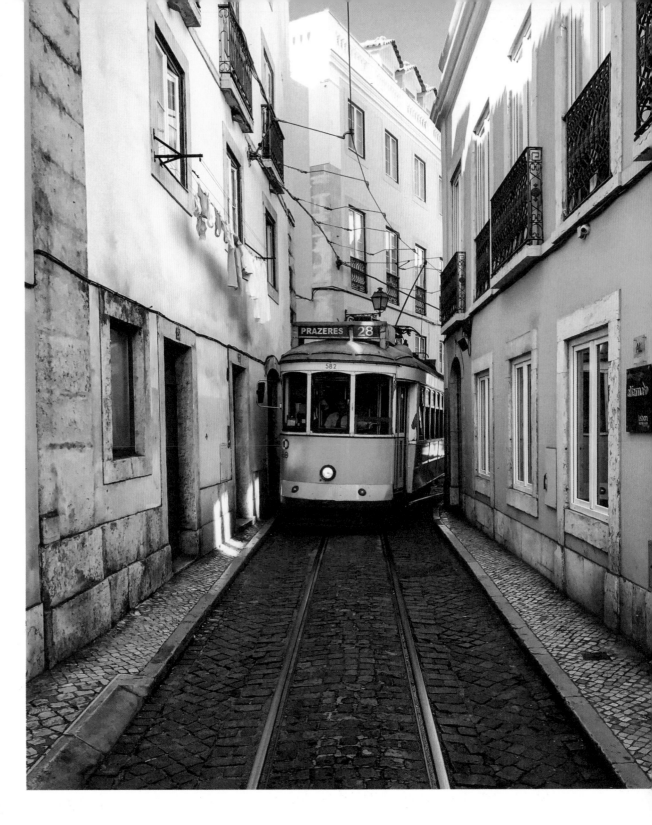

THE ELEVADOR DA Bica is one of three funiculars in Lisbon and has been in operation for over a century. This tram was deemed a national monument and allows visitors to enjoy sweeping views atop steep hills without the hike. For more views of the city, ride the Elevador de Santa Justa to the top to see Tagus, the longest river in the Iberian Peninsula, and the ruins of Carmo Convent. Other sites worth visiting include the National Pantheon, Cape Roca, and Praça do Comércio where the palace used to stand before being demolished in 1775 by an earthquake.

Lisbon, Portugal
Nico Oppel
@eskimo

→

Praça do Comércio, Lisbon, Portugal
Ana Linares
@ananewyork

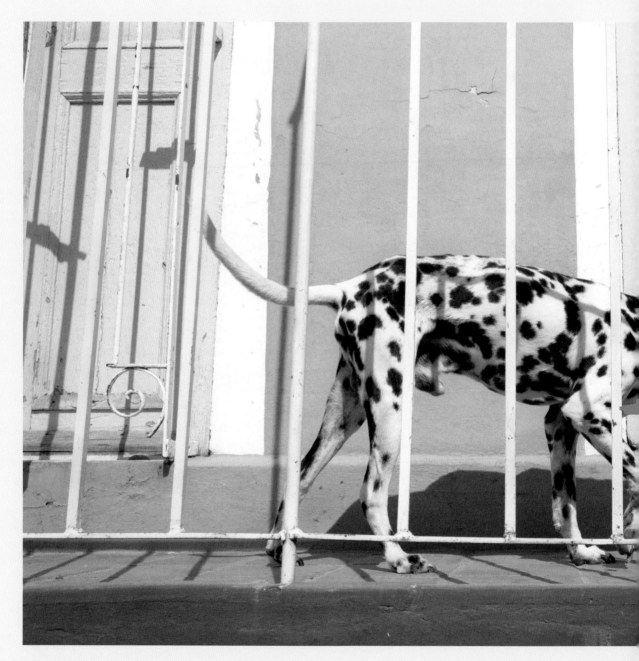

Trinidad, Cuba

MAGDALENA WOSINSKA

@magdawosinskastudio
@themagdalenaexperience

WHO IS MAGDALENA?

Photographer Magdalena (Magda) Wosinska takes on life with an invincible ferocity. She spent her early years in communist Poland, before her family moved to rural Arizona in 1991— an immensely different place, where she didn't speak the language and didn't understand the culture. Rather than retreating, Magdalena dug in and found community at the skate park, where she would skate for hours on end. She learned photography and started shooting skate and punk culture at home, with later shoots bringing her as far as Barcelona and Paris.

Magda's energy is unstoppable. She works out of Los Angeles, California, often on a number of projects at once. Magda's photography work has expanded into moving pictures, and she now directs commercial content and is starting to make short films. Never satisfied to be busy just as a photographer and director, she has recently finished rebuilding a home in Pioneer Camp, California. Her home there, which she calls Desert Milk Adobe, is a space to create and learn, where she hosts workshops on topics ranging from cooking and meditation to photography.

MAGDALENA'S MOTION

Magda's images convey a sense of fearlessness and a love of life in motion. From photographing skate culture around the world in the 1990s, to capturing hand-rebuilt vintage motorcycles zipping through the mountains outside Los Angeles, to her nude self-portraits taken in landscapes throughout her travels, Magdalena conveys a sense of perpetual motion and boldness in all that she does.

Magdalena herself is almost always on the move, traveling around the world constantly for assignments (two of her favorite locations to shoot are Ireland and Mexico). She has always been drawn to rawness and authenticity, rather than beauty and youth, which so often seem to be photographers' focus. Her aim as an artist is to show the realness and vastness of the human experience.

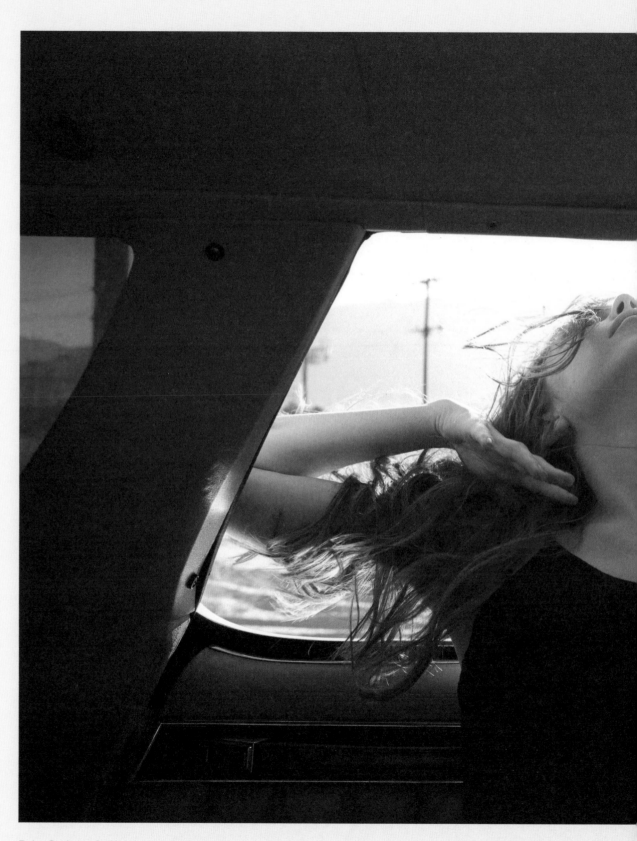

Palm Springs, California, United States

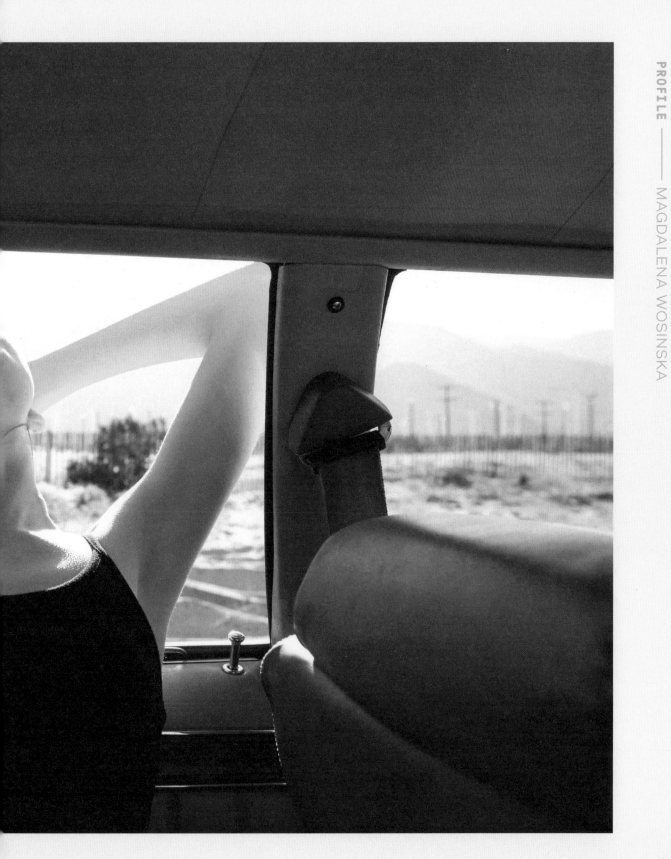

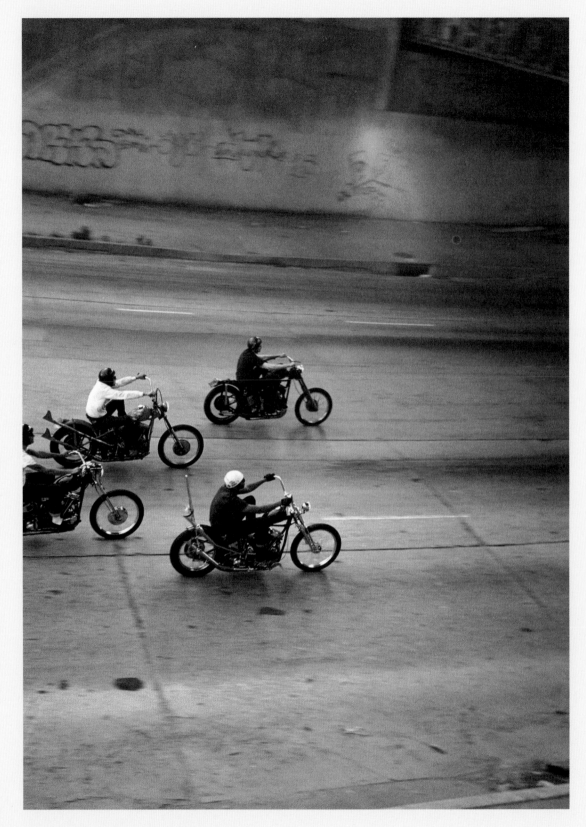

Los Angeles, California, United States

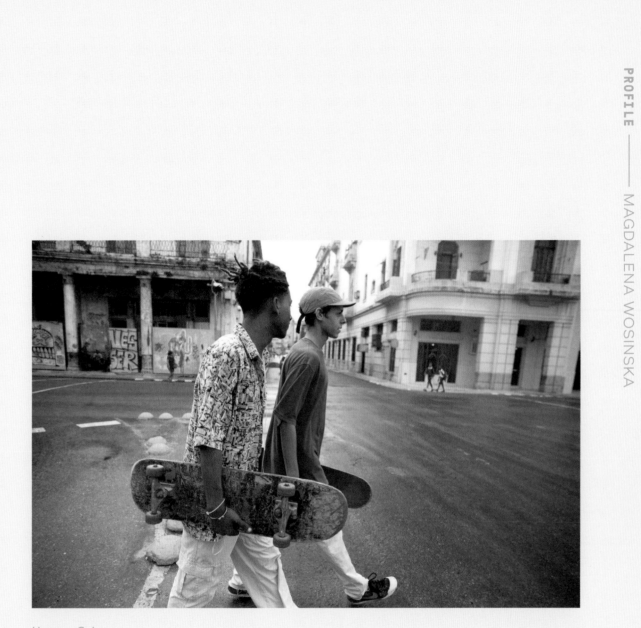

Havana, Cuba

↓

Okayama, Japan

Marioly Vazquez
@cestmaria

→

**Wan Chai District,
Hong Kong**

Kevin Mao
@k_mao

⟶

Cappadocia, Turkey

Sam Horine
@samhorine

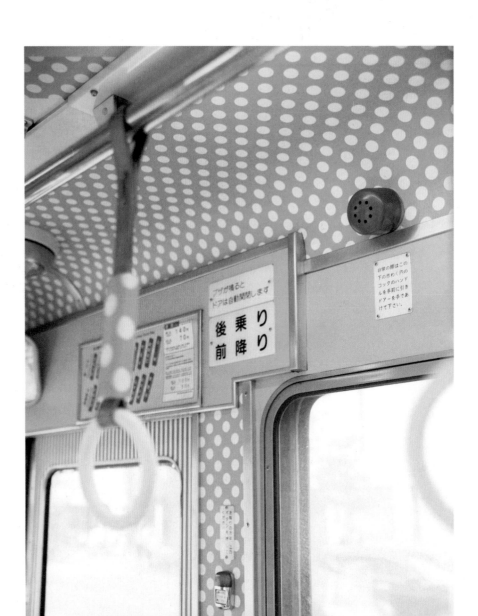

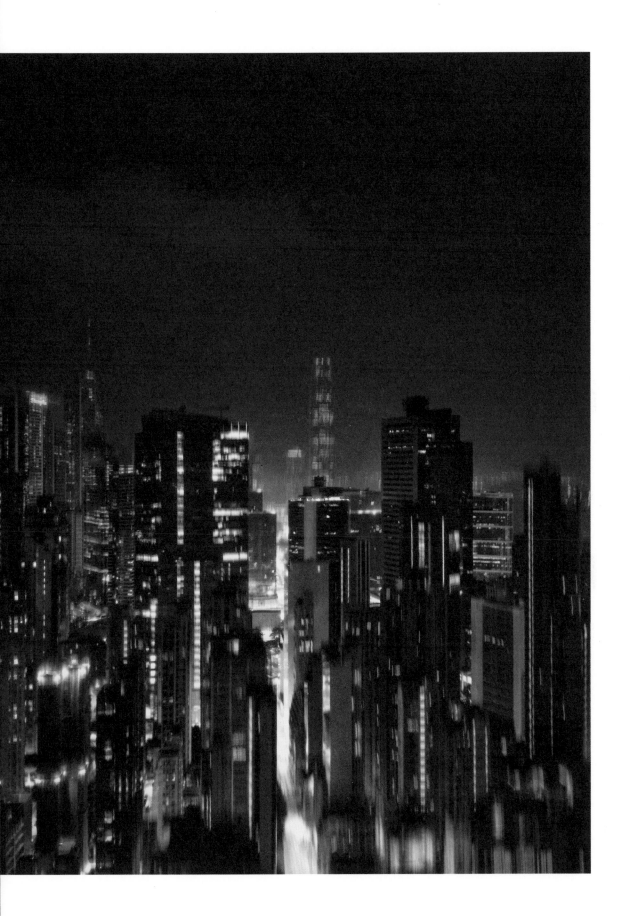

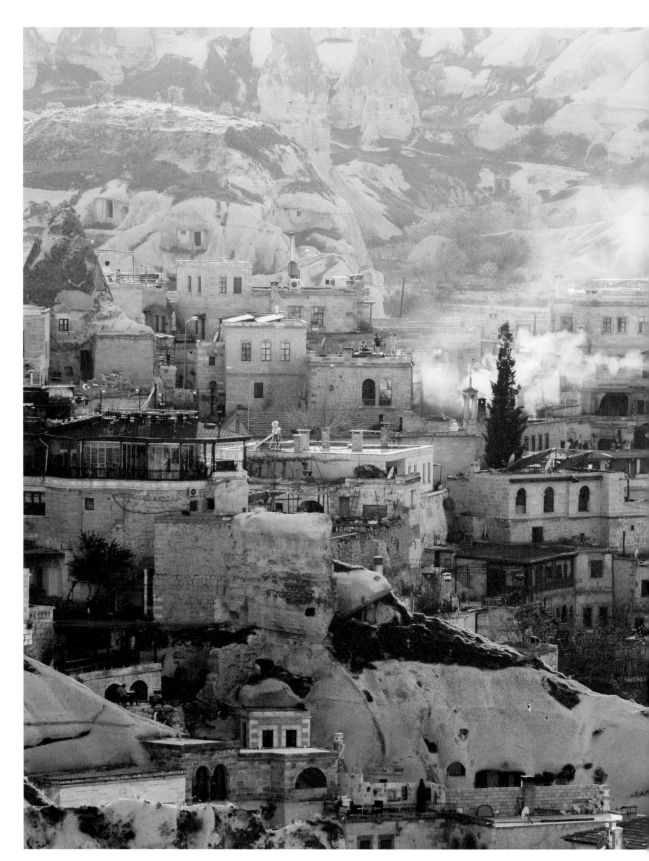

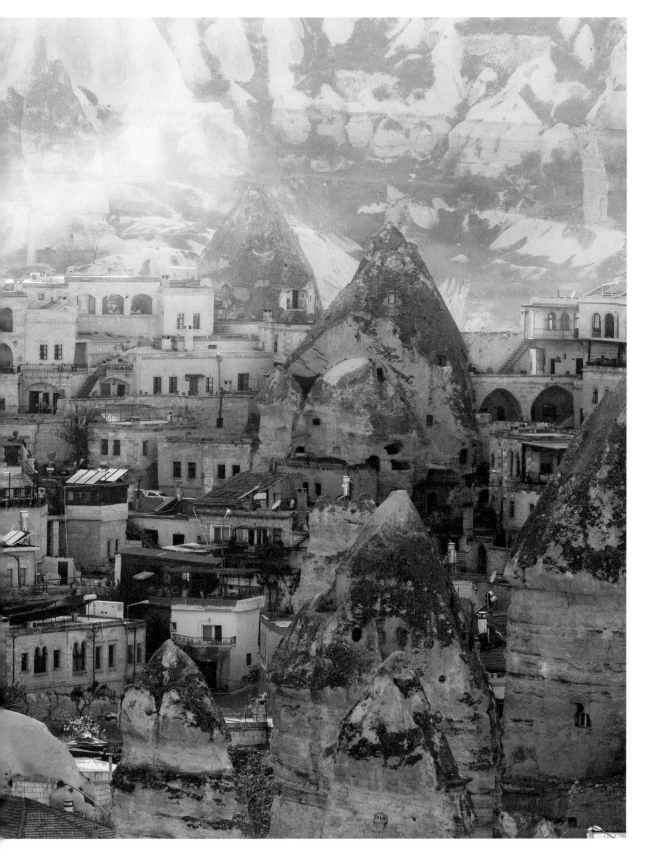

↓

Qinghefang
Street, Hangzhou,
Zhejiang, China

Dee Larsen
@dee_larsen

→

Metropolitan Ervin
Szabó Library,
Budapest, Hungary

Elke Frotscher
@elice_f

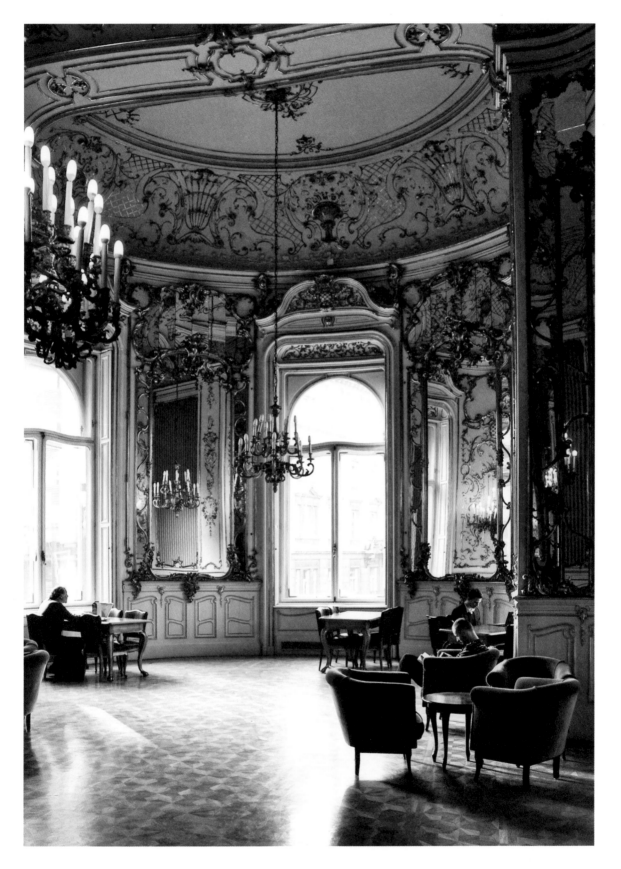

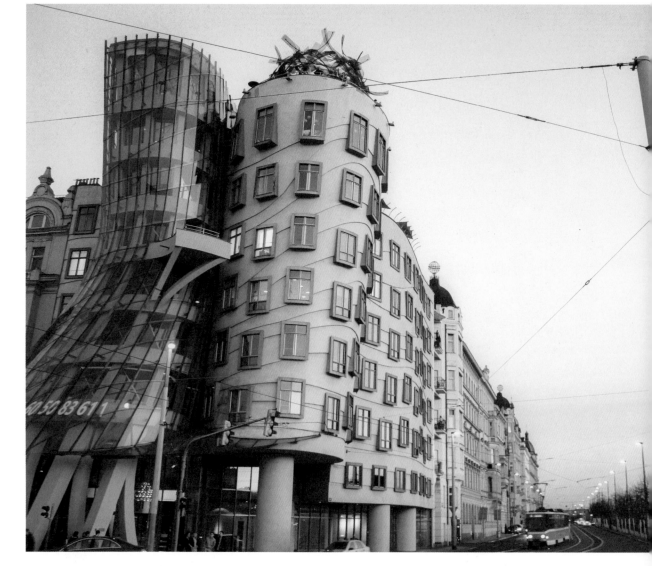

Prague, Czech Republic

Tara Hadipour
@tarahadipour

John Hancock Center,
Chicago, Illinois,
United States

Elliot Vernon
@elbow_macaroni

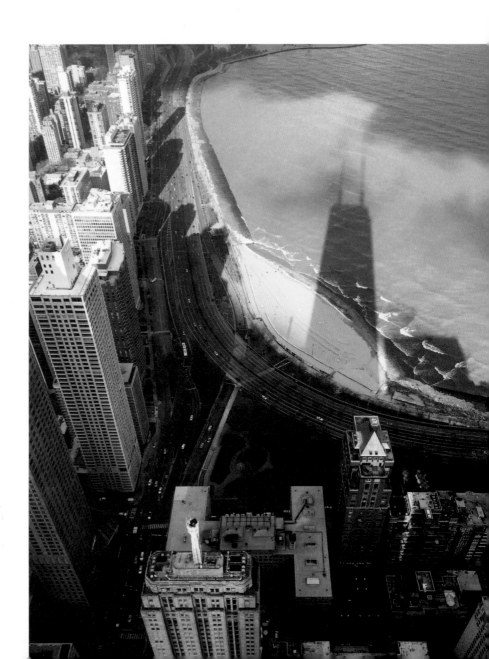

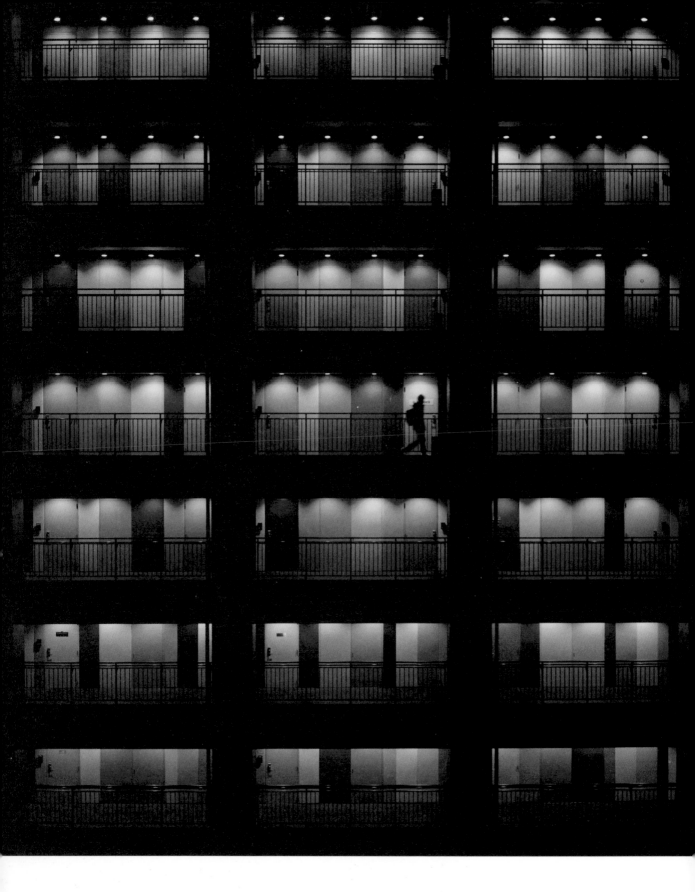

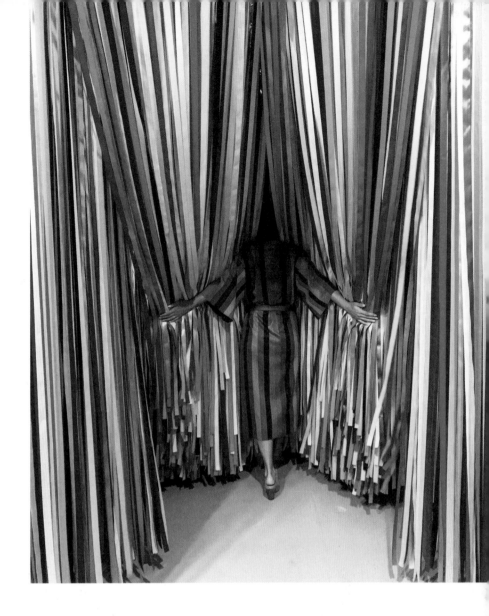

← THE SOHO OFFICE complex is located in Koto and serves as a coworking space with amenities you would find at a hotel including a gym, library, and spa.

Tokyo, Japan
Tyson Wheatley
@twheat

↑ THE COLOR FACTORY is a traveling pop-up museum that celebrates all things color via immersive installations. This display of ten thousand hand-tied ribbons in San Francisco was created by Swedish artist Jacob Dahlgren.

Color Factory, San Francisco, California, United States
Erin Fong
@erinlovesfun

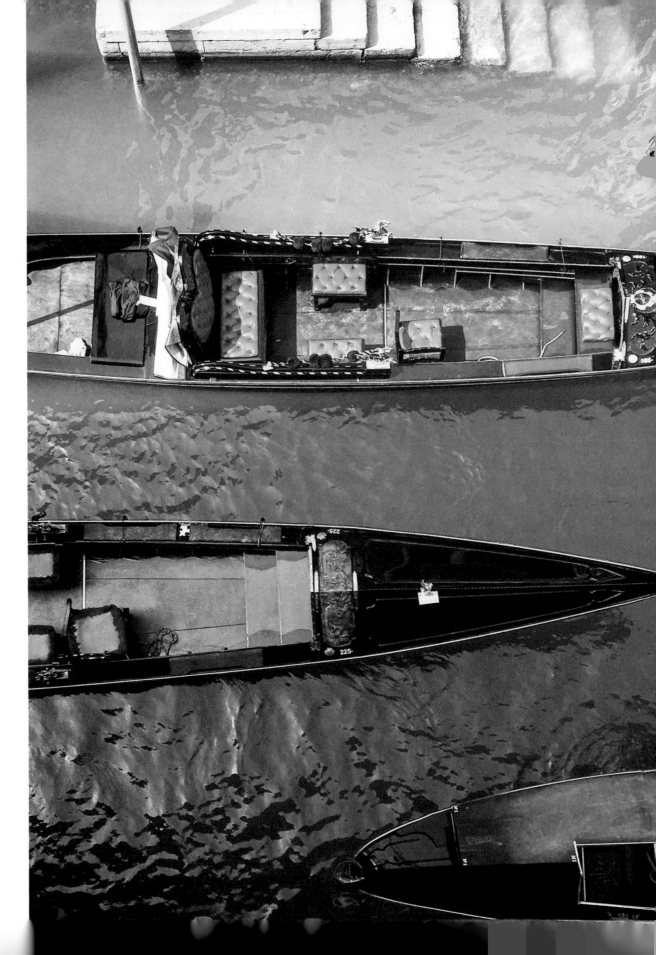

← **Venice, Italy**
Joe Pickard
@josephowen

↑ **Rue Vivienne,
Paris, France**
Ayako Bielsa
@_aya.lulu_

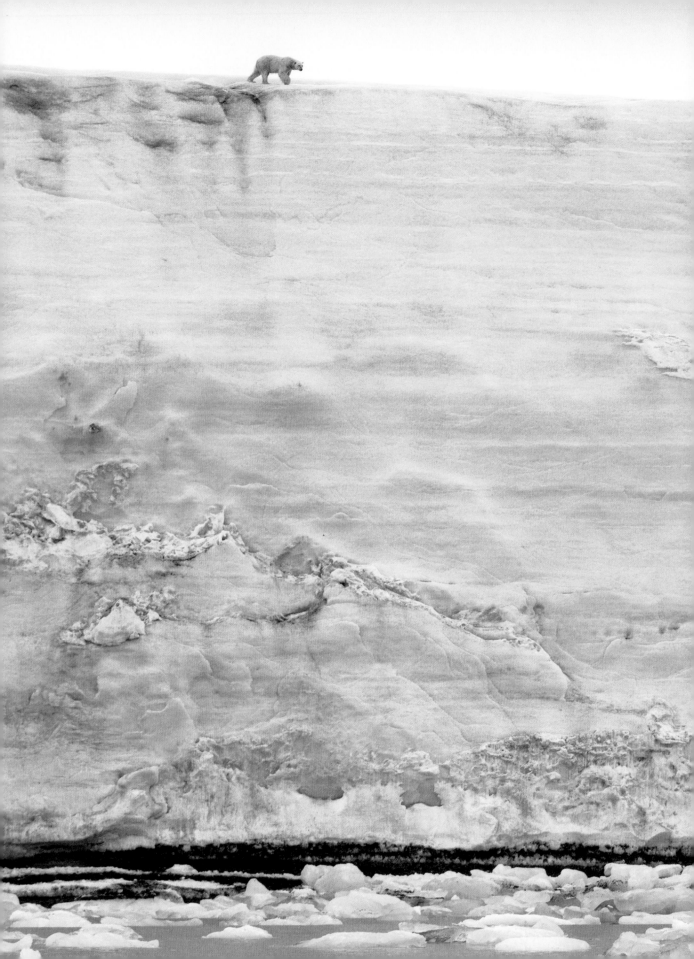

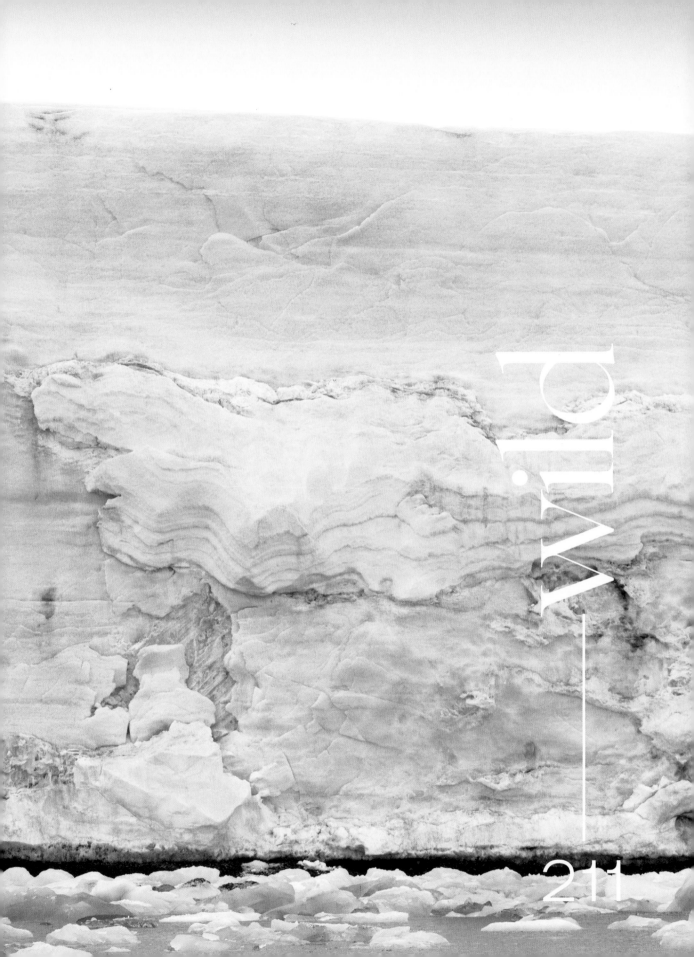

wild

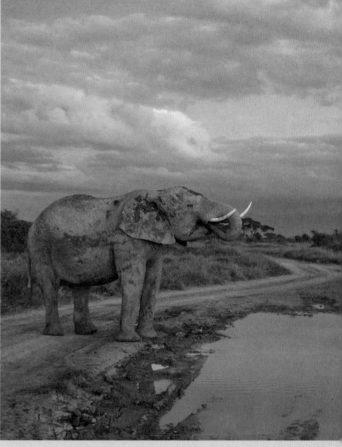
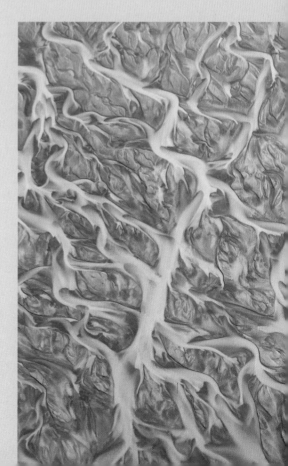

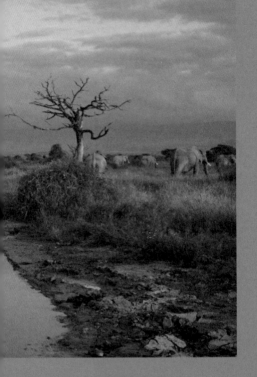

Being in the wild unleashes a sense of freedom. As travelers and photographers, an empathic link is forged when we spend time in the wilderness. Returning home, the treasures we bring back are the moments we captured when we experienced the beauty found in all wild creatures, when we might have been fortunate enough to sit, silently, watching a tusked elephant on the savannah in Kenya as she stops to drink from a pond. We treasure moments like these even more because we understand the tenuous status of this massive gentle creature and her habitat. The pictures we take when we are in the presence of the wild give voice to those who cannot speak for themselves, namely the plants, animals, and environments found there.

When we see pictures of a flock of sparrows crossing marshlands at sunset, or a bear looking over her shoulder at the expanse of her homeland, we light up, not just as viewers but also as stewards and champions of our planet. The relationship that is developed when we have the opportunity to be in the wild drives us to share these moments and precarious habitats with others through imagery.

←

Svalbard, Norway
Kim Goodwin
@kim.goodwin

↖

Maryland, United States
Cyndi Monaghan
@elf_girl

↑

Amboseli National Park, Kajiado County, Kenya
Alice Gao
@alice_gao

←

Chilkat River, Haines, Alaska, United States
Jordan Dyck
@joordanrenee

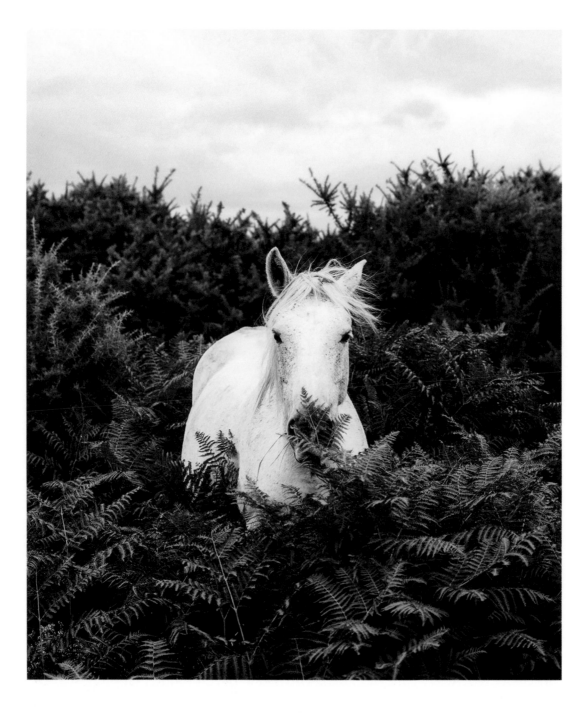

↑

New Forest, Hampshire, England

Matthew Leonard
@matthewleonard29

→

Chinook salmon in Tofino, British Columbia, Canada

Jeremy Koreski
@jeremykoreski

TUCKED INTO THE backwoods of northeastern
Idaho's high desert is a chain of six waterfall-fed
hot springs. Situated between the small towns
of Salmon and Challis, Goldbug Hot Springs is
a rugged respite. To experience the epic soak
requires hiking one and a half sun-drenched
switchback miles through desert landscapes and
an additional half mile of steep terrain up to the
pools. These springs pride themselves on having
responsible visitors who respect the surrounding
sagebrush-dusted landscape and wildlife (including
snakes during the warmer months). Visitors are
always expected to leave no trace of their time
in the majestic beauty.

**Goldbug Hot Springs,
Salmon-Challis National
Forest, Idaho,
United States**

Sarah Murphy
@sarahirenemurphy

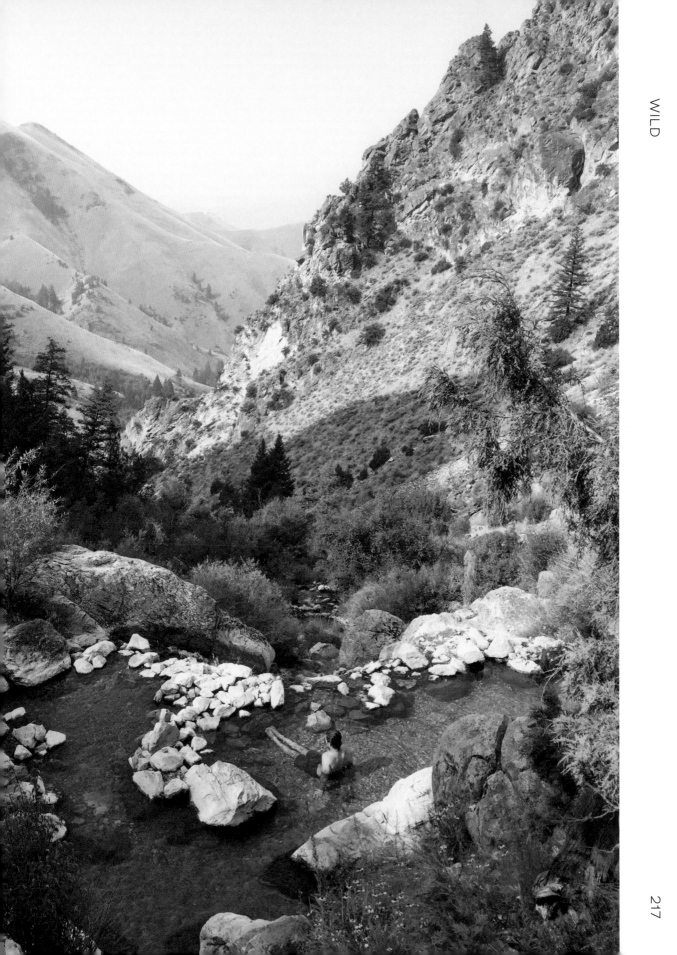

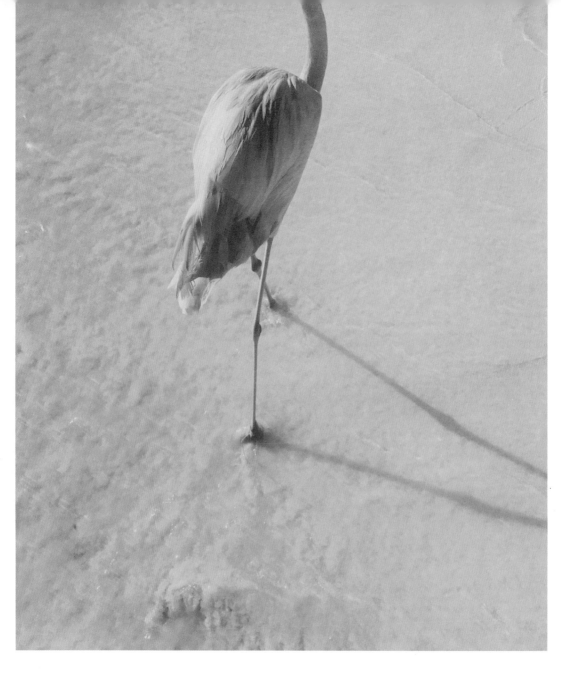

↑

RENAISSANCE ISLAND'S 40 acres of tropical
landscape houses Aruba's famous flamingos.
Day passes are available to those not staying
on the property who want to experience classic
Aruba: palm trees, clear blue waters, white sandy
beaches, plus these bright pink flamingos.

**Renaissance Private
Island, Aruba**

Arielle Vey
@ariellevey

→

**Antelope Canyon,
Arizona, United States**

Giulia Dini
@giuliadini

⟶

**Kaikoura, South Island,
New Zealand**

Allison McCarthy
@aquinnm

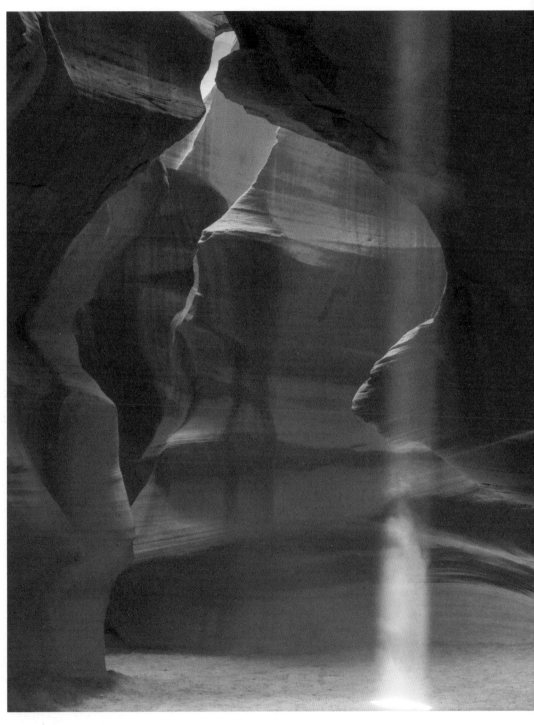

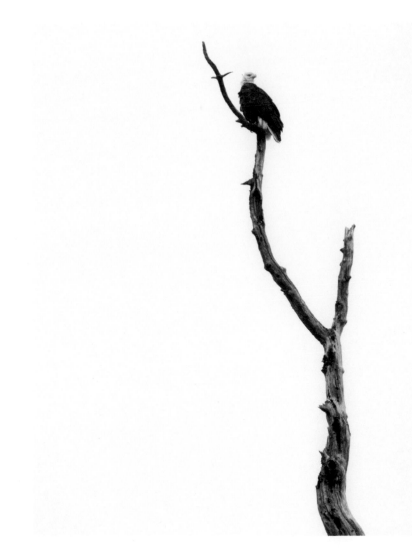

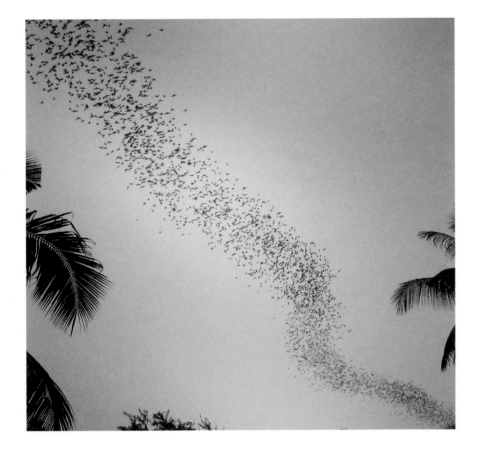

↑

A SWARM OF bats make their daily exodus from
limestone caves in Phnom Sampeau Mountain,
7 miles southwest from Battambang, Cambodia's
second-most populous city. It can take an hour
for one to three million bats to escape. Macaque
monkeys amuse visitors who come to see
pyramids of skulls in the caves, as well as shrines
and temples at the entrance. A monastery with
two golden stupas is a steep one-hour climb
up stairs, or a fast scooter ride, at the top of
the mountain.

←

**Cordova, Alaska,
United States**

Nels Evangelista
@nellee_

**Phnom Sampeau Mountain,
Battambang, Cambodia**

Dawn Powell
@dawnboas

8 Hands Farm, Cutchogue,
New York, United States

Gabriela Herman
@gab

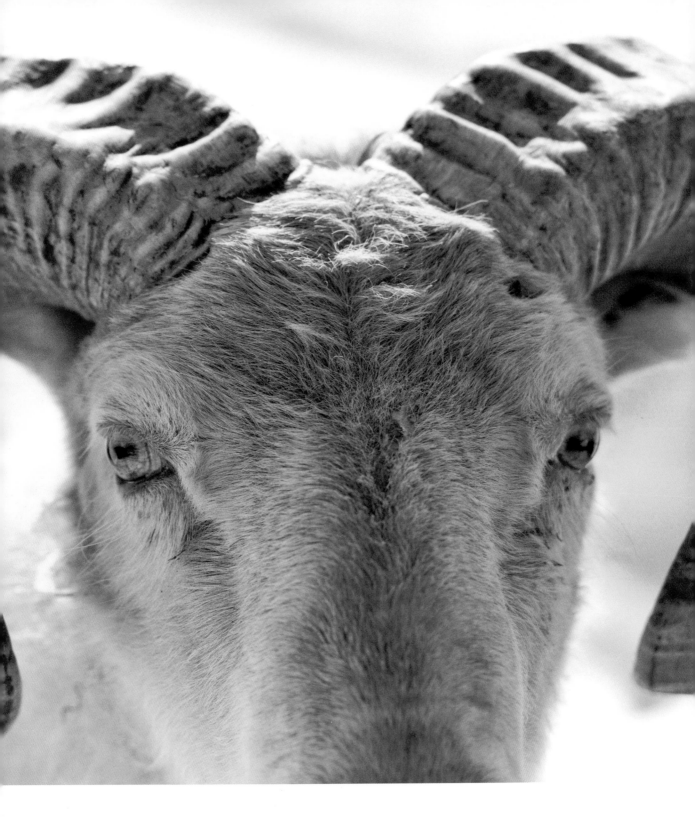

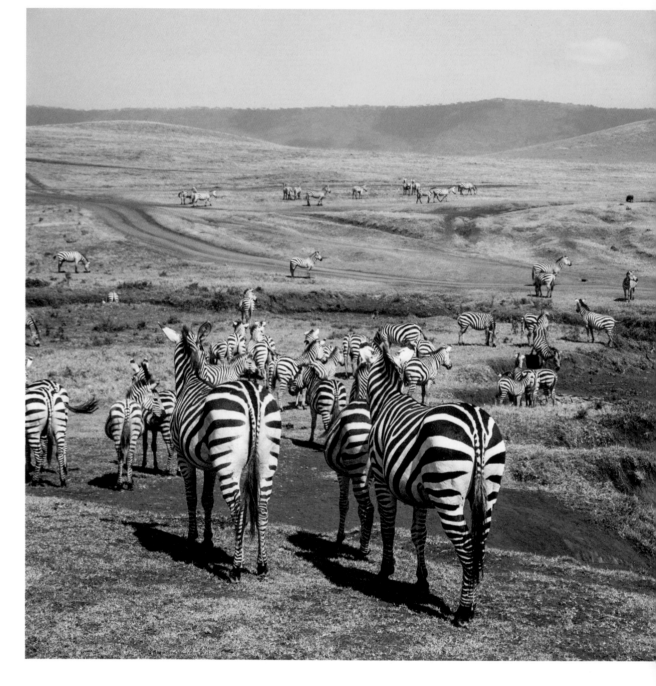

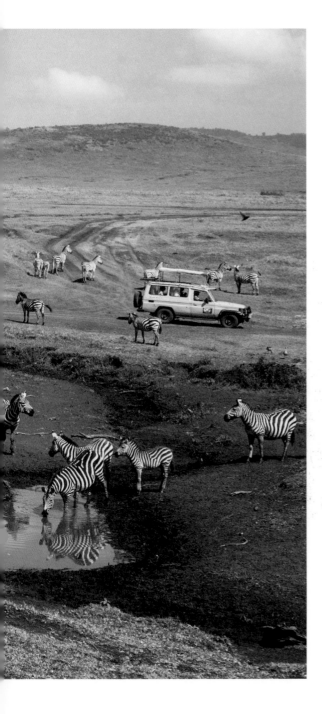

Ngorongoro
Conservation Area,
Arusha Region,
Tanzania

Jade Spadina Mackenzie
@jadespadina

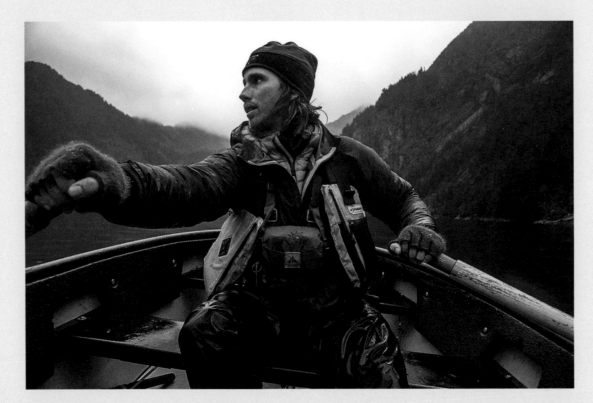

Charles in Humpy Cove, Seward, Alaska, United States
Rachel Pohl
@rachel.pohl

CHARLES POST

@charles_post

WHO IS CHARLES?

Ecologist and filmmaker Charles Post has always been drawn to the wild things in life. He grew up in California's beautiful Marin County, just north of San Francisco, in a land of towering redwoods, coho salmon runs, and migrating hawks soaring above the hills.

Charles spent his youngest years fishing with his family and spending much of his time outdoors, which coaxed him down the path to a master's degree in ecology from UC Berkeley. His dedication to conservation, animals, and the outdoors has led him to share the stories unfolding around us that we might not be aware of—like the seasonal migrations of raptors in the skies above our heads, land conservation projects in Colorado, and the management of wild horses on public lands—through photography, writing, and film.

CHARLES'S WILDERNESS

For Charles, the rugged beauty of Montana has a special draw—living there means that his backyard is one of the least densely populated areas of the United States, and one that is dotted with roaming wolves, grizzlies, elk, muledeer, bighorn sheep, and eagles. Montana's landscape is abundant with life, untrammeled wilderness, and expansive space. The slow cadence of life here allows Charles to dive into the natural spaces that he cares so deeply about. He also moved to Montana for love—not just the love of space and wildlife, but for his wife, artist and environmentalist Rachel Pohl, who calls Montana home.

While he still finds a sense of home in the Californian landscape that he grew up in—ever fascinated by the tule elk, elephant seals, and other coastal wildlife native to California—Charles feels at peace anywhere with a sense of wildness. Wild places pulse with life, and in these landscapes he can slide into his comfort zone and observe and document an ecosystem in all of its complexity.

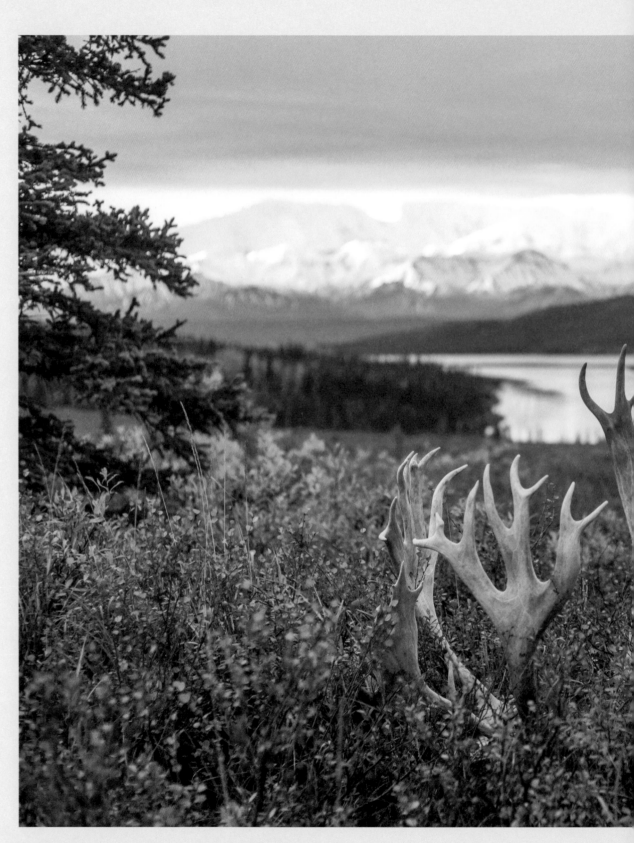

Denali National Park and Preserve, Alaska, United States

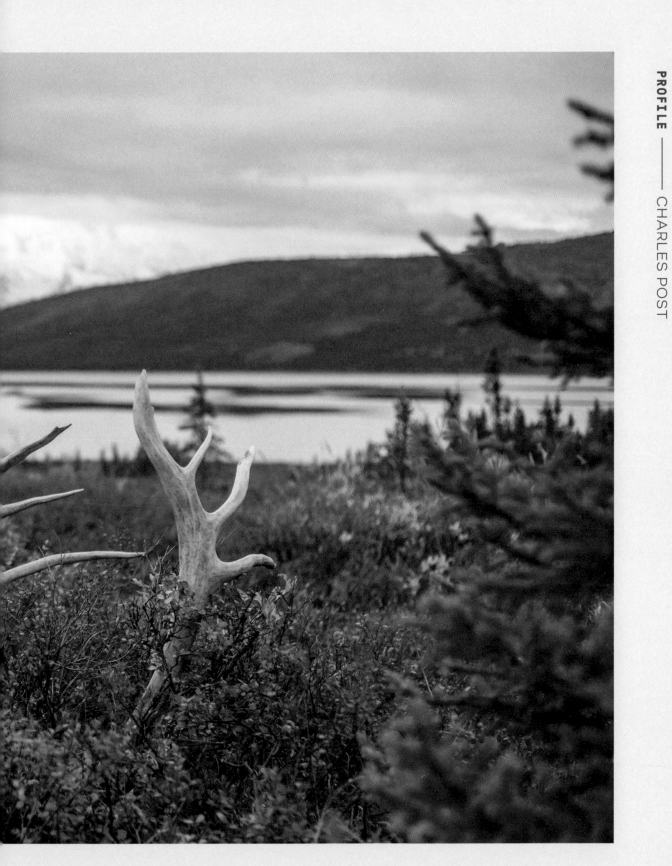

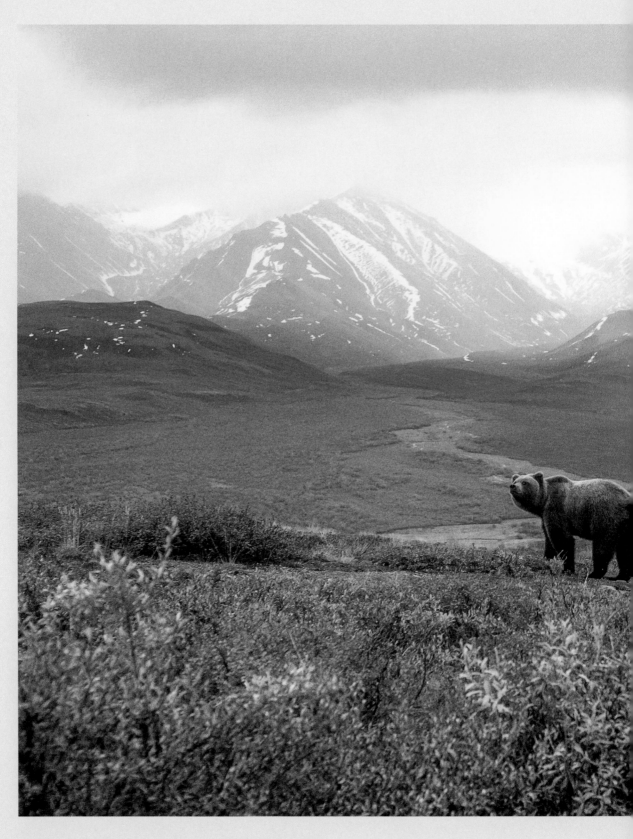

Denali National Park and Preserve, Alaska, United States

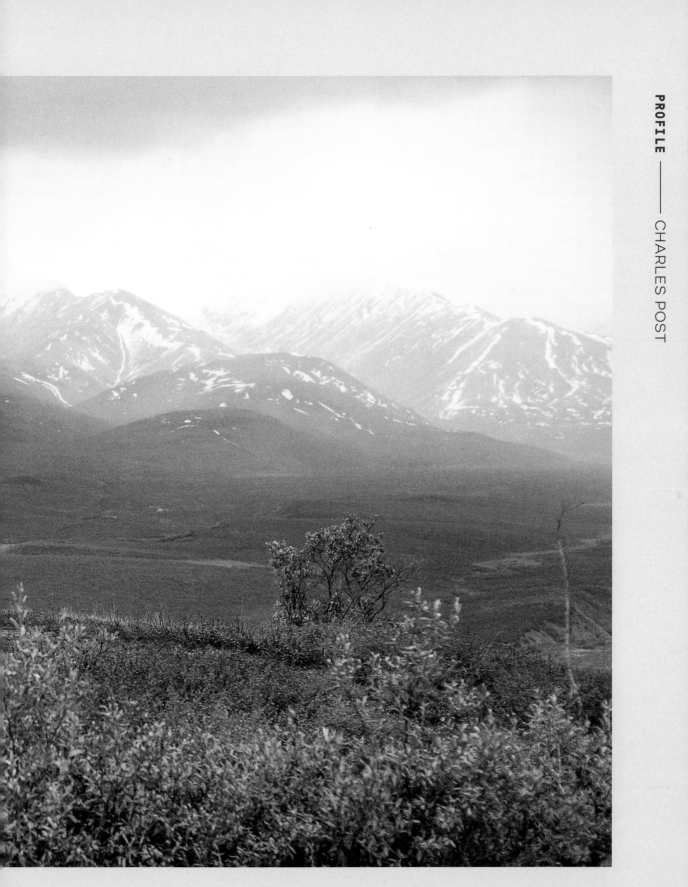

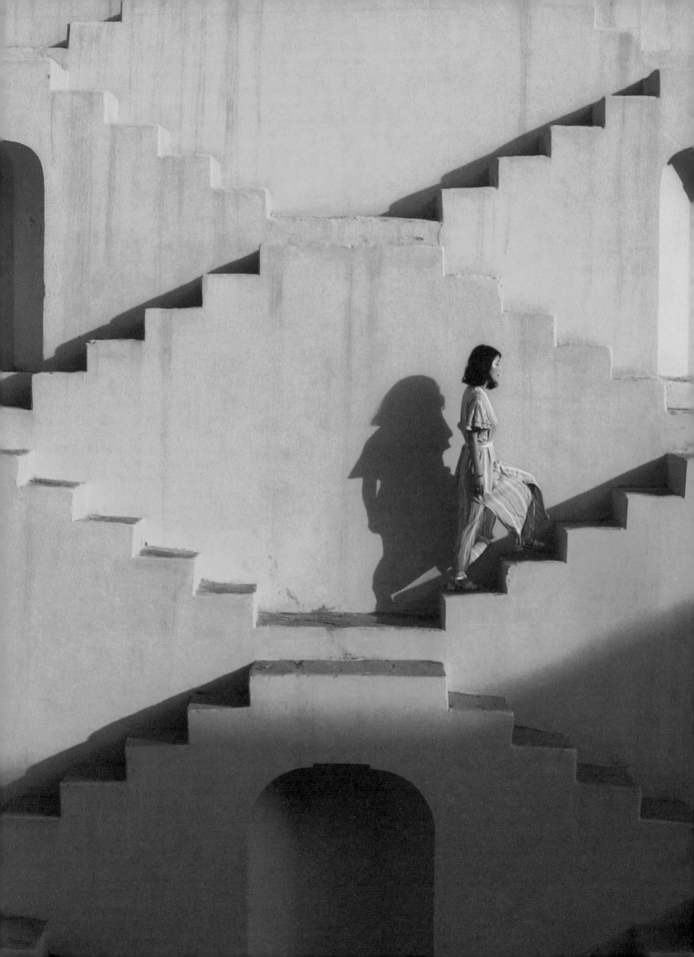

—structured

235

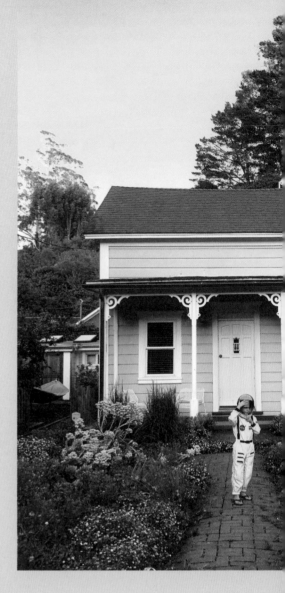

←

**Panna Meena ka
Kund Stepwell, Amer,
Rajasthan, India**

Tyson Wheatley
@twheat

↖

**Uummannaq, Avannaata,
Greenland**

Jessie Brinkman Evans
@jebrinks

↑

**Marin County, California,
United States**

Emily Nathan
@ernathan

←

**Grand Fiesta Americana
Coral Beach, Cancun, Mexico**

Andrea Quiroz
@neaqmol

The human eye finds patterns—it's out of our conscious control. We can't help but notice a series of identical archways or a row of candy-colored homes, even if we fly by on a hoverboard. But should we stop and combine our natural detection, which we've isolated and lined up, with that mechanized version of our eye we call a camera, the three-dimensional world is pulled into two: the rectangular or square frame we know as a photograph.

So it comes as no surprise that travel photography loves a nicely aligned world. On our adventures in unknown places, an easy way to codify the manufactured world around us is with perfectly lined-up compositions. Be they buildings small or huge, stone-carved walls in Machu Picchu, or modernist architectural masterpieces in Rome, we line them up. Doorways and windows and portals, once set straight through a viewfinder or lens, click into a tidy spot in our brains. Once these buildings are positioned in our minds, our imaginations are free to wander. What was it like to live behind those doors? What does it feel like to walk for morning coffee along that wall?

In this image of mine from Marin County, California, my young son, astronaut costume and all, sits neatly where perspective trains your eye to look. The roofline is nice and straight across the frame. After you notice these details, you might find yourself free to ask, Who lived here before? What was it like? What brought the family here? Who built this house? What did they have for breakfast each morning?

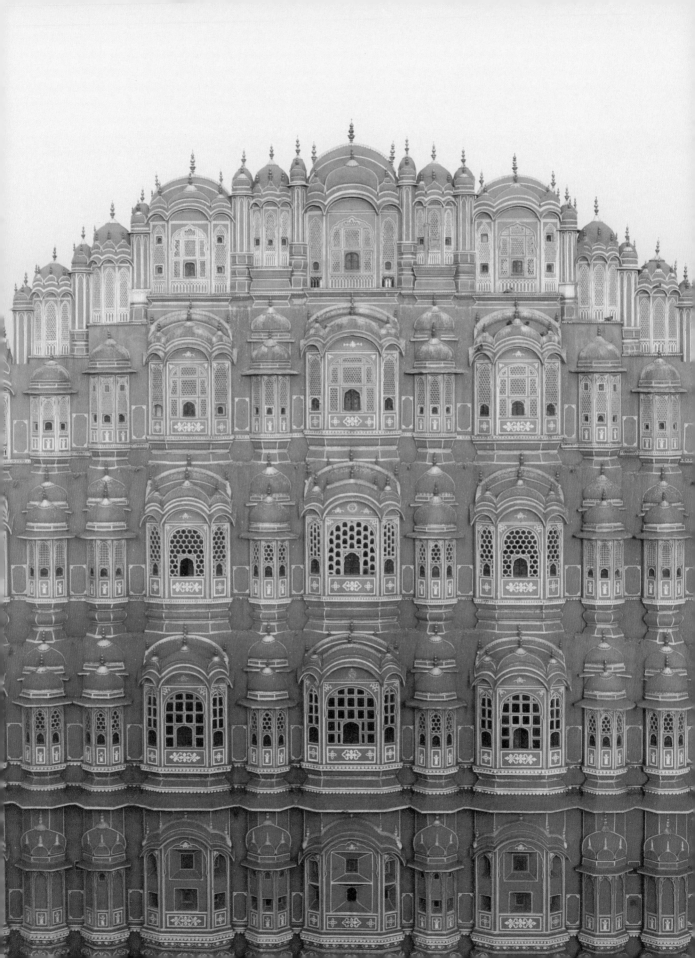

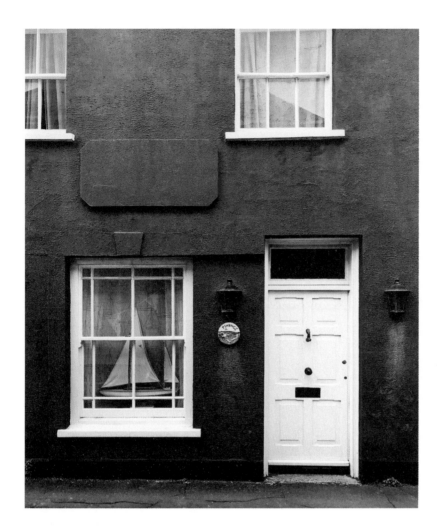

←

BUILT IN 1799, Hawa Mahal is an extension of
the Royal City Palace of Jaipur so that the royal
ladies could watch the activities and festivals on
the streets from one of the 953 windows without
being seen by the public. The palace is made of
red and pink sandstone, is the tallest building in
the world without a foundation, and is able to stay
standing due to its curved shape. To get this shot
of the exterior of Hawa Mahal, cross the street
and climb to the third floor for a roof deck and the
Wind View Cafe.

**Hawa Mahal, Jaipur,
Rajasthan, India**

Tyson Wheatley
@twheat

↑

**Yarmouth, Isle of
Wight, England**

Michael Sullivan
@mistersullivan

⟶

**Palazzo Della Civiltà
Italiana, Rome, Italy**

Nicolee Drake
@cucinadigitale

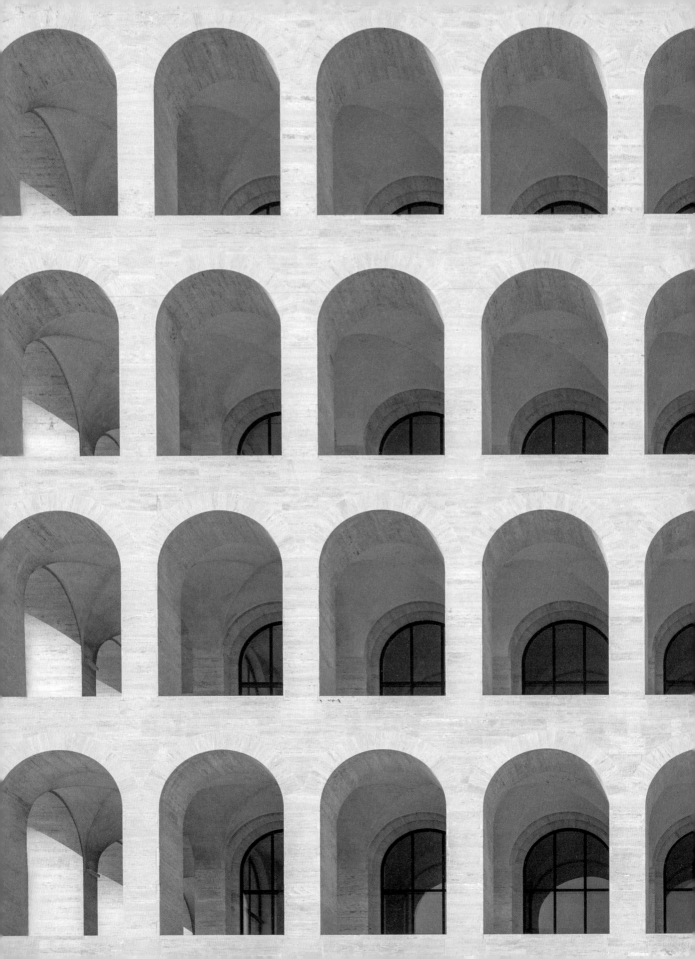

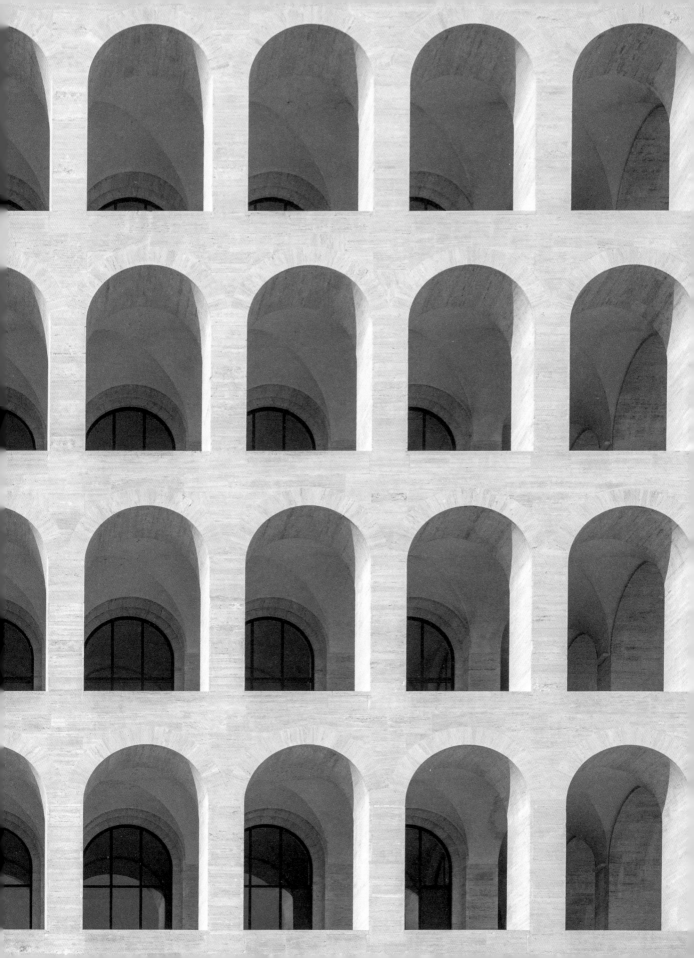

↓

El Cosmico, Marfa, Texas, United States

Jules Davies
@julesville_

→

Choi Hung Estate, Wong Tai Sin District, Kowloon, Hong Kong

David Leøng
@d.leong

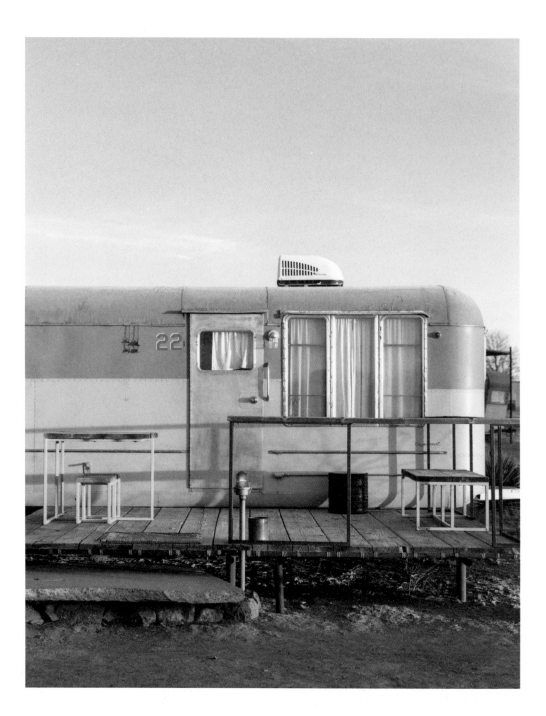

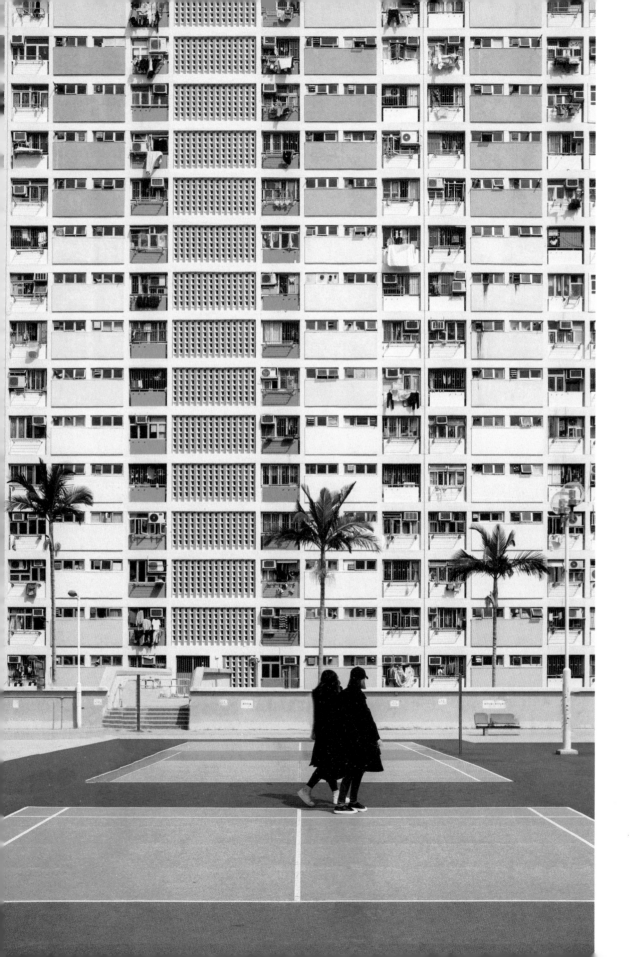

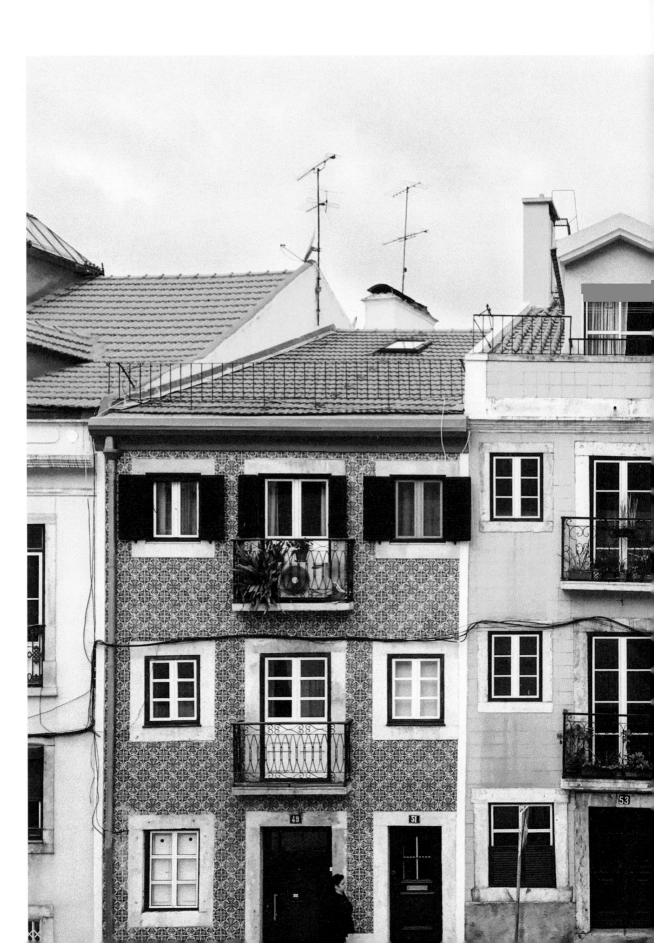

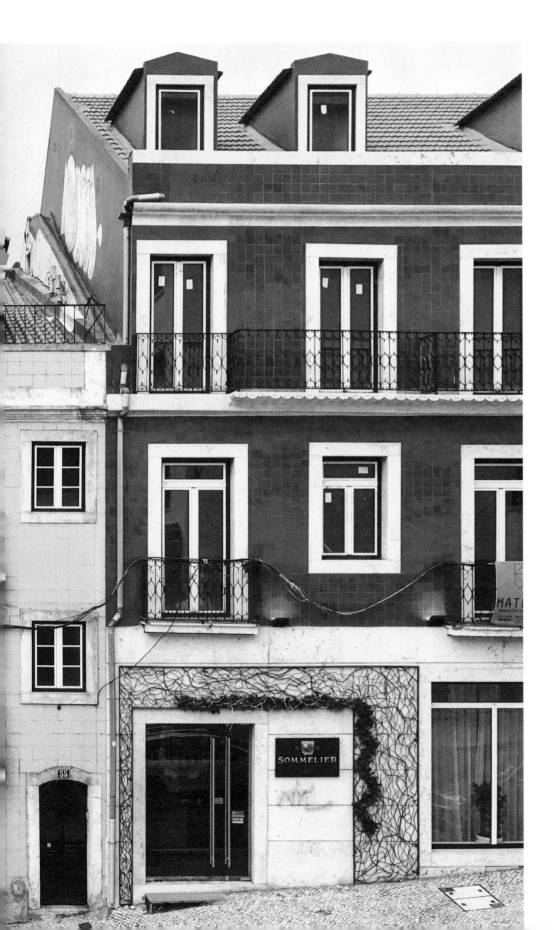

Lisbon, Portugal

Grant Legan
@grantlegan

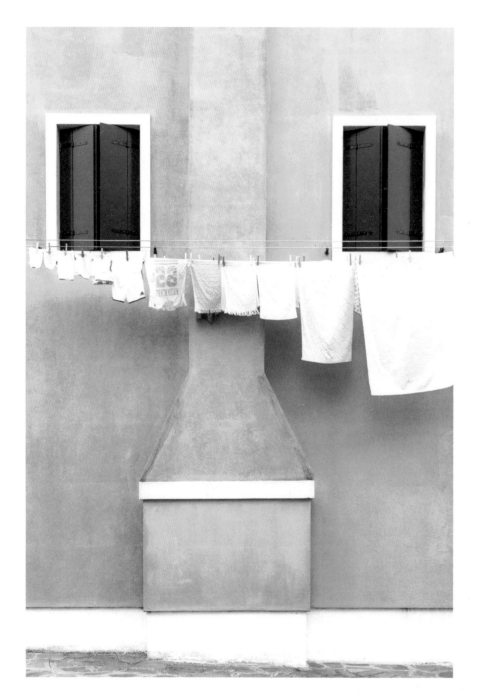

↑

Burano, Italy

Shannon
Hammond
@photobyshannon

→

**Machu Picchu,
Peru**

Brian Flaherty
@brianflaherty

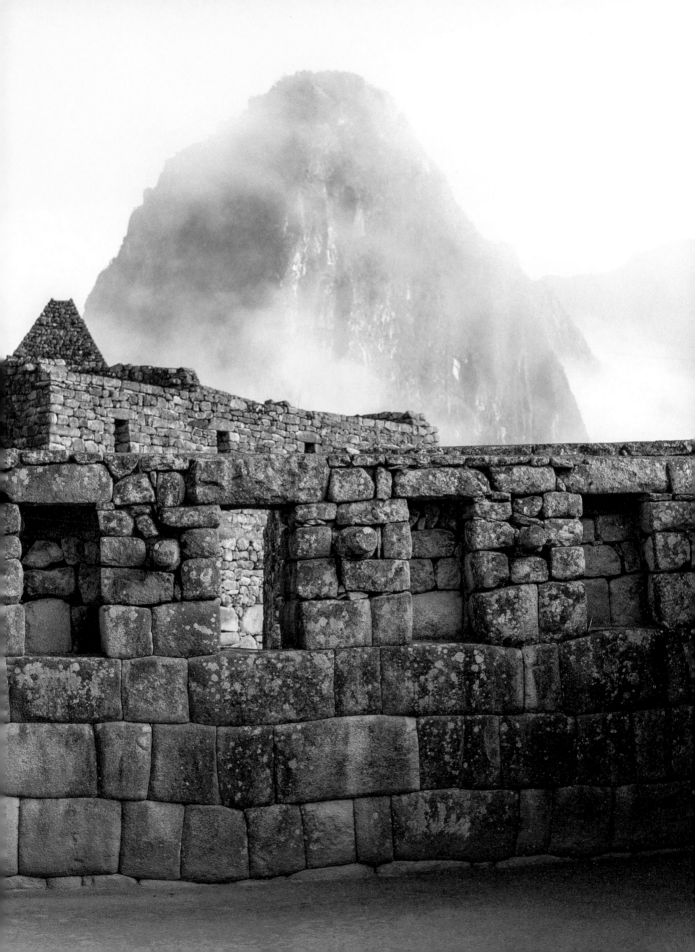

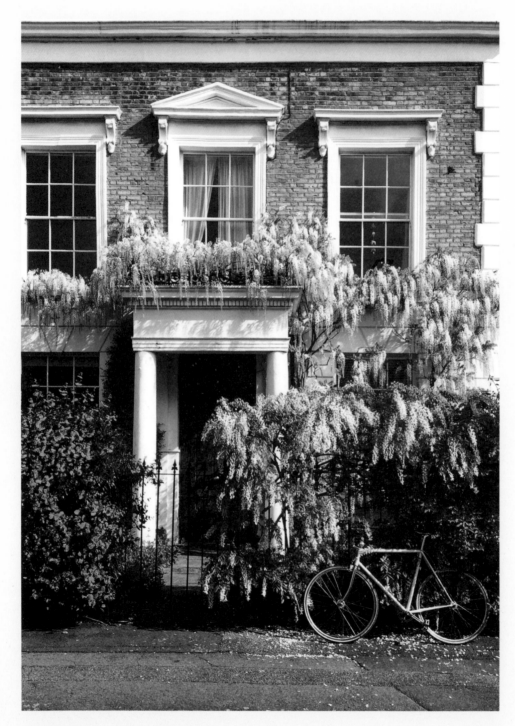

London Fields, London, England

PROFILE

ELKE FROTSCHER

@elice_f

London, England

WHO IS ELKE?

Elke Frotscher's accent is hard to place. She was born in Tanzania to German-speaking parents. But people in London, where she's lived for the past decade, mistake her for American. She speaks five languages and has been traveling for most of her life.

She still has the Pentax camera her father gave her when she was eight, which she used to shoot slides as they wandered through far-flung countries together. In architecture school, taking photos became a tool for her to study dimension and proportion.

Her eyes have been trained to find repetition and form wherever she looks—big walkable cities present a visual feast. But she also seeks wild places, like remote beaches, specifically those with a good number of waves, in which she identifies patterns lined up against the horizon.

ELKE'S LONDON

For Elke, the fragility of West London's pastel-colored structures can't compare to the bold façades, old bricks, and bright weathered paint of East London.

Her architecture studio is here, around the corner from the Spitalfields district—the neighborhood lined with eighteenth-century Huguenot homes that she returns to time and again to photograph. She shoots the buildings straight on, displaying countless right angles. Foliage heavy in texture and color lends the subtle tension she craves in her images.

Elke's photos of East London's largely unchanged architecture make the era hard to discern, which she cherishes—enough to wait days or weeks for a vintage car to pull up and complete the effect.

Marylebone, London, England

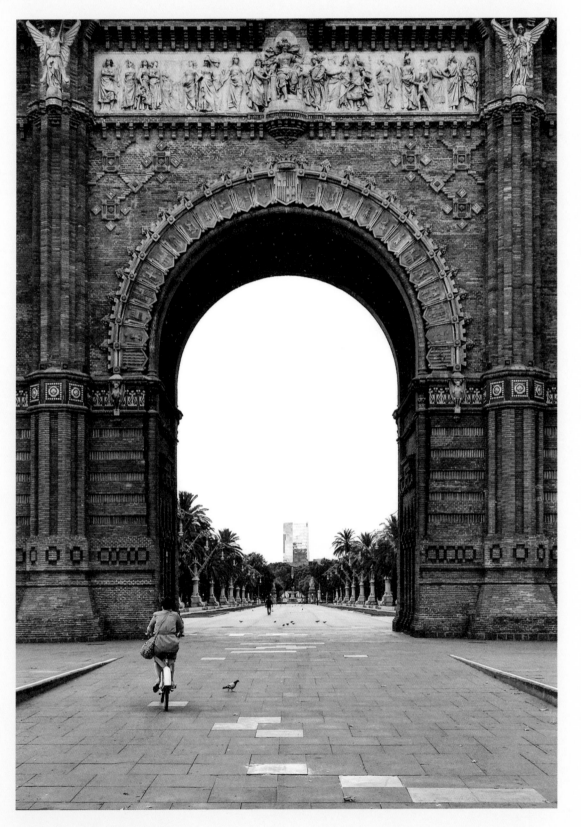

Arc de Triomf, Barcelona, Spain

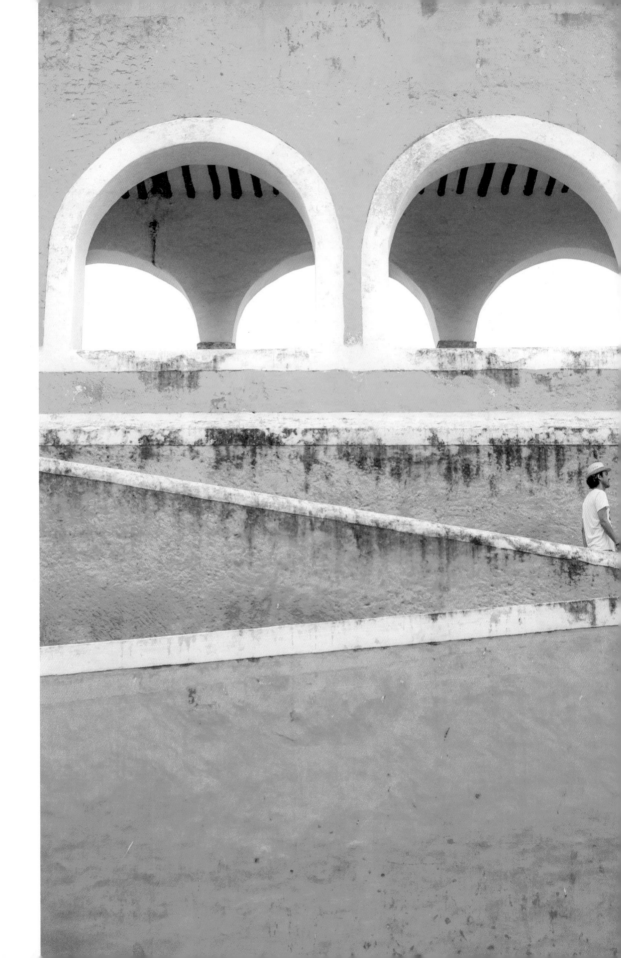

A DAY TRIP away from Mérida, Izamal was the center for worship of the Mayan gods, particularly the supreme god Itzamna and the sun god Kinich-Kakmó. Visit this city, now known as "the Yellow City" for its traditional yellow buildings, on foot or by horse-drawn carriage. This is one of two cities in Yucatán considered by the Mexican government to be "magical" due to its rich history and tradition. The city is best known for the Franciscan convent San Antonio de Padua, which has the largest atrium in the Americas and rests upon the flattened top of the Mayan pyramid built for the god Itzamna.

**Izamal Pueblo Magico,
Yucatan, Mexico**
Romana Lilic
@romanalilic

→
Havana, Cuba
Emily Nathan
@ernathan

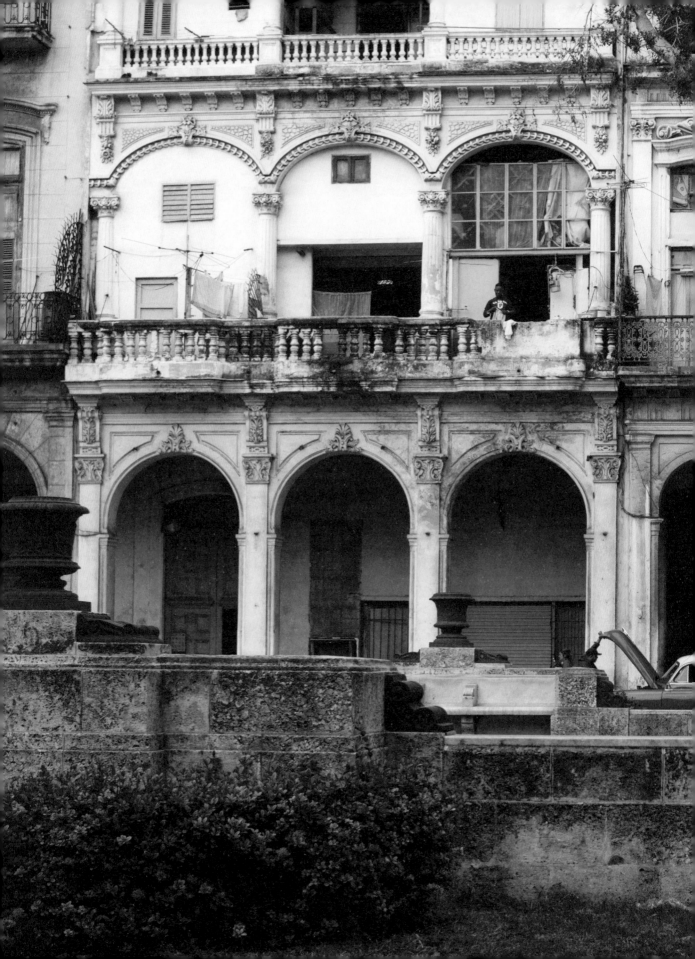

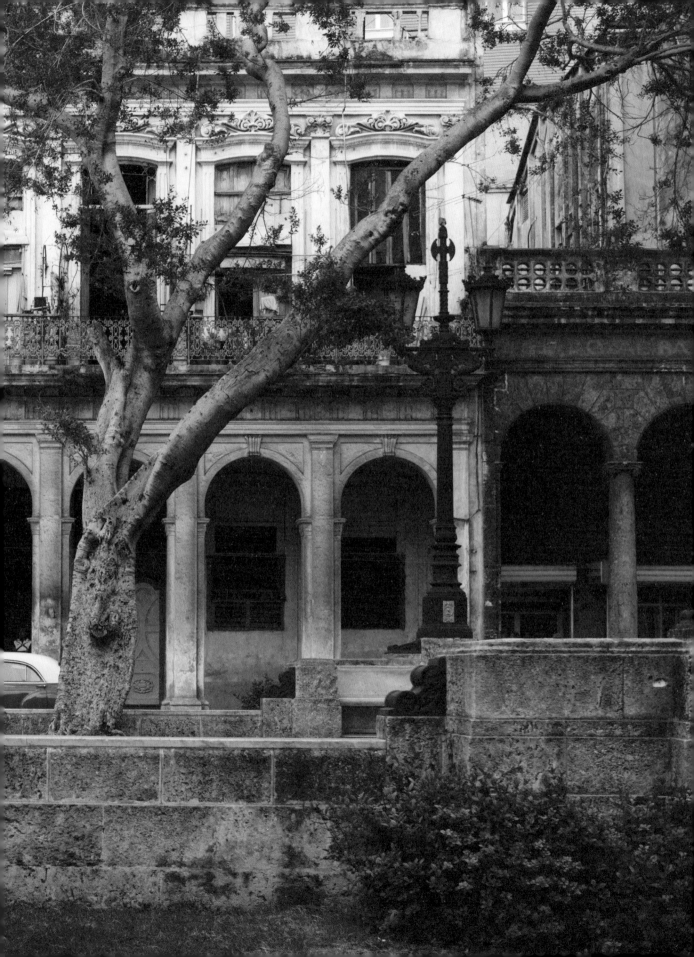

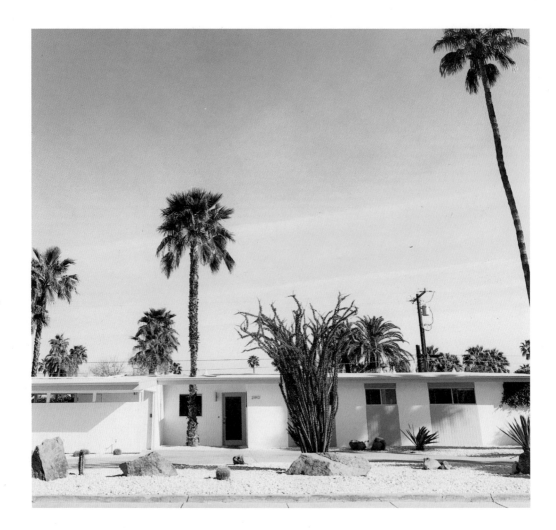

↑

**Palm Springs, California,
United States**

Isabel Castillo Guijarro
@byisabel

→

BUILT IN THE eighteenth century, the Chapel
of Souls is located in the heart of old Porto in
northern Portugal. In 1929 the chapel was covered
with nearly sixteen thousand blue painted tiles
that depict the lives of saints, including the death
of Saint Francis. This shot was taken across the
street from the Chapel of Souls on the Rua de
Fernandes Tomas.

**Chapel of Souls,
Porto, Portugal**

Kylie Pan
@kyliepan

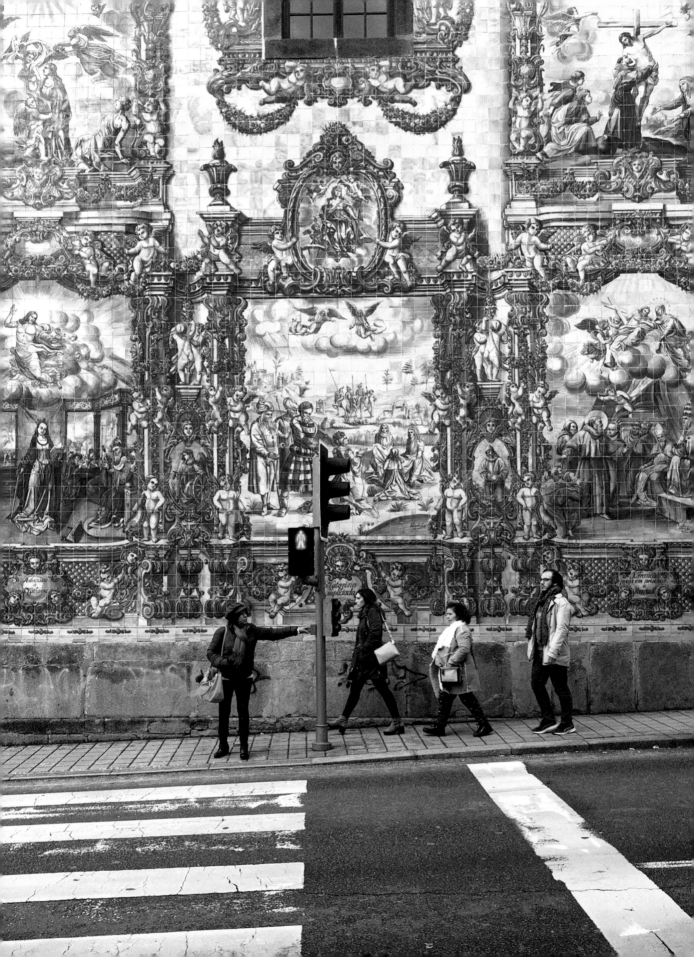

←

**Mandarin's House,
São Lourenço,
Macau, Guangdong,
China**

Emily Nathan
@ernathan

↓

THIS ITALIAN-STYLE MANSION is home to Egyptian artifacts, an art collection, and a Japanese garden, all included in the price of admission. The plot was originally a part of the royal estate and is near Wimborne Minster church. The estate is owned by the National Trust, one of the United Kingdom's largest charities, which cares for historical properties and nature reserves. Nearby Dorset attractions that don't cost a penny include Greenhill Gardens with views of Weymouth Bay, walks along the trails of Durlston Country Park National Nature Reserve, and Maiden Castle, one of Europe's biggest Iron Age hill forts.

**Kingston Lacy, Wimborne,
Dorset, England**

Michael Sullivan
@mistersullivan

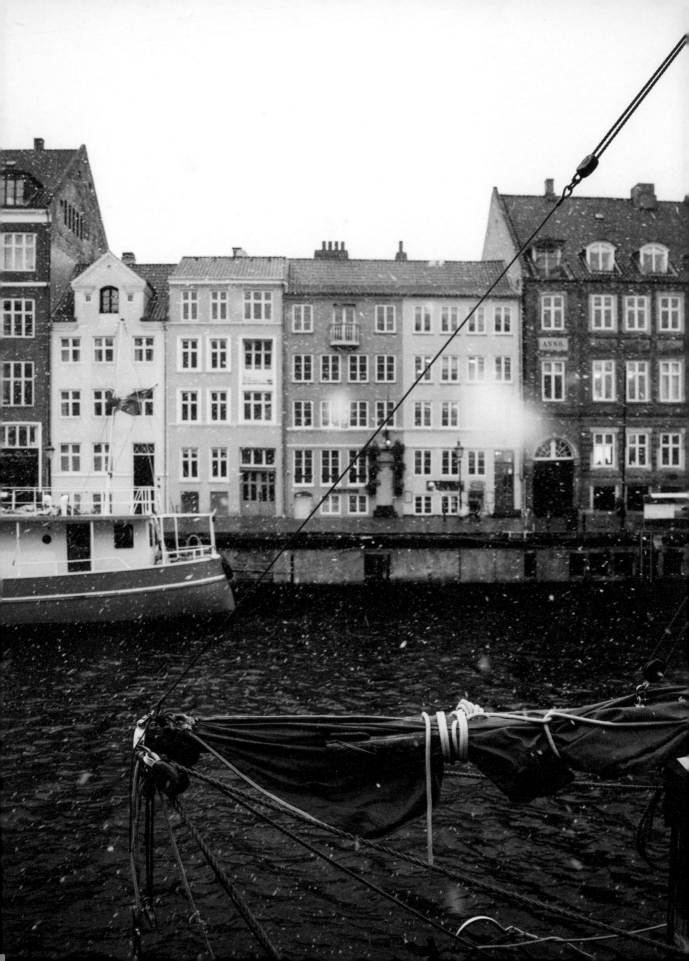

←

THE NYHAVN NEIGHBORHOOD canal
separates the north side's colorful
seventeenth- and eighteenth-century
townhouses from the south side's
elaborate mansions.

Copenhagen, Denmark
Morten Nordstrøm
@mortenordstrom

↑

**New Orleans Arts Disctict,
Louisiana, United States**
Reggie Thomas
@zobleu

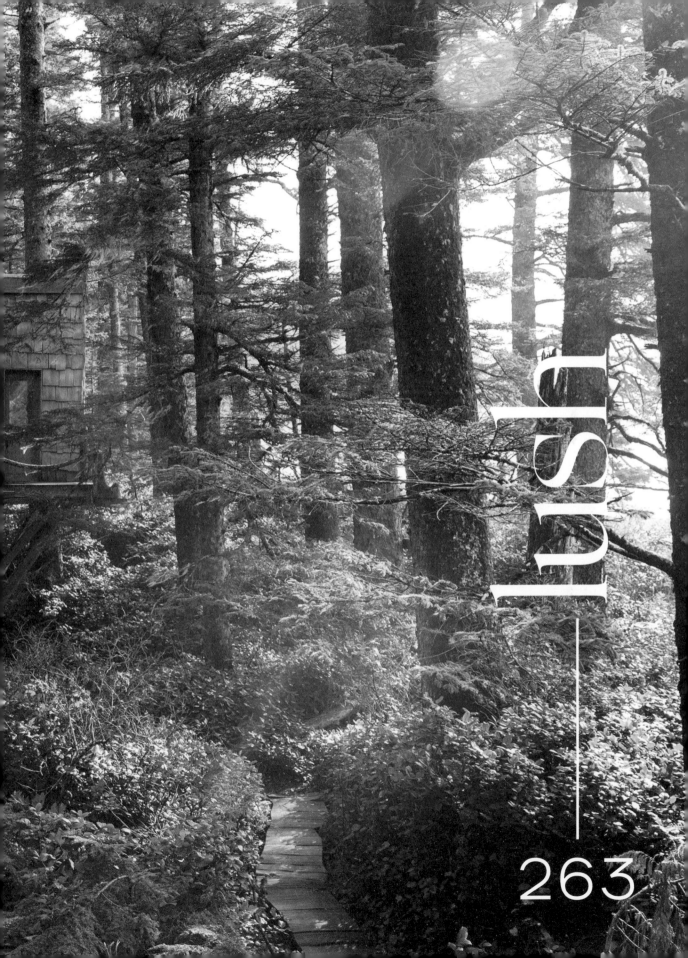

lush

263

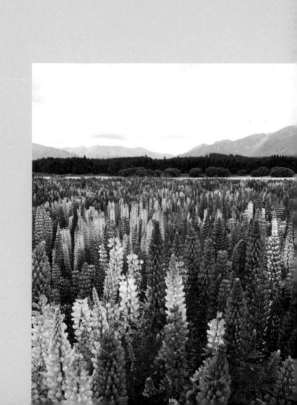

Just as architectural landmarks quickly locate a city in our mind's eye, so too can the subtle cues of plants inform us about geography and place. When you see an image of hundreds of fuchsia lotus blossoms nestled inside a gigantic woven basket at a flower market, you know immediately that picture was not taken in Iceland. A picture of a valley filled with lupines alight in midnight sun was not taken in India. A wall of palm leaves hints that you are probably not in New York.

Plants are also a great teacher about microclimates and the particularities of place. On a trip to upcountry Maui for *Tiny Atlas*, we visited a protea farm in the fog. If you know that these temperate flowers can grow in Maui, it might mean that you have driven up to Maui's highest volcano, Haleakala, and seen them at a roadside flower stand. Seeing the vivid pinks of sea life on Lummi Island in the San Juans, you can begin to characterize the unexpectedly vivid colors of the wet- and cold-loving flora of the Pacific Northwest.

Plants are a reminder of the immediacy in our lives. They breathe and grow as fast as we do (or faster). Like people, plants are living, evolving lifeforms. Instead of showing time pulled back to a distance of eons, plants allow us to view the world at our scale, living and changing day by day, moment by moment. A photograph of a plant is an enchanting time capsule.

←

Nootka Island, British Columbia, Canada

Erin Kunkel
@erinkunkel

↖

Visalam, Kanadukathan, Tamil Nadu, India

Emily Nathan
@ernathan

↑

Lotus blossoms, Chennai, Tamil Nadu, India

Emily Nathan
@ernathan

←

Lake Tekapo, South Island, New Zealand

Emily Blake
@emilylaurenblake

↓

San Gregorio, California, United States

Molly Margaret Meyer
@mollymrgrt

→

Lummi Island, Washington, United States

Stephanie Eburah
@seburah

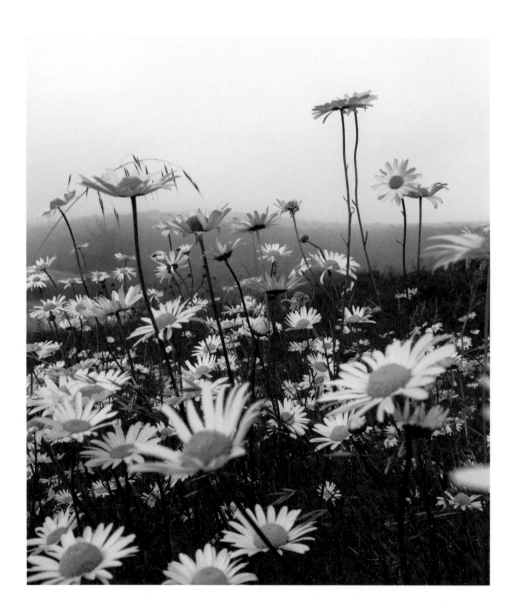

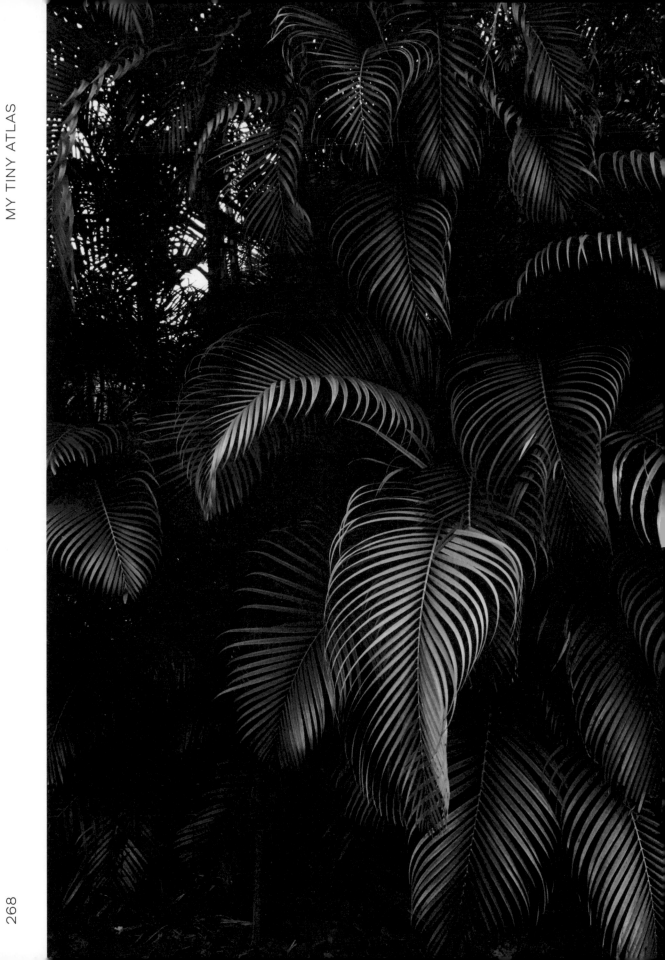

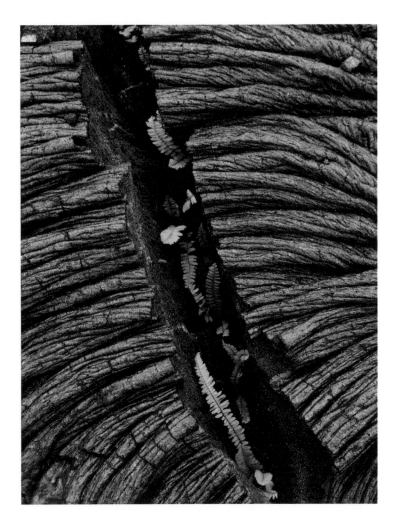

↑

**Pahoa, Hawaii,
United States**

Emily Nathan
@ernathan

←

**Haena, Kauai, Hawaii,
United States**

Emily Nathan
@ernathan

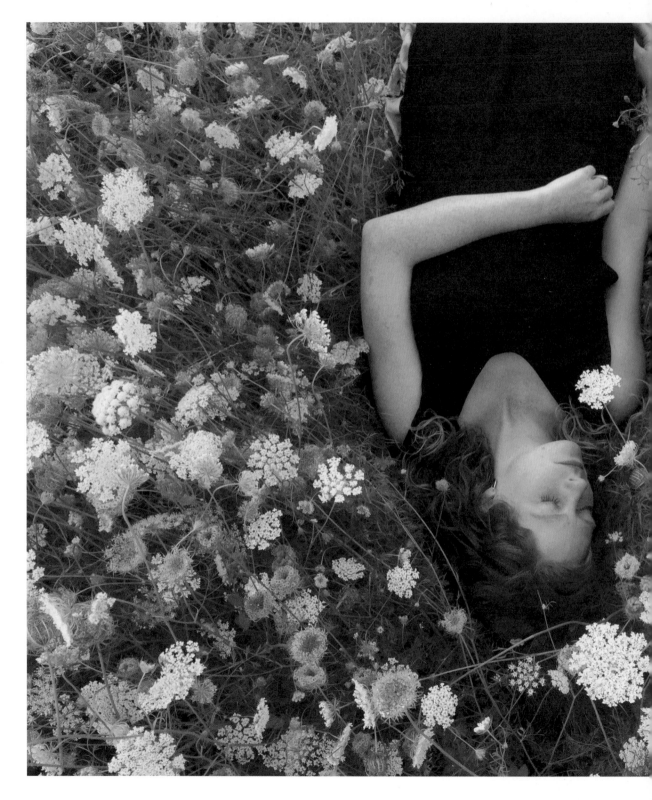

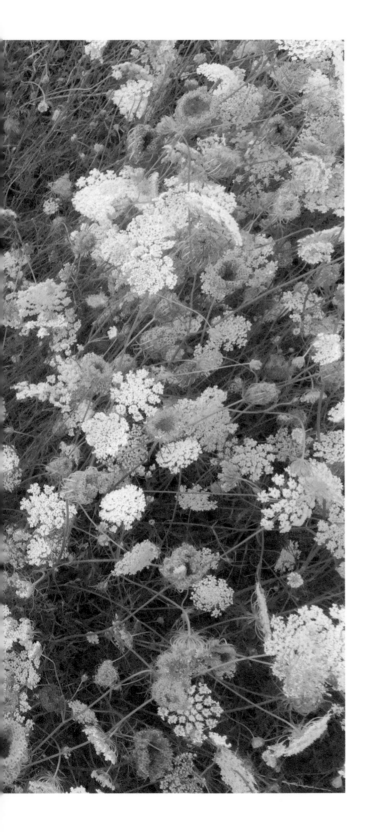

NATURAL BEAUTY SURROUNDS
California's best-preserved Gold
Rush town, tucked in a basin on the
western slope of the Sierra Nevada
foothills.

**Nevada City, California,
United States**
Molly Margaret Meyer
@mollymrgrt

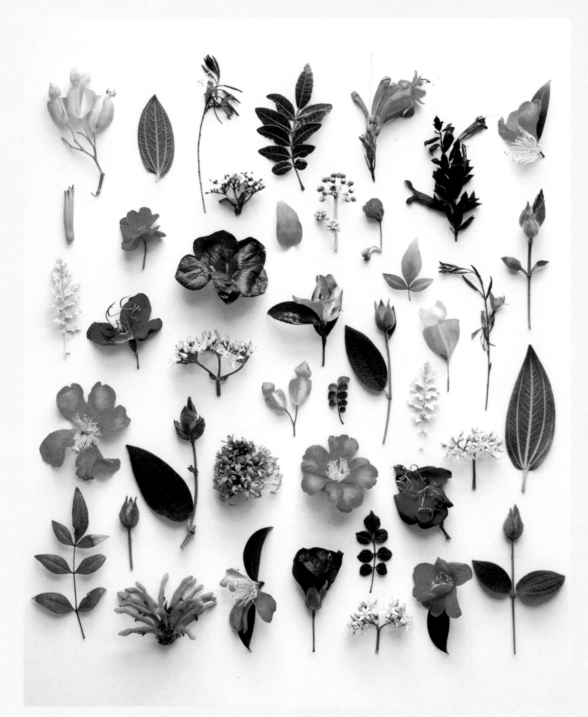

Mission Dolores Park, San Francisco, California, United States

PROFILE

JA SOON KIM

@omjsk

WHO IS JA SOON?

Ja Soon Kim has lived many lives in her seventy-odd years. She remembers being a child during the Korean War, when her family was forced to move to Busan, in the far south of the country. She later worked for many years as an art director and graphic designer in Honolulu. Then, after a stint in Paris, she worked at the Whitney Museum of American Art in New York City. Today she paints, shoots pictures, and teaches yoga in Santa Fe, New Mexico, all while taking photography assignments to continue to discover all she can of the natural world.

Ja Soon's father was a serious amateur photographer, and creating images means remembering him. Ja Soon's photographs combine her sense of design with a focus on the natural world, which she works to protect and elevate through her photography. When she visits her daughter in Lanikai on Oahu, she'll arrange pau tree leaves in neat rows for one image. In another, she'll record an entire beach's plant life by arranging specimens atop a rectangle of soft white sand. Ja Soon then captures these objects from directly overhead in a flat-lay shot, a style that she finds particularly intriguing.

JA SOON'S SANTA FE

A job offer at a large fine art gallery led Ja Soon to Santa Fe. Once she moved, she fell in love with the desert. Drawn to the natural phenomena of the landscape—like cactus flower blooms in the spring or clouds of snow dust in the winter—she quickly became entranced by the nature and seasonal shifts of New Mexico.

On her walks through the desert, Ja Soon collects little pieces of nature that she finds along the way—a stray feather, a fallen flower, a few rocks or shells. Then, she carefully arranges these found objects, creating a design that represents life in the desert and how it shifts throughout the seasons. For Ja Soon, this is a meditative process. The foraging is time for introspection and meditation, the arrangement is an exercise in design and detail, and shooting the final photos is an opportunity to create something lasting out of something organic and ephemeral.

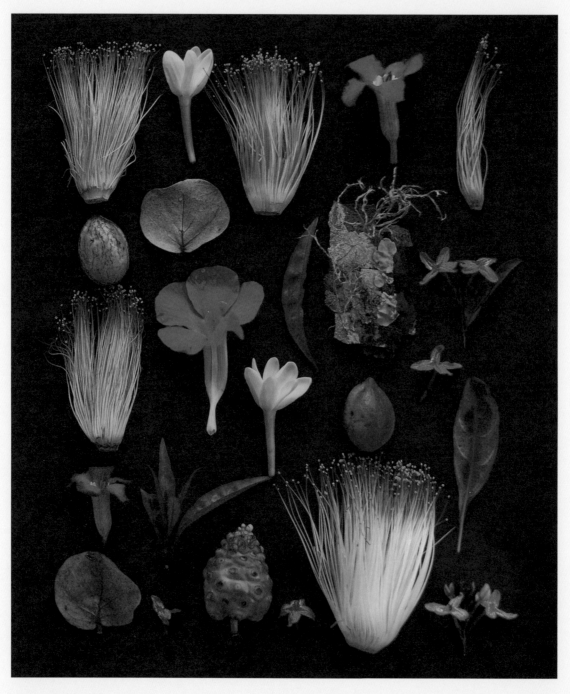

Mo'orea, French Polynesia

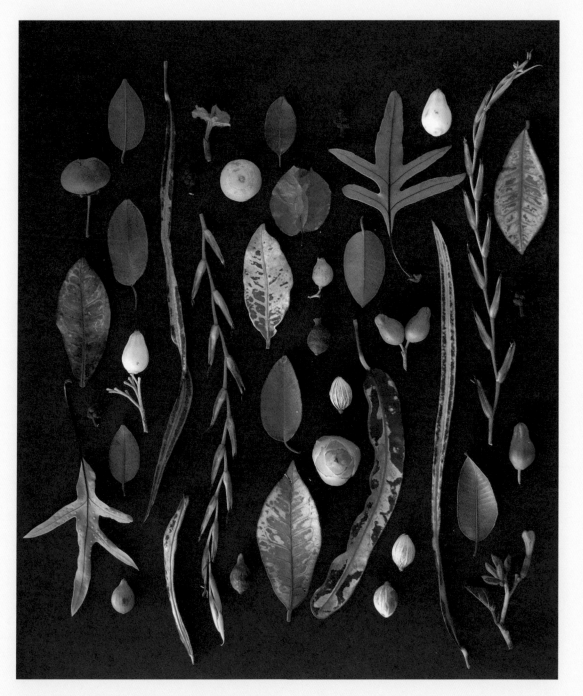

Lanikai Beach, Kailua, Oahu, Hawaii, United States

← Garfield Park
Conservatory, Chicago,
Illinois, United States

Dani Soukup
@danisoukup

⟶ Upcountry Maui,
Hawaii, United States

Emily Nathan
@ernathan

↓ BUILT IN 1878 the Palmhuset ("Palm House")
greenhouse was modeled on Kew Gardens' Palm
House and shipped from Britain for the Garden
Society of Gothenburg. The nineteenth-century
park is one of the best-preserved and largest
in Europe.

Palmhuset, Gothenburg,
Sweden

Elke Frotscher
@elice_f

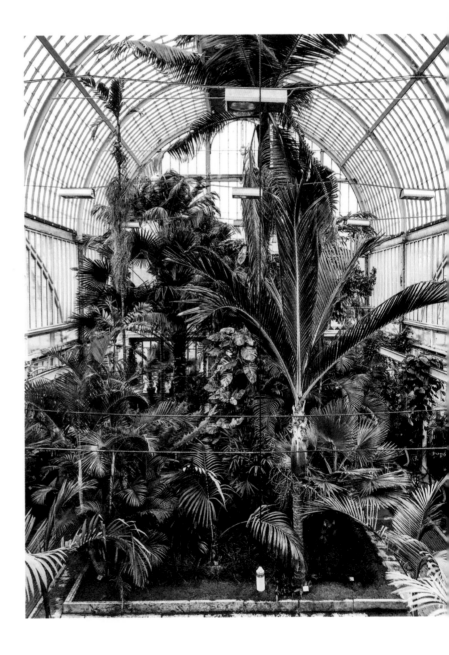

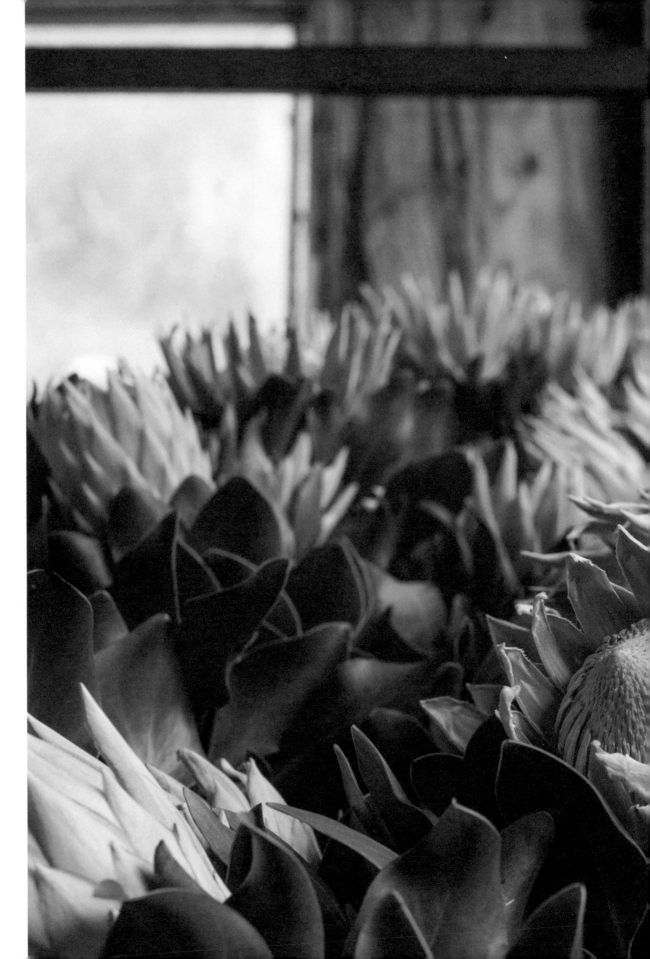

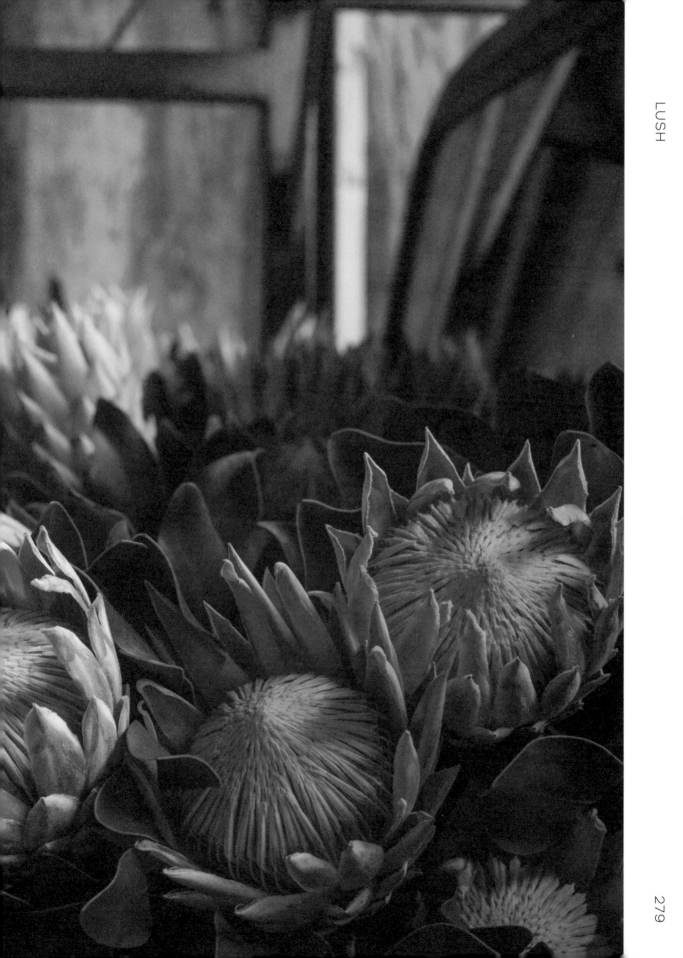

↓

SEA LAVENDER LINES Del Mar's many trails. Hike along the network of dirt trails atop the bluffs at Torrey Pines State Beach to catch a glimpse the contrasting greenery of the wildflowers with the deep blue Pacific Ocean below.

**Del Mar, California,
United States**

Patric Phillips
@patricwithno_k

←

**Sahara Desert,
Morocco**

Jill Livingston
@jlblivingston

⟶

**Zion National Park,
Utah, United States**

Lisa Weatherbee
@jungletimer

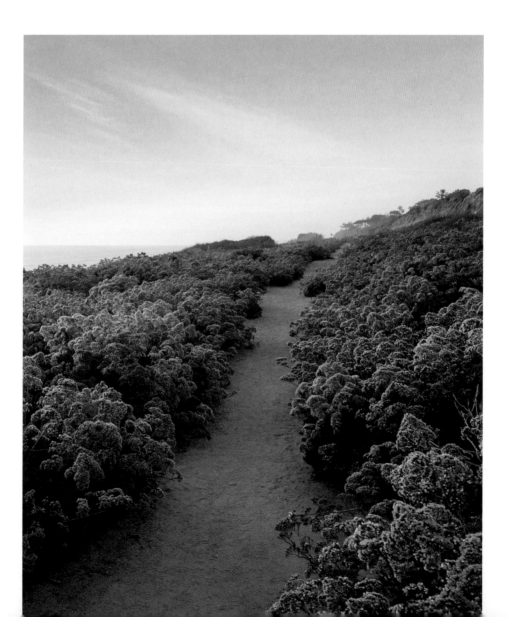

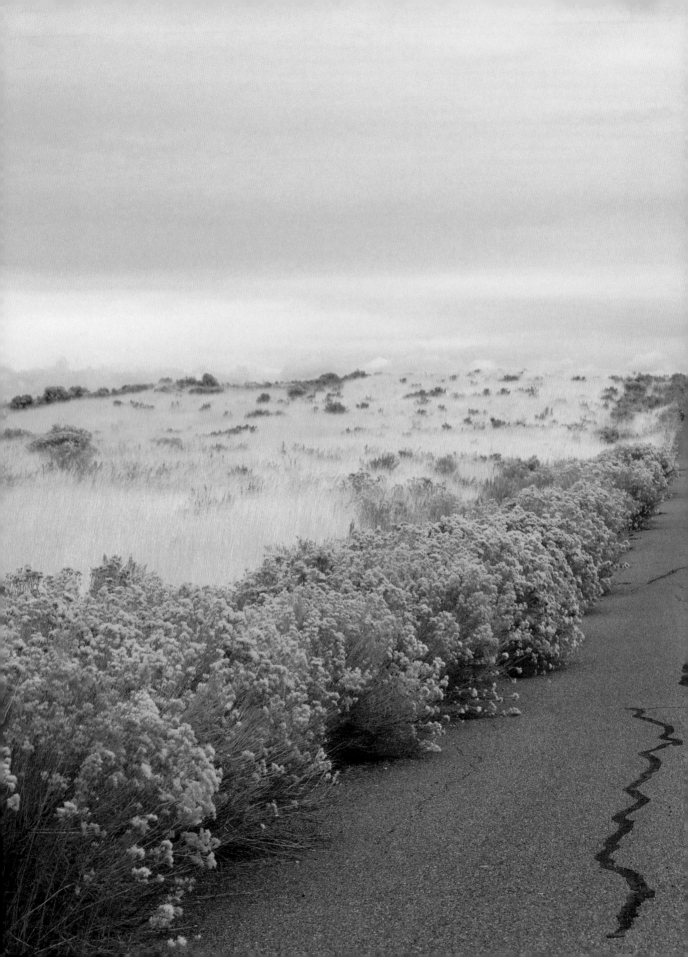

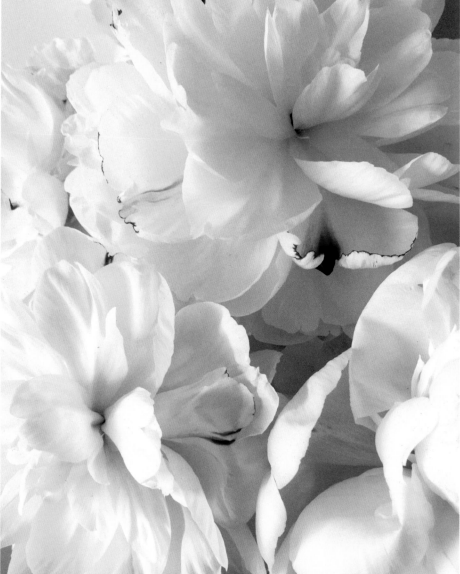

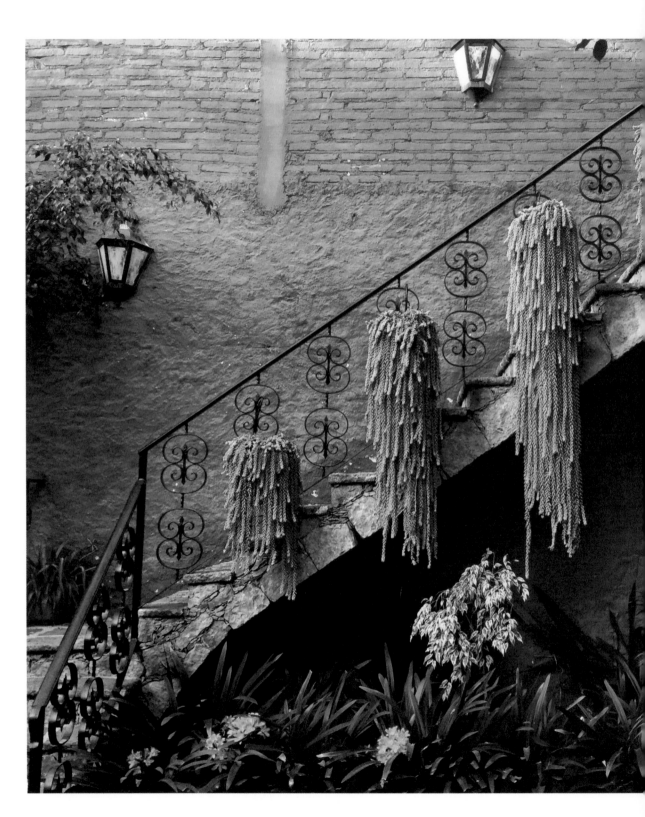

SAN MIGUEL DE ALLENDE is known for its baroque architecture, fine art galleries, and folk art museums, as well as its famous central square—also a park—known locally as El Jardin.

**Casaluna Hotel Boutique,
San Miguel de Allende,
Guanajuato, Mexico**

Shelly Strazis
@shellystrazis

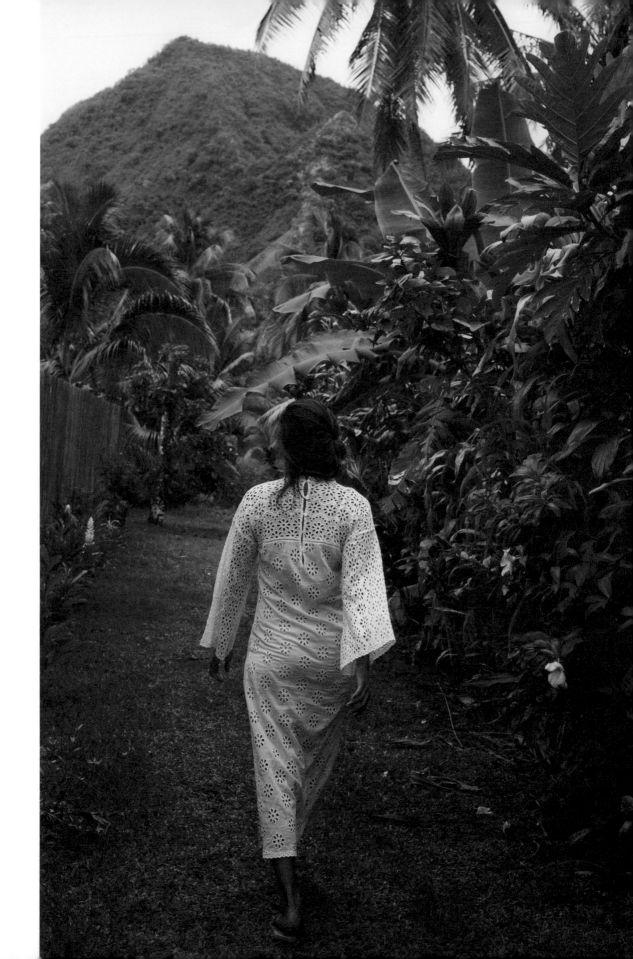

**Teahupo'o, Tahiti,
French Polynesia**

Emily Nathan
@ernathan

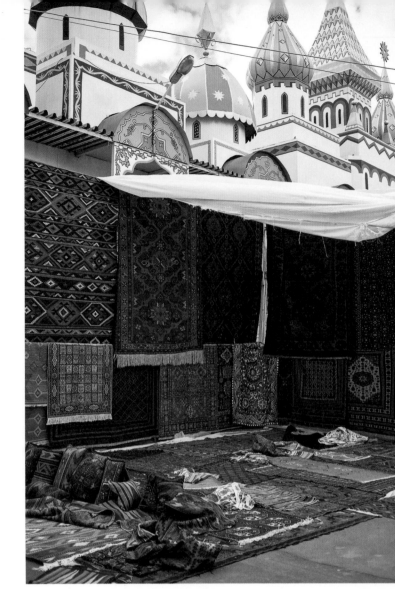

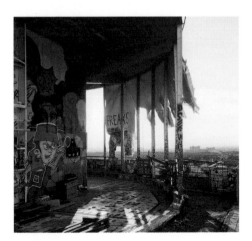

↑
Moscow, Russia

Sara Kerens
@sarakerens

→
Berlin, Germany

Sofia Tomé
@sofiatome

acknowledgments

There are so many people to thank for the creation of this book, but first and foremost I need to thank my literary agent, Kate Woodrow. She is smart, talented, and such a warm ray of sunshine. After experiencing the pressure of self-publishing and distributing a print magazine, I was at first a little skeptical about making a book. But Kate simply glowed with talent and assurance, and I felt like I could actually get a project of this scope done with her in my corner. Because I was busy with the day-to-day life of the magazine, going on shoots, and running *Tiny Atlas* projects all over the world (to say nothing of taking care of my young son), I wasn't as focused as I should have been on getting my book proposal done at first (ahem, I handed it in eight months later than I said I would). In the end, I finally finished it just so I wouldn't disappoint Kate. I wasn't sure anyone was going to say yes to us, but I had told her I wanted to make a book (because of course I wanted to make a book!!!). She sent the proposal off and the following day we had a book deal.

In order to actually create our book proposal I needed help both on the design and concept sides. Explaining what *Tiny Atlas* is takes more work than you might think, and in this endeavor I've had many allies. Janna Stark, a great friend, confidant, and creative jack of all trades proved to be of invaluable assistance in that effort, flying up from LA for book meetings and working with me remotely from her home (while taking care of two young kids herself—there is a theme here). I called Janna one day and asked if she could please help me just finish this proposal I felt like I was never going to complete (a talented designer and former *Tiny Atlas Quarterly* intern Lizzie Vaughan had started the proposal with me). With Kate's stewardship and Janna's help and intuition, our proposal was completed. Early on, managing editor Flora Tsapovsky helped me wrench my thoughts into a written plan. Later, another former intern, Summer Sewell, saw what the writing for the book could be and helped me shape it (thanks to another old managing editor, Diana Mulvihill, who had suggested she get in touch with me).

Like Summer, Charlotte Boates proved key to content creation. We met Charlotte when she was writing with Spot, an excellent travel app (whose team actually helped us immensely on the first organization of book contributors) that featured Tiny Atlas a few years ago. We knew a good thing when we met her and Charlotte has been working on written *Tiny Atlas Quarterly* projects with us ever since. Charlotte researched and profiled so many tastemakers with me— always with a smile and always a joy to work with.

From the start of the project Jenny Wapner, our executive editor at Ten Speed Press, was our advocate. She knew and loved *Tiny Atlas* and had a vision for how we could make a beautiful book together. The creation of this book has been such a pleasure because Jenny wanted a *Tiny Atlas* book to be just that. Every core value I have instilled into the brand—the authentic and loose quality of the imagery, the accessibility of the locations, the wide variety of contributors who themselves are all really fascinating people, the beauty of the imagery explored in a natural and casual way—was precisely what Jenny wanted explained, explored, and highlighted in this book. Jenny also pushed to make the minimal written content we envisioned for this photography-first book both interesting and useful.

Our Ten Speed designer, Lizzie Allen, had a beautiful but challenging project with the design of this book. I could only get the photo edit whittled down so far without actually putting together the entire book. So I made larger pools of favorite images for each chapter, and then relayed them to Lizzie, who then got super creative with the pairings and flow for the layout. She took on the challenge of having too many beautiful images with aplomb, and gave back gorgeous page after gorgeous page. Working behind the scenes in production at Ten Speed, Jane Chinn had a key role in color proofing, sourcing materials for the jacket, and coordinating with printers.

Anne Goldberg waded deep into the heart of the content production and design, and proved a wonderful guardian editor and bastion of the process and our ethos as a whole while Jenny was on maternity leave. She has been a cheerleader throughout the hardest written portion of this book, while also focusing on the core of my vision with warmth and generosity.

Even though I went to school for writing (long ago), my entire adult life has been mostly about photographic communication. I feared readers might just skip any writing in the book, and I was hesitant to write overly simple introductions to all the chapters--I wasn't a writer but damn it, if I was going to write something, I wanted it to be good! The saving grace came from Jennifer Rodrigue, who I knew first as my yoga instructor in San Francisco. Years later I found out she is a professional editor, and recruited her to work with me on the Tiny Atlas magazine as an executive editor who came with the grounding and depth you might expect from a lifelong yogi. When it came time to do the hard work of trying to reconcile writing something meaningful for all the introductions within the elusive world of deadlines and tracked changes, Jennifer saved me. She came into the process knowing me, knowing *Tiny Atlas*, and understanding both where *Tiny Atlas* had started and where we were headed. She was the best possible writing

coach. By the time we were done I was proud of the thoughtfulness, clarity, and utility of all the chapter intros and tastemaker profiles.

Our magazine editor and photo partnerships director Deb Hearey held down the fort at *Tiny Atlas* while I pursued this #dreambook. Deb kept the lights on with all the projects we were running concurrently (meanwhile taking care of three young kids of her own) so that I could make this book. Lindsey Adams, our social media editor and all around production support, made sure deadlines were met and projects completed time and again. Alex Genette has kept our website alive and moving towards the future throughout the process as well. I have a village of support, and I have not even mentioned any of the contributors to the book's content.

The work of creating this book has been the curation and writing, but the pure joy and fun of it has always been in discovering the content and the creators whose photographs fill these pages with their travels. A big thanks to all of the creators whose work we profiled in the chapters, and especially to Elke Frotscher, who came to California for a few weeks while we were deep in the thick of the process, and edited alongside me.

Thank you to Jimmy Mezei, the wonderful illustrator whose beautiful print lines the inside of the jacket, who we know thanks to the late and great Tom Slaughter, whom I met on Instagram. Thank you to Mark Sloan for our incredible rebranding, and for being my design bastion at all sorts of important moments during the past few years.

Thanks to all of the photographers who trusted us with an image or two in the book. Thank you to all of the creators who submitted work to us to review for the book; my only regret is that there was not space to feature every one of you. A #mytinyatlas book would have never happened without this community. Our thanks goes out to Instagram for that matter, to creators Kevin and Mikey who gave the world this crazy gift of photographic connection. The #mytinyatlas hastag was launched to the world at the tail end of our first Kickstarter campaign because my friends Michael O'Neal and Daniel Dent agreed to meet me at a bar and discuss a tag that could work to spread word about the magazine on social media. Thank you for being the first contributors to the tag.

The creation of #mytinyatlas transformed what could have been called a blog into what has become a new form of travel media. My thanks to the many friends who have supported the project from day one. Amy Frost jumped in at *Tiny Atlas* events with cases of rose in hand, Amy Guittard showed up with boxes of chocolates, Tae Kim of Alite Designs, George Sylvain from Social Print Studio and Joan Rutherford at Fuji all collaborated with *Tiny Atlas* on a number of

influential creative projects and events that fueled our growth. Our first branded photo production came about due to early insights into Tiny Atlas' social reach by Lindsay Arakawa, who was working on social media for TEVA at the time. Later, at the suggestion of Laura Rubin of Allswell, and with the expert help of Tom Werney from Earth Missions, *Tiny Atlas* started to take larger groups of photographers on trips around the world. These first productions were catalysts for so many future ones. There are many more people to thank, too many to thank here but please know we are grateful for your friendship, your time collaborating with us, your images, your support, and your encouragement along the way.

Thanks to all the *Tiny Atlas* interns ever; we would never have been able to keep this project going without your hard work and dedication. Special thanks to those of you who worked on the book: Alexia Delgado, Rachael Medina, Courtney Kinnare and Tara Hadipour.

In the end, my deepest gratitude goes out to my family. My sisters and parents have always been my rock and foundation, and have been at the other end of emotionally draining phone calls since, well, forever. My mom has been the biggest supporter of my creative endeavors my entire life, with unwavering enthusiasm since I first started writing and taking pictures as a child. My dad came in to save the day multiple times when I felt *Tiny Atlas* was just too much work.

Finally, without my husband Jake, there would be no Tiny Atlas. For pretty much my whole professional life Jake has supported my creative work—both as a partner and also as a creative himself. He designed all of my early websites, and then put in ridiculous hours on the first few years of the original Tiny Atlas website, directing the overall design as well as leading the UX for our updated site. Jake created a website unlike any other, really, and that helped us get early attention and traction. In addition, he has always been a caring and supportive listener, offering thoughtful and intelligent responses to any questions I bring home. My son Otto is an inspiration to everyone who knows him, and his love and passion for life are always an inspiration to me.

Thank you, all!

Emily

JACKET

1 Lisbon, Portugal

Ana Linares
@ananewyork

2 Gazelugatxe Islet,
Basque Province,
Spain

Grant Harder
@grantharder

3 Cox Bay, Tofino,
British Columbia

Jeremy Koreski
@jeremykoreski

4 Panna Meena ka Kund
Stepwell in Jaipur,
Rajasthan, Jaipur, India

Ray Yun Gou
@rayraywanders

5 White Sands National
Monument, New Mexico,
United States

Emily Nathan
@ernathan

TITLE PAGE

Oaxaca, Mexico

Lucille Lawrence
@lucillelawrence

HALF TITLE PAGE

**Los Angeles, California,
United States**

Cara Harman
@arrowsleadnowhere

Text copyright © 2019 by Emily Nathan

Published in the United States by Ten Speed Press, an imprint of the Crown
Publishing Group, a division of Penguin Random House LLC, New York.
www.crownpublishing.com
www.tenspeed.com

Ten Speed Press and the Ten Speed Press colophon are registered trademarks
of Penguin Random House LLC.

Some of the photographs in this work were originally published in Tiny Atlas
Quarterly (tinyatlasquarterly.com).

Library of Congress Cataloging-in-Publication Data
Names: Nathan, Emily, 1976- editor.
Title: My tiny atlas : our world through your eyes / Emily Nathan.
Description: First edition. | New York ; California : Ten Speed Press, 2019.
 | Includes index. | A collection of images created by the Tiny Atlas
 Quarterly community of professional photographers and casual shooters.
Identifiers: LCCN 2018051044 | ISBN 9780399582264 (paperback)
Subjects: LCSH: Travel photography. | Voyages and travels—Pictorial works. |
 BISAC: PHOTOGRAPHY / Subjects & Themes / Landscapes. | TRAVEL /
Special Interest / Adventure.
Classification: LCC TR790 .T56 2019 | DDC 770—dc23

Hardcover ISBN: 978-0-399-58226-4
eBook ISBN: 978-0-399-58227-1

Printed in China

Design by Lizzie Allen

Special thanks to Charlotte Boates and Summer Sewell for their help
with the writing.

10 9 8 7 6 5 4 3 2 1

First Edition